T0190711

FLASH OF THE SPIRIT

Robert Farris Thompson

FLASH OF

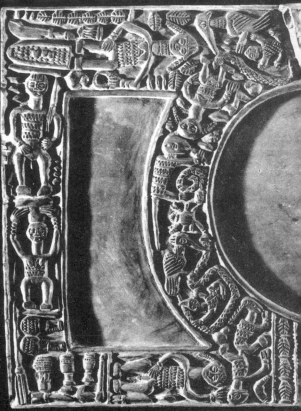

African and Afro-American

Vintage Books

THE SPIRIT

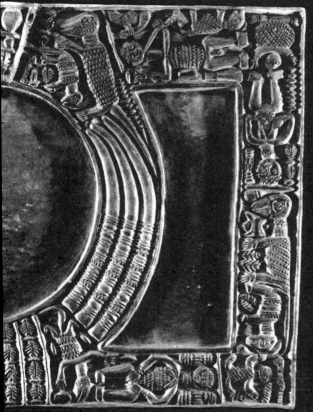

Art and Philosophy

A Division of Random House New York

First Vintage Books Edition, August 1984

Copyright © 1983 by Robert Farris Thompson

All rights reserved under International and Pan-American Copyright
Conventions. Published in the United States by Random House, Inc.,
New York, and simultaneously in Canada by Random House of Canada
Limited, Toronto. Originally published by Random House, Inc. in
1983.

Library of Congress Cataloging in Publication Data
Thompson, Robert Farris.
Flash of the spirit.
Includes bibliographic references and index.
1. Blacks—America—History. 2. Afro-Americans—History.
3. Arts, Black—America.
4. Afro-American arts.
I. Title.
E29.N3T48 1984 973'.0496 83–40298
ISBN 0–394–72369–4 (pbk.)

Manufactured in the United States of America

35th Printing

For Dr. and Mrs. R. F. Thompson,
the late Mrs. E. B. Hood, and
Henriette Wyeth Hurd

Acknowledgments

An artist in Nigeria once taught me a proverb: One tree cannot make a forest *(Igi kan kì s'igbo)*. In other words, a person who does not work together with his colleagues and his friends will not accomplish very much. The recognition of this truth lies behind all acknowledgments.

Thus with profound pleasure and gratitude I record, first of all, the names of the women and men without whose fundamental contributions in the field of African or Afro-American aesthetics I doubt this book would have been conceived at all—W. E. B. DuBois, Melville J. and Frances S. Herskovits, Zora Neal Hurston, Maya Deren, Harold Courlander, Alan Lomax, Alan Merriam, Roy Sieber, Richard Alan Waterman, Marshall W. Stearns, Nat Hentoff, William Bascom, Jean Price Mars, Alejo Carpentier, Argeliers León, Lydia Cabrera, Arthur Ramos, Ralph Ellison, William Fagg, Kenneth Murray, Frank Willett, Roger Bastide, Pierre Verger, Ulli Beier, Janheinz Jahn, Kwabena Nketia, and Don Fernando Ortiz. Their work encouraged my lifetime interest in African/Afro-American musical and visual contributions.

Several friends and colleagues generously read my manuscript, in part or in its entirety, and made many useful suggestions. Nancy Gaylord Thompson, William Rout, Richard N. Henderson, Richard and Sally Price, George Kubler, Henry Drewall, Sidney Mintz, Paul Newman, Roger Abrahams, John Szwed, Perkins Foss, John Janzen, Jan Vansina, Wyatt MacGaffey, Fu-Kiau Bunseki, Daniel Biebuyck, Nehemiah Levtzion, Charles Bird, Keith Nicklin, Araba Eko, Clarence Robins, Lydia Cabrera, Dennis Warren, Roy Sieber, Claude Savary, Harold Courlander, L. Prussin, and K. Campbelle.

The following persons helped in various ways: Vincent Scully, Nelson Ikon Wu, Charles Seymour, Sheldon Nodelman, Robert and Fi Herbert, Leonard Doob, Leon Lipson, Sumner Crosby, Arthur Wright, Anne Hanson, John Blassingame, Richard Morse, Henry Louis Gates, Jr., Margaret Webster Plass, Bernard Fagg, Jacqueline Delange, Charles Ratton, Jürgen Zwernemann, Ekpo Eyo, Kenneth Murray, John Picton, Oginnin Ajirotitu, A. Onayemi Williams, Alaperu Iperu, Adisa Fagbemi, Wole Soyinka, Tahonzagbe Hountondji, C. Malcolm Watkins, Clarence Robins, Ted Holiday, John Amira, Sunta, John Mason, Babalosha Adefunmi, Akinleye Awolowo, B. C. de Groot, J. Douglas, Valdelice Girão, Katherine White Reswick, Morton D. May, Huguette van Geluwe, Vinigi Grottanelli, Albert Maesen, Ezio Bassani, Aldo Tagliaferri, Carlo Monzoni, José Adario dos Santos, Deoscoredes e Juana dos Santos, Vivaldo da Costa Lima, Clodimir Menezes da Silva, Renato Ferraz, Christopher Healey, Janina Rubinowitz, Gaama Gazon, Leo Fonseca e Silva, John Dwyer, Arlete Soares, Balbino, Arnaldo e Helma Marques, Oresto Mannarino, Alain Chevalier, Ragnar Widman, Bertil Söderberg, Torben Lundbaek and Paul Mork, Sylvia de Groot, André Köbben, Ambassador Franklin Williams, Ambassador and Mrs. Oakley, Lloyd and Sarah Garrison, Agogohene of Agogo, Thomas Akyea, Mr. and Mrs. Michael Hoyt, Rick Lawler, Peter Eno, Charles Miller, Chiefs of Ngbe and Obasijum at Itu and Defang (Cameroon), Obon Ndidem, Big Qua Town (Calabar), Gerry Amede, Ludovique Elien, Nathaniel Spear III, Mrs. Edward Webb, Albert Sanders, Judith Wragg Chase, Harris Lewis, Andrew Lewis, Muriel and Malcolm Bell, Mary Granger, André Phanord, André Pierre, Frère Cornet, Nestor Seuss, Gweta Lema, Shaji, Mrs. William R. Eve, Mr. and Mrs. Clemens de Baillou, Barbara Rivette, Elisabeth Coffman, Earle S. Teagarden, Patrick Pleskunas, Junellen Sullivan, J. Carter Brown, George Ellis, Regan Kerney, Robert L. Bernstein, and P. Lawford.

I salute the strong support of my editor at Random House, Erroll McDonald, who helped to shape and protect this book; the inspiring presence of my children, Alicia and Clark; and, above all, the priestesses and priests of traditional Africa, and of Afro-America, who guard the coming of divine aspiration from heaven to this world.

New Haven R.F.T.
October 1982

Contents

Introduction
The Rise of the Black Atlantic Visual Tradition

Listening to rock, jazz, blues, reggae, salsa, samba, bossa nova, juju, highlife, and mambo, one might conclude that much of the popular music of the world is informed by the flash of the spirit of a certain people specially armed with improvisatory drive and brilliance.

Since the Atlantic slave trade, ancient African organizing principles of song and dance have crossed the seas from the Old World to the New. There they took on new momentum, intermingling with each other and with New World or European styles of singing and dance. Among those principles are the *dominance of a percussive performance style* (attack and vital aliveness in sound and motion); *a propensity for multiple meter* (competing meters sounding all at once); *overlapping call and response* in singing (solo/chorus, voice/instrument—"interlock systems" of performance); *inner pulse control* (a "metronome sense," keeping a beat indelibly in mind as a rhythmic common denominator in a welter of different meters); *suspended accentuation patterning* (offbeat phrasing of melodic and choreographic accents); and, at a slightly different but equally recurrent level of exposition, *songs and dances of social allusion* (music which, however danceable and "swinging," remorselessly contrasts social imperfections against implied criteria for perfect living).

Flash of the Spirit is about *visual* and *philosophic* streams of creativity and imagination, running parallel to the massive musical and choreographic modalities that connect black persons of the western hemisphere, as well as the millions of European and Asian

people attracted to and performing their styles, to Mother Africa. Aspects of the art and philosophy of the Yoruba of Nigeria and the Republic of Benin; the Bakongo of Bas-Zaire and neighboring Cabinda, Congo-Brazzaville, and Angola; the Fon and Ewe of the Republic of Benin and Togo; the Mande of Mali and neighboring territory; and the Ejagham of the Cross River in southeastern Nigeria and southwestern Cameroon, have come from sub-Saharan Africa to the western hemisphere.

All of these traditions are ancient and charged with nobility of blood and purpose. And all of them, with the exception of the villager Ejagham, are urban. Since the Middle Ages or earlier, the ancestors of the Yoruba, the Bakongo, the Fon, and the Mande peoples have lived in commanding towns, centers of visual richness and creativity. Even the Ejagham, with their widely imitated important men and women associations, founded respectively under the sign of the leopard and the crocodile—emblematic of intimidating powers of moral vengeance and strong government—live surrounded by miniature versions of the trappings of the courts of ancient urban queens and kings.

These civilizations not only were impressive for their urban density, refinement, and complexity, but were empowered with an inner momentum of conviction and poise that sent them spiraling out into the world, overcoming accidents of class, status, and political oppression. The rise, development, and achievement of Yoruba, Kongo, Fon, Mande, and Ejagham art and philosophy fused with new elements overseas, shaping and defining the black Atlantic visual tradition. To portray not only the originating impulses of these different black civilizations but some sense of the special inner drive and confidence that has kept them going—that showered the northeast of Brazil with famous beads and emblems and gowns of the Yoruba and Dahomey; that fundamentally enriched the culture of North America with profound and sophisticated Kongo- and Angola-influenced herbalism, mental healing and funereal traditions among black people of the Old Deep American South and so on—this is the scope and sweep and purpose of this book. For several decades, scholarly concentration upon shared main organizing principles of dance and music have shown generalized African cultural unities linking the women and men of West and Central Africa to black people in the New World. This book begins the project of identifying *specifically Yoruba, Kongo Dahomean, Mande,* and *Ejagham*

influences on the art and philosophies of black people throughout the Americas.

Flash of the Spirit opens with a discussion of the art and ideals of the Yoruba, black Africa's largest population, creators of one of the premier cultures of the world. The Yoruba believe themselves descended from goddesses and gods, from an ancient spiritual capital, Ile-Ile. They show their special concern for the proprieties of right living through their worship of major goddesses and gods, each essentially a unique manifestation of *àshe*, the power-to-make-things-happen, a key to futurity and self-realization in Yoruba terms. There are thousands of deities in Yoruba territory, western Nigeria and eastern Benin Republic, but only the most widely worshipped and important survived the vicissitudes of the Atlantic Trade. These deities include Eshu, spirit of individuality and change; Ifá, god of divination; Ogún, lord of iron; Yemoja, goddess of the seas; Oshun, goddess of sweet water, love, and giving; Oshoosi, god of hunting; Obaluaiye, dread spirit of disease and earth; Nana Bukuu, his mother; Shàngó, the fiery thunder god, who has inspired thousands of Afro-Americans (two Afro-American religions—Shàngó in Trinidad and Xango in Recife in Brazil—bear his name). There are many other spirits of the Yoruba, alive and brilliantly worshipped by thousands in the New World, such as Obatálá, deity of creativity; Orisha Oko, a celestial judge and restorer of fertility in life and cultivation of the earth; Egúngún, ancestral spirits, virtual moral inquisitors, who form the world of the dead. In *Flash of the Spirit,* I offer portraits of ten *orisha,* deities of the Yoruba, to represent the impact of the mind and spirit of millions of Yoruba in West Africa on key black urban populations in the Americas, most notably in Havana, Salvador, Brazil, and the heavily Hispanic barrios of certain cities of the United States, especially Miami and New York. In other words, the richness of detail, moral elaboration, and emblematic power that characterize the sacred art of the Yoruba in transition to Brazil, Cuba, and the United States, as sampled in this volume, is but an introduction to a wider universe of interlocking forms that will require future books fully to explore and explain.

Also widespread across the black Atlantic world are the signs and insights of the great Kongo people of Zaïre, Angola, Cabinda, and Congo-Brazzaville. There is a clear connection between the cosmographic signs of spiritual renaissance in the classical religion of the Bakongo and similarly chalked signs of initiation among blacks of

Cuba, Haiti, the island of St. Vincent, the United States, and Brazil where numerous Kongo slaves arrived. The Kongo sign of the four moments of the sun—dawn, noon, sunset, and the mirrored noon of the dead that we call midnight—the master icon of their religious and philosophic world, informs the rituals of heavily Kongo-influenced parts of the New World. Kongo, for instance, largely sparked the rise of a beautiful ideographic tradition among the Haitian people, ground-signatures of deities called *vèvè*, and an equally famous and pervasive ground-sign tradition among the blacks and African-influenced people of Rio de Janeiro—signs that are called *pontos riscados*. They can be compared with yet more signs, richly reflecting Christian and other Western influences, on the isle of St. Vincent in the black Caribbean and with others found among Kongo-Cubans and U.S. mainland blacks from Memphis to the Carolina coast. These drawings and their accompanying rituals of healing and/or initiation reflect the confluence of originating Kongo impulses plus other African and European influences.

In Haiti occurred a deep synthesis of the main forms and tenets of the classical religions of the Yoruba, the Dahomeans, and the Bakongo that was partly informed by the saints of the Roman Catholic Church and by their attributes. The result was *vodun:* formally speaking, one of the richest and most misunderstood religions of the planet. In the chapter on Haitian *vodun* I will not only review those elements of Yoruba and Kongo art and thought informing the main forms of vodun, but also focus in particular on the Dahomean influence. I will describe the greatness of *vodun* art by way of an examination of perhaps the religion's two most beautiful expressions: the ground-paintings called *vèvè* and sequin-studded flags of mediation, for the goddesses and gods, called *drapeau de vodun.*

Two mainstreams of visual lore and creativity came from the ancient Mande to the Americas. The cone-on-cylinder building traditions of the Mande and their neighbors—their special spatial patterns and proportions—were models for Afro-Mexican cone-on-cylinder structures along a stretch of the southwestern littoral of Mexico locally called the "little coast" (La Costa Chica), a few hours south of the well-known city of Acapulco.

The specificity of design of the rhythmized textiles of the Mande and their neighbors and of the far-flung replications of this mode, mediated through the Dyula and other Mande traders, has been handsomely reexpressed in the western hemisphere. Four main Afro-

American textile traditions—Barbadian aprons, Afro-Suriname Djuka *aséesenti,* and Saamaka *aséesente,* some U.S. black quilt-tops, and Afro-Bahian *panos da costa*—show traits deriving in part from Mande and Mande-related textile traditions. Chief among these features is the sewing together of narrow strips to form multistrip textile compositions in which the accents of one strip are staggered in relation to the accents of the strip immediately adjoining it but matched with the accents of other strips in the composition. This striking style of suspended patterning is one of the most dramatic elements of African influence not only in the visual art of the Afro-American world but also in its dance and music.

Flash of the Spirit ends with a discussion of the ideographic writing of the Ejagham of eastern Nigeria and western Cameroon. Through the accident of their proximity to Calabar, one of the notorious slaving ports of Africa, their art and ideology of accomplishment and prowess, specially symbolized among men by the sign of the leopard, indelibly influenced the art history of western Cuba. There men of Calabar-area descent founded Cuban chapters of the male "leopard" associations of Calabar and the Ejagham to the north with many aspects of their art and ideographic writing recalling the sumptuousness of the feathered art of the noblewomen of Ejagham. Ejagham artistic influence in the Americas extends a deeply rooted and significant African ideographic writing system, surprising only to those who still believe that Africa alone among the continents was without letters before the arrival of whites, without a means for recording and transmitting moral and folk lore. The transformation of Ejagham *nsibidi* writing into the creolized off-shoot in Cuba known as *anaforuana* is one of the signal achievements of the black New World.

Flash of the Spirit, then, illumines art and philosophy connecting black Atlantic worlds. I hope, in opening these lines of inquiry, that the identification and explanation of some of these mainlines, intellectually perceived and sensuously appreciated, will provide a measure of the achievement of African civilizations in transition to the West, for theirs is one of the great migration styles in the history of the planet.

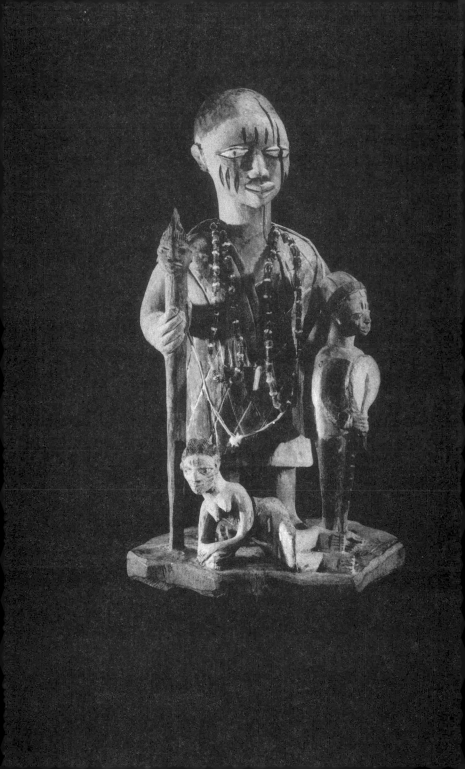

One

BLACK SAINTS
GO MARCHING IN

Yoruba Art and Culture
in the Americas

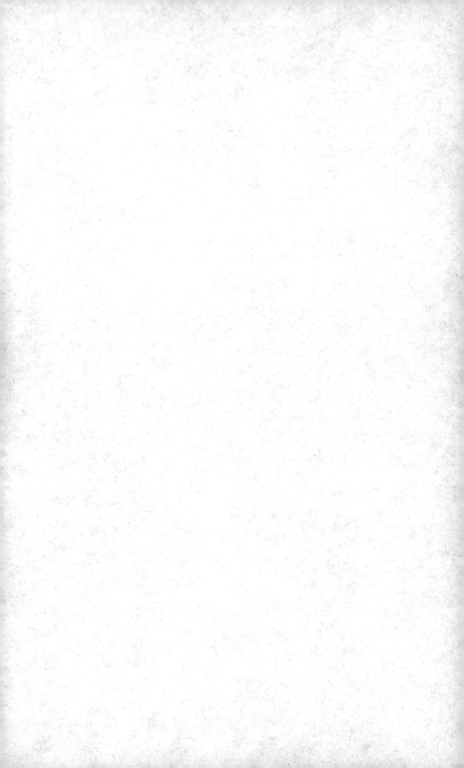

One bright morning in the middle of the nineteenth century, a young American missionary, R. H. Stone, ascended a lofty granite boulder and looked down upon the Yoruba city of Abeokuta. He wrote:

> What I saw disabused my mind of many errors in regard to
> . . . Africa. The city extends along the bank of the Ogun for nearly
> six miles and has a population approximately 200,000 . . . instead
> of being lazy, naked savages, living on the spontaneous produc-
> tions of the earth, they were dressed and were industrious . . .
> [providing] everything that their physical comfort required. The
> men are builders, blacksmiths, iron-smelters, carpenters, cala-
> bash-carvers, weavers, basket-makers, hat-makers, mat-makers,
> traders, barbers, tanners, tailors, farmers, and workers in leather
> and morocco . . . they make razors, swords, knives, hoes, bill-
> hooks, axes, arrow-heads, stirrups. . . . women . . . most diligently
> follow the pursuits which custom has allotted to them. They spin,
> weave, trade, cook, and dye cotton fabrics. They also make soap,
> dyes, palm oil, nut-oil, all the native earthenware, and many other
> things used in the country.[1]

The city of Abeokuta seethed with creative activity, belying the condescending Western image of "primitive Africa."

The Yoruba are one of the most urban of the traditional civiliza-tions of black Africa. Yoruba urbanism is ancient, dating to the Middle Ages, when their holy city, Ile-Ife, where the Yoruba believe

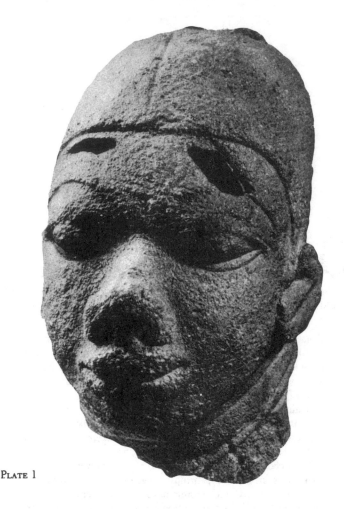

<small>PLATE 1</small>

the world began, was flourishing with an artistic force that later
provoked the astonishment of the West. At a time, between the
tenth and twelfth centuries, when nothing of comparable quality
was being produced in Europe, the master sculptors of Ile-Ife were
shaping slendid art, as exemplified by a Berlin Museum terra-cotta
head (Plate 1).[2] In the elegant conception of the head, perhaps
representing a person of status or a most important spirit, can be
seen the signs of spiritual alertness (the searching gaze) and self-

4 Flash of the Spirit

discipline and discretion (the sealed lips), which suggest, in Yoruba symbolic terms, the confidence of the people's monarchic traditions, and the complexity and poise of their urban way of life.

Like ancient Greece, Yorubaland consisted of self-sufficient city-states characterized by artistic and poetic richness. The Yoruba themselves cherish the creators of their aesthetic world, as one of their hunters' ballads states:

> not the brave alone, they also praise those who know how to shape images in wood or compose a song.[3]

When the first missionaries penetrated the city of Abeokuta in the 1840's, they found that the talents of the local master carver Kashi "had procured for him the headship of the artisans in Abeokuta, and he had great influence among the people."[4]

The Yoruba assess everything aesthetically—from the taste and color of a yam to the qualities of a dye, to the dress and deportment of a woman or a man. An entry in one of the earliest dictionaries of their language, published in 1858, was amewa, literally "knower-of-beauty," "connoisseur," one who looks for the manifestation of pure artistry.[5] Beauty is seen in the mean (iwontúnwonsi)—in something not too tall or too short, not too beautiful (overhandsome people turn out to be skeletons in disguise in many folktales) or too ugly.[6] Moreover, the Yoruba appreciate freshness and improvisation per se in the arts. These preoccupations are especially evident in the rich and vast body of art works celebrating Yoruba religion.

The Yoruba religion, the worship of various spirits under God, presents a limitless horizon of vivid moral beings, generous yet intimidating. They are messengers and embodiments of àshe, spiritual command, the power-to-make-things-happen, God's own enabling light rendered accessible to men and women.[7] The supreme deity, God Almighty, is called in Yoruba Olorun, master of the skies. Olorun is neither male nor female but a vital force. In other words, Olorun is the supreme quintessence of àshe.

When God came down to give the world àshe, God appeared in the form of certain animals. Àshe descended in the form of the royal python (ere), the gaboon viper (oka olushere), the earthworm (ekolo), the white snail (lakoshe), and the woodpecker (akoko). God, within these animals, had, according to Yoruba belief, bestowed upon us the power-to-make-things-happen, morally neutral power, power to give, and to take away, to kill and to give life, according

to the purpose and the nature of its bearer. The messengers of *àshe* reflect this complex of powers. Some are essentially dangerous, with curved venomous fangs. Others are patient and slow-moving, teaching deliberation in their careful motion. Even the earthworm has its power, "ventilating and cooling earth without the use of teeth."[8]

We find the avatars of *àshe* dramatically suggested on the body of a superb ritual ceramic bowl for the thunder god and other deities *(ikoko shango)*. Made in Oyo Yoruba territory, perhaps in the late nineteenth century or the early decades of the present century, it was found in a market in the city of Ibadan in 1964. The object (Plate 2) now forms part of the exhibition collection of the Yale University Art Gallery. Deferring for the moment a discussion of the central motif—the square representing the four corners of the earth along with the three concentric circles within the square that are the triple sign of the Yoruba goddess Earth—we note strong zigzag patterns in relief that suggest the coming down of *àshe* in the form of lightning. These patterns also signify the embodiment of *àshe* within the python, gaboon viper, and many other serpent messengers of the deities. Y-shaped representations bespeak the balancing of this fiery enabling power upon thunderstaffs, i.e., double meteorites upon a royal scepter. Above these Y-shaped thunderstaffs appear smooth rectangular emblems representing thunderstones themselves come from heaven. Time and again the story of the descent of God's *àshe*, in multiple forms, in multiple avatars, is suggested ideographically upon this important vessel. To the right and left of the central square emblem appear chiefly scepters, underscoring the essential nobility of the persons who embody and comprehend the power-to-make-things-happen. The three concentric circles suggest three stones, the kind Yoruba women use to support their cooking vessels, meaning that adherence to the moral sanctions of Earth supports us all, safeguarding the equilibrium of the country and its people.[9]

Some trees are also thought to be avatars of *àshe*, sentinels guarding the Yoruba universe. The mighty teaklike *iroko (Chlorophora excelsa)* is often so honored in traditional towns by the tying of a white cloth to its trunk as an offering.[10] Iron, as time-resistant as the towering *iroko* when specially consecrated, is also believed to contain *àshe*. *Àshe* may also be present in a drop of semen or a drop of blood—for many Yoruba, red, "supreme presence of color,"[11] signals *àshe* and potentiality.

Àshe has other formal representations, including iron staffs, iron

Flash of the Spirit

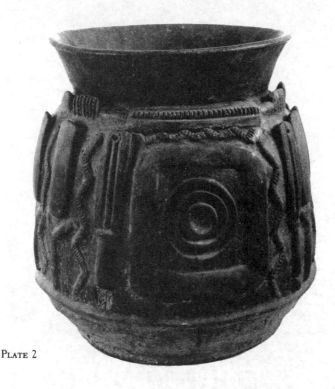

sculptures of serpents and long-beaked birds, and even the fluid of snails poured over altar emblems.

A thing or a work of art that has *àshe* transcends ordinary questions about its makeup and confinements: it is divine force incarnate. This richest of all privileges is merited by the highest women and men of the land: the master priestesses, the diviners, the kings, the most important chiefs. All have *àshe*. And even their words are susceptible to transposition into spirit-invoking and predictive experiences, for *àshe* literally means "So be it," "May it happen."

Yoruba kings provide the highest link between the people, the ancestors, and the gods. Their relation to the Creator is given in the praise poem *Oba alashe ekeji orisha*, "The king, as master of *àshe*, becomes the second of the gods." Birds, especially those connoting the *àshe* of "the mothers," those most powerful elderly women with a force capable of mystically annihilating the arrogant, the selfishly rich, or other targets deserving of punishment, are often depicted in

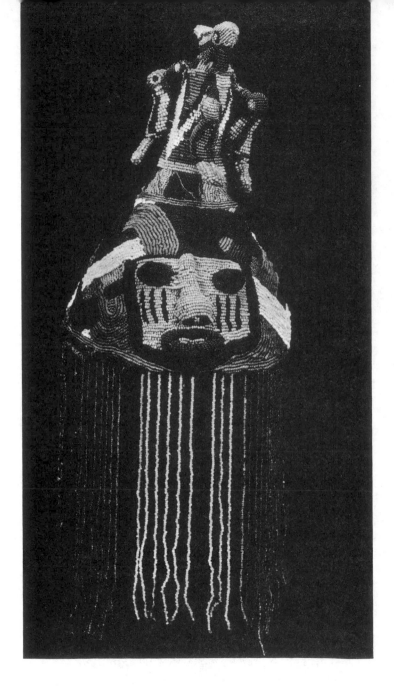

PLATE 3

bead embroidery clustered at the top of the special crowns worn by
Yoruba kings (Plate 3) signifying that the king rules by mastering
and participating in the divine command personified by them. These
feathered avatars brilliantly rendered in shining beads protect the
head of the supreme leader. The veil that hangs across the wearer's
face protects ordinary men and women from the searing gaze of the
king in a state of ritual unity with his forebears.

Ritual contact with divinity underscores the religious aspirations
of the Yoruba. To become possessed by the spirit of a Yoruba deity,
which is a formal goal of the religion, is to "make the god," to
capture numinous flowing force within one's body. When this hap-
pens, the face of the devotee usually freezes into a mask, a mask
often (but not always) held during the entire time of possession by
the spirit. Àshe is untranslatable. But it is clearly manifest in proph-
ecy and predictive grace; hence persons possessed by the spirit of a
Yoruba deity are believed to speak of things yet to come. They
attract large crowds wherever they appear. They look about grandly
with fixed expressions, with eyes sometimes wide and protuberant.
The radiance of the eyes, the magnification of the gaze, reflects àshe,
the brightness of the spirit. According to the Yoruba:

> The gods have "inner" or "spiritual" eyes *(ojú inún)* with which
> to see the world of heaven and "outside eyes" *(ojú ode)* with
> which to view the world of men and women. When a person
> comes under the influence of a spirit, his ordinary eyes swell to
> accommodate the inner eyes, the eyes of the god. He will then
> look very broadly across the whole of all the devotees, he will open
> his eyes abnormally.[12]

In addition to *àshe*, *iwa* (character) is another crucially important
consideration in Yoruba religion and art. The Yoruba impart to
many figurations a sense of ideal noble character by details of atti-
tude and gesture as well as the use sometimes of white-colored
media. Character is a force infusing physical beauty with everlasting-
ness. "I want to deliberate on this," an elder of Ipokia, capital of the
Anago Yoruba, once told me, "beauty is a part of coolness but beauty
does not have the force that character has. Beauty comes to an end.
Character is forever."[13]

The importance of good character *(iwa rere)*, which is virtually
synonymous with coolness, with gentle generosity of character *(iwa
pele)*, is poetically rendered by the Yoruba:

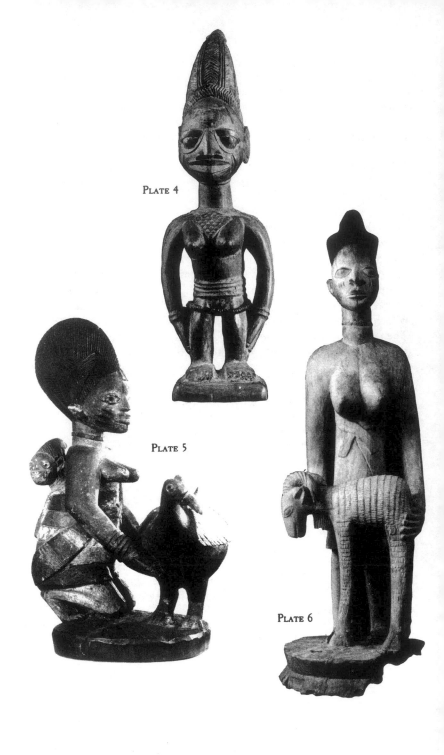

Plate 4

Plate 5

Plate 6

A man may be very, very handsome
Handsome as a fish within the water
But if he has no character
He is no more than a wooden doll.[14]

According to the Yoruba art historian Babatunde Lawal, the Yoruba see the force of inner character operating as a smoky flame *(eefin n'iwa)* easy to detect, for outward beauty can be burned through by inner ugliness or selfishness.[15]

Like *àshe*, good character originates in God. God is praised as Lord of Character *(olu iwa)*. Hence, that which attains proximity to the divine generally is progressively imbued with fine character. Artistic signs communicating this noble quality, *iwa*, are often white. Immaculate white cloths may be honorifically draped over sculpture honoring gods or ancestors famed for spotlessness of reputation, as in the case of the cult of Obatala, the god of creativity. Purity of sculptural presentation; symmetry; balance: these qualities can memorably imply *iwa*. *Iwa* also means custom, the traditional ways of life. An image portraying a person fulfilling the canons of the land in terms of fine posture or careful hands-to-the-sides gestures of spiritual alertness (Plate 4), or giving to an elder in the correct and prescribed manner—with *both* hands—(Plates 5, 6) suggests submission to moral authority or to higher forces.[16]

A main focus of the presentation of ideal character in Yoruba art is the human head, magnified and carefully enhanced by detailed coiffure or headgear. This tendency, in combination with the use of the symbolic color of good character, white, is strikingly present in the Yoruba shrine of the head *(ilé orí)*. It is often a pointed, crownlike box, lavishly covered with a sheath of cowrie shells (Plate 7) to represent the riches a good head—good character—will bring, for cowries were the traditional currency of Yorubaland.

According to traditional authority, shrines of the head also conceal, in the covering of the shining white shells, an allusion to a certain perching bird, whose white feathers are suggested by the overlapping cowries.[17] This is the "bird of the head" *(eiye ororo)*, enshrined in whiteness, the color of *iwa*, and in purity. It is the bird which, according to the Yoruba, God places in the head of man or woman at birth as the emblem of the mind.[18] The image of the descent of the bird of mind fuses with the image of the coming down of God's *àshe* in feathered form.

The sense of certainty, which character and *àshe* confer, is enriched by mystic coolness *(itutu)*, whose emblematic color is often blue or indigo or green. Lawal introduces us to this sovereign concept, which cuts across virtually the whole of Yoruba figuration:

> To tame or pacify is to "cool the face" *(tu l'oju)*. Thus, providing the non-figurative symbol of an orisha with sculptured face facilitates the pacification of that orisha, for what has a face is controllable.[19]

Much Yoruba art is informed by *itutu*. To carve a calm face upon a represented thunderstone, or upon an abstract divination tray, or to incise it upon the swelling curves of a calabash for sacred things is to provide critical focus for acts of sacrifice and devotion.

Further manifestations of aesthetic coolness in Yoruba art include representations of idealized action. We must take care not to stress

PLATE 7

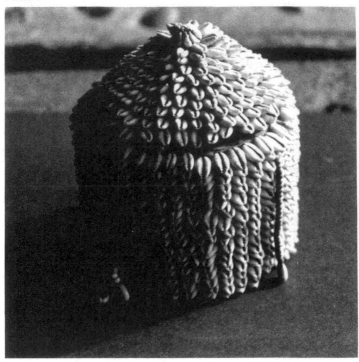

Flash of the Spirit

character and coolness as separate semantic structures because they shade into each other and also blur into the existential definition of àshe. The interrelation of the concepts is explicitly given in vernacular testimony from the capital of the Anago:

> Coolness or gentleness of character is so important in our lives. *Coolness is the correct way you represent yourself to a human being.* When I saw you, I opened my cap. It is *itutu,* answering past *itutu* you made to me.[20]

The phrasing is significant—*opening* the cap, instead of doffing or removing it, in Western parlance, is a sign of generosity of response, of coolness in life and art. Thus Yoruba art abounds with images of men or women proffering a vessel. Witness a thunder god scepter-image of a naked kneeling woman supporting her breasts, with both hands (Plate 8). This is a sign of giving—"This milk shall be the sustenance of my children." It relates to another frequent image, the man or woman who presents an open, empty kola bowl (Plate 9), held with both hands, again as a sign of honor and respect. In the case of women, the location of the bowl at the level of the womb deliberately hints at the giving of children to the world.

Generosity, the highest form of morality in Yoruba traditional terms, is suggested yet another way: by the symbolized offering of something by a person to a higher force through the act of kneeling. Thus a senior priest: "If you wish to talk to an elder, you do not stand, you kneel. When presenting a plate of food to someone important, *kneel* as you make the presentation. *Kneel* and give with *both* hands, the left with the right, the 'mother hand' and the 'father hand,' the hand-which-keeps and the hand-which-acts" (Plate 5).[21] Giving with both hands, in a gesture of submission, emphasizes in traditional terms the act of giving as an embodiment of character and perfect composure, a point given further focus, in both art and life, by the firmness of the facial expression that accompanies the noble act.

"Constant smiling is not a Yoruba characteristic," a village elder once told me. Sealed lips, frequent in Yoruba statuary, are a "sign of seriousness." They, too, imply the coolness of the image, as in an idiom that refers to discretion in ordinary discourse: "His mouth is cool" *(ẹnu ẹ̀ tútù),* which is one of the ways the Yoruba would say, "He fell silent."[22] Like character, coolness ought to be internalized as a governing principle for a person to merit the high praise "His

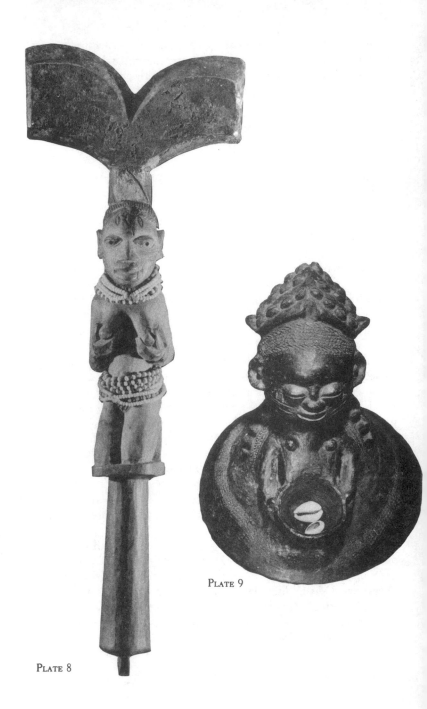

Plate 8

Plate 9

heart is cool" *(okan è tutu).* In becoming sophisticated, a Yoruba adept learns to differentiate between forms of spiritual coolness: (1) direct sacrifice *(ebo),* the cooling of the gods by the giving of cherished objects—such as the proffering of a ram to the thunder god; and (2) propitiation *(irele),* the utterance of conciliatory words or acts to hardened or angered deities, entreating them to become generous and concerned at times of crisis, such as birth, death, or initiation.[23] A three-figure image for the deity Earth *(ere* Ogboni), carved in Abeokuta in the twentieth century (Plate 10), splendidly illustrates cooling by propitiation. Here, where a male helper holds

PLATE 10

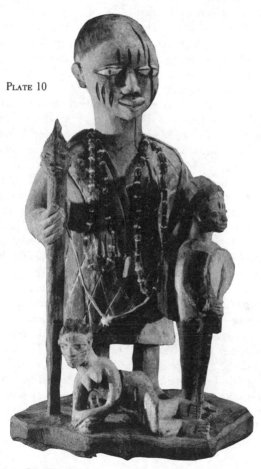

a fan, a literal sign of coolness and rank, a woman cools *(tu)* her
spiritual superior, the towering Ogboni cult leader with his staff of
office, by prostrating herself on her right side. Through this gesture,
called *yinrinka,* a female member of a compound traditionally paid
her respects every morning to the head man and head woman of the
compound. (The corresponding male gesture of submission, *idobale,*
involved a complete prostration of the body on the ground. It was
used also in saluting superiors.)[24] The notion of coolness in Yoruba
art extends beyond representations of the act of sacrifice and acts or
gestures of propitiation. So heavily charged is this concept with ideas
of beauty and correctness that a fine carnelian bead or a passage of
exciting drumming may be praised as "cool."

Coolness, then, is a part of character, and character objectifies
proper custom. To the degree that we live generously and discreetly,
exhibiting grace under pressure, our appearance and our acts gradu-
ally assume virtual royal power. As we become noble, fully realizing
the spark of creative goodness God endowed us with—the shining
ororo bird of thought and aspiration—we find the confidence to
cope with all kinds of situations. This is *àshe.* This is character. This
is mystic coolness. All one. Paradise is regained, for Yoruba art
returns the idea of heaven to mankind wherever the ancient ideal
attitudes are genuinely manifested.

The Yoruba remain the Yoruba precisely because their culture
provides them with ample philosophic means for comprehending,
and ultimately transcending, the powers that periodically threaten
to dissolve them. That their religion and their art withstood the
horrors of the Middle Passage and firmly established themselves in
the Americas (New York City, Miami, Havana, Matanzas, Recife,
Bahia, Rio de Janeiro) as the slave trade effected a Yoruba diaspora
—reflects the triumph of an inexorable communal will.

Yoruba traditional culture and religious art had seemed destined
for total obliteration in the wake of the slave trade, civil wars, and
modernization. By the early decades of the nineteenth century the
stability of western Yorubaland had been destroyed. The protective
military arm of the old empire of the Oyo Yoruba, centered in their
capital city of Oyo-Ile near the Niger River, collapsed during severe
political dislocations following the end of the reign of King Awole
in 1796. The western and northwestern groups of Yorubaland were
consequently harassed by Dahomean slave-hunting warriors and
Fulani horsemen, and later even by other Yoruba. Refugees fled to

the south, where they banded together in new settlements, such as Ibadan and Abeokuta, for protection. These camps rapidly became cities, only to come in conflict with ancient established kingdoms, such as the Ijebu.[25]

With the restraining hand of Oyo weakened, inevitably civil wars flared, starting with conflict at the ancient city of Owu in 1821. Ijebu began selling Egba and Ibadan captives; Egba and Ibadan retaliated. By 1845 Ibadan, successor to Oyo's power, had evolved into a military state and marched east to capture and sell Ijesha Yoruba, for the latter's capital, Ilesha, was the strongest northeastern kingdom and hence an obvious candidate for conquest in Ibadan's search for expansion into the area.[26] While all this was happening, the Yoruba were beset by the Atlantic slave trade.

New World Yoruba emerged from all this strife. Ketu Yoruba men and women captured by the Dahomeans turned up in Haiti and Brazil, where to this day they are called by the Dahomèan word *nago*.[27] Oyo and other captives of the Fulani were brought to Cuba, Brazil, and the Caribbean, notably Trinidad. The Yoruba of Cuba were called Lucumí, probably after an ancient Yoruba phrase meaning "my friend" *(oluku mi)*.[28] Thus the deities—the *orisha*—of the city-states of Oyo and Ketu were introduced to Cuba and Brazil, where the names of particular goddesses and gods of abiding fame —Shàngó, Yemoja (often called Yemayá in the New World), Oshoosi, Orisha Oko, Eyinle—derived from the Oyo region. The cults of Oyo and Ketu deities (the latter including especially Obaluaiye, Omoolu, and Nana Bukuu) were reinforced by their encounter with most of the principal Yoruba deities: Eshu, Ifa, Osanyin, Ogun, and Obatala. Yoruba-influenced Ewe, Popo, and Fon slaves from territory directly to the west of Yorubaland brought their own cults and also influenced the syncretism of deities. A remarkable fusion of *orisha*, long separated by civil war and intra-Yoruba migrations, took place in the New World.

What is more, especially in Cuba and Brazil, New World Yoruba were introduced to the cult of Roman Catholic saints, learned their attributes, and worked out a series of parallelisms linking Christian figures and powers to the forces of their ancient deities.[29] Thus the smallpox deity was equated, in some places, with Saint Lazarus because of the latter's wounds illustrated in chromolithographs. Thus the Virgin Mary was sometimes equated with the sweet and gentle aspect of the multifaceted goddess of the river, Oshun. Thus

Shàngó, the Yoruba thunder god, in Cuba was frequently equated with Saint Barbara, whose killers were struck dead by God with lightning.[30]

Yoruba-Americans, outwardly abiding by the religious proprieties of the Catholics who surrounded them, covertly practiced a system of thought that was a creative reorganization of their own traditional religion. Luminously intact in the memories of black elders from Africa, the goddesses and the gods of the Yoruba entered the modern world of the Americas. They came with their praises *(oríkì)*, extraordinary poems of prowess that defined the moral and aesthetic reverberation of their presence.

Portraits of Major *Orisha*

Eshu-Elegba

According to legend, at a crossroads in the history of the Yoruba gods, when each wished to find out who, under God, was supreme, all the deities made their way to heaven, each bearing a rich sacrificial offering on his or her head. All save one. Eshu-Elegbara, wisely honoring beforehand the deity of divination with a sacrifice, had been told by him what to bring to heaven—a single crimson parrot feather *(ekodide),* positioned upright upon his forehead, to signify that he was not to carry burdens on his head. Responding to the fiery flashing of the parrot feather, the very seal of supernatural force and *àshe,* God granted Eshu the force to make all things happen and multipy *(àshe).*[31] *Outward* signs of submission and material bounty were no match for wisdom and humility. Once granted his powers of dominion, Eshu, instead of arrogantly subordinating everyone to himself, did the "cool" (generously appropriate) thing: he gave a vast commemorative feast to share his newfound prestige, and to honor God for the priceless treasures of *àshe.* And he warned those who did not recognize his status that he would bend them, "like a string upon a bow," or pound them "like a shell."[32]

The sign of the crimson feather worn upon the brow, the seat of mind and judgment, was clearly interpreted as a symbol of *àshe* and the techniques of ritual assuagement *(etutu)* that lead to the attainment of *àshe.* Representing both the means and the end, the red parrot feather is seen today in initiatory contexts in the Yoruba religion ranging from the Benin Republic to Bahia in Brazil. *Àshe*

Flash of the Spirit

is a privilege of righteous living, not a right, and it can be seriously diminished when someone has slighted a deity or an important person. This means that one must cultivate the art of recognizing significant communications, knowing what is truth and what is falsehood, or else the lessons of the crossroads—the point where doors open or close, where persons have to make decisions that may forever after affect their lives—will be lost.

Eshu consequently came to be regarded as the very embodiment of the crossroads. Eshu-Elegbara is also the messenger of the gods, not only carrying sacrifices, deposited at crucial points of intersection, to the goddesses and to the gods, but sometimes bearing the crossroads to us in verbal form, in messages that test our wisdom and compassion ("Is this true; shall I help him; what larger purpose opens up beyond this message?"). He sometimes even "wears" the crossroads as a cap, colored black on one side, red on the other, provoking in his wake foolish arguments about whether his cap is black or red, wittily insisting by implication that we view a person or a thing from all sides before we form a general judgment.[33]

Because of his provocative nature, Eshu has been characterized by missionaries and Western-minded Yoruba alike as "the Devil."[34] Outwardly mischievous but inwardly full of overflowing creative grace, Eshu-Elegbara eludes the coarse nets of characterization. Even his names compound his mystery. Some call him Eshu, "the childless wanderer, alone, moving only as a spirit."[35] Others call him Elegbara (or Elegba), "owner-of-the-power"[36] (the ever-multiplying power communicated by the crimson feather that he bore to heaven), a royal child, a prince, a monarch. He is, of course, all these beings and more—the ultimate master of potentiality. Eshu becomes the imperative companion-messenger of each deity, the imperative messenger-companion of the devotee. The cult of Eshu-Elegbara thus transcends the limits of ordinary affiliation and turns up wherever traditionally minded Yoruba may be.

So it was that Eshu-Elegbara became one of the most important images in the black Atlantic world. Blacks honor him in Cuba, for example, where "men or women of African descent pour cool water at crossroads—unobtrusively if white strangers be about—in honor of Eshu."[37] Cuban blacks associate Eshu with change: "favorable, he modifies the worst of fates; hostile, he darkens the most brilliant of happenings."[38] And thousands honor him today in Rio de Janeiro, where candles begging Eshu's favor may be lit in the gutters

at intersections, in the very shadows of the skyscrapers that line the beaches of Ipanema or Copacabana.[39] Aware of the complexity of his nature, whose different sides are symbolized by different names, Afro-Cubans share with Nigerians the belief that Eshu is a homeless wanderer, "whose mood is perpetual evil," while Elegba is demonstrably less difficult.[40]

Witness against this shared exegetic backdrop the richness of art concerning Eshu-Elegbara on both shores of the Atlantic. The most important icons of this spirit in Africa are figures in lateritic earth and clay.[41] These forms took root deeply in Cuba, Brazil, Miami, and Spanish Harlem. Wood sculpture, which is regarded within the cult as less ancient and consequently less essential, is divided in Nigeria and the Benin Republic into several categories: tiny suppliant figurines; paired male and female images united by a richly cowrie-studded strand; large ceremonial, figurated dance-hooks, which rest in ceremonial context upon the performer's shoulders; large votive images for decorating shrines and gates to the compounds of the illustrious and the great. Of these, only paired male and female icons sometimes reappeared on New World altars, and even they had attributes—such as an upright knife upon the head,[42] as an emblem of Eshu's wonder-working powers, the limitlessness of his àshe—that were more generally shared and communicated by images in clay in the black Americas.

The descendants of the Yoruba in Cuba tell a myth relating to Eshu's clay imagery:

> Once upon a time there was a child named Eshu who was always telling lies. One day young Eshu met a pair of terrifying eyes, shining in the shadows of a shell of a cocoanut, lying by a crossroads.
>
> He told his parents about this marvel (his parents were king and queen) but no one would believe him, such was his reputation for mendacity. And so Eshu was left alone, soon to die a mysterious death, caused by unknown influences emanating from the eyes beside the crossroads. He had not honored these disembodied eyes [which may have been his own!] and that is why he died.
>
> Nor did the members of the court see fit to offer sacrifice beside these eyes, still burning with a sinister light. Suddenly death and disaster struck the world with annihilating force. Divination priests were summoned. Ultimately they found the crossroads where the eyes once gleamed. But by this time the shell had weathered into nothing; the eyes were gone. Whereupon the

priests then selected a certain stone, soothed it with assuaging fluid. By this rite they caused the spirit of the god Eshu to come from the forest to live within this stone, there to receive their profferings of honor. And so Eshu was properly honored, by sacrificial signs of honor and respect, and order returned to the world.[43]

In Yorubaland itself, the "stone" of atonement was actually a piece of lateritic earth and believed to be the oldest icon of Eshu. Consider a letter, written in 1919 by a Christian convert at Ibadan, relating to Eshu sculpture in wood that once belonged to the writer's father and was probably carved toward the end of the nineteenth century:

My late father was once the chief worshipper of the gods of mischief, Eshu or Elegbara. Formerly these gods were not represented in human form [i.e., figurated wood] but were adored in the shape of a stone—a kind of laterite or sandstone—but the number of their worshippers increasing, wood statues of these gods began to be made.[44]

Laterite is said to be the oldest and most important medium for representing Eshu, Eshu-Yangi, father of all Eshu.[45] I assume that the custom of marking the presence of Eshu with lateritic cones of hard red clay extends at least as far back as 1659; surviving exemplars of relief sculpture representing Eshu at that time indicate that other iconographic particulars of his image were complete.

The cone of laterite *(yangi)* appears in Yoruba markets over which cult officials pour daily offerings of palm oil to maintain Eshu's problematic coolness.[46] Laterite-cone altars to Eshu recall a myth whereby Eshu devoured enormous quantities of fish and fowl offered to him by his mother, and finally devoured his mother, too. Whereupon his father, the god of divination, alarmed, himself consulted a divination expert and was told to sacrifice a sword, a male goat, and fourteen thousand cowries. The god of divination did as he was told. Consequently, when Eshu threatened to devour him, too, the god took a sword and hacked him to pieces, and the pieces became individual *yangi*, lateritic shards. Orunmila pursued Eshu through nine heavens until finally, in the last heaven, Eshu was pacified by Orunmila and said that all the particles of his spirit, the *yangi* stones and shards, would become his representatives. All Orunmila had to do was to consult them (make sacrifice upon them and ask a blessing)

whenever he wanted to send them on a mystic mission. Eshu then returned his mother, alive, to the world.[47] His terrifying gluttony had therefore concealed an abundant generosity, the many pieces of laterite, the myriad Eshu. This represents the fact that he can take anything away—or give it back—according to whether his surrogates in clay are worshipped with sacrifice and devotion.

Juana Elbein dos Santos strikes to the core of this legend:

> each individual is constituted and accompanied by his personal Eshu, the element which permits his birth, ultimate development, and progeny. . . . in order that [Eshu] can fulfill harmoniously a person's cycle of existence, the person must without fail restore, through sacrifices, the àshe devoured, in a real or metaphoric way, by his principle of individualized existence.[48]

Eshu the prince devoured the truth by lying, never sacrificing, heedless of the damage done, and paid for his arrogance, when he finally told the truth, by dying. Thus in the Afro-Cuban myth Eshu devours himself but once again returns when proper sacrifice, centered upon a piece of stone, is made. The story of Eshu is an intricate retelling of the Yoruba belief that the highest form of morality is sharing and generosity—the strongest talisman to hold against jealousy.

At some time the lateritic cones and pillars, which stand to remind the world of Eshu's power to disintegrate or multiply all happening, became figurated. Adding a note of literal sacrifice, cowrie shells, the ancient Yoruba coinage, mark the eyes and mouth of these figures of Eshu. Such images, like *yangi* before them, could be fashioned within a shrine or at a crossroads or upon a threshold. They appear very widely in Yoruba and Yoruba-influenced lands.

From western Togo comes an arresting exemplar (Plate 11). It was collected at Misahöhe, Togo, in 1912 and is now in the Linden Museum, in Stuttgart. Here Legba (Elegbara) is a tiny rounded head of whitened clay, set on a rounded neck and shoulders also made of clay, the whole set, with feathers, within an earthenware dish similarly coated with whitish clay. This silent, staring little sprite, like the head and shoulders of a human embryo suddenly exposed, projects an image that is at once spectral and unfinished-looking. The gazing eyes recall the Afro-Cuban myth's burning orbs within the shell beside the crossroads. Diminutive dimensions and the use of clay as the main material recall the original animate fragments of laterite into which Eshu was divided.

Flash of the Spirit

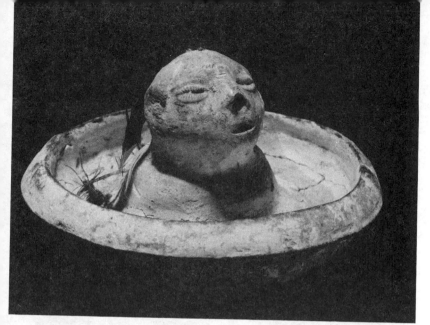

PLATE 11

The custom of making small votive images for Eshu was strongly reinstated in western Cuba. Many images were made of clay in Cuba, while some, in stone, were given eyes and mouths either by incisions or with paint, including a sui generis image, shown in a work published by Lydia Cabrera in 1954, carved in the form of a profile of the little spirit's head.[49] Clay heads positioned in an earthenware pan *(cazuela de barro)*, analogous to the Ewe mode, emerged also in western Cuba. This is a hint that the rising style acquired its force through fusion of both Ewe/Dahomean (Arará) and Yoruba (Lucumí) manners of formal exposition.[50] Moreover, clay and small stone sculpture were portable artifacts easy to hide from strangers, even under conditions of far-reaching oppression.

The vitality of reemergence is evinced by the numerous modes of Afro-Cuban clay statuary for Elegba. An elegantly innovative example of a style that apparently flourished in Havana in the nineteenth century was given as a gift to Lydia Cabrera by Asikpa, El Moro, a follower of the Yoruba gods. The artist took the round earthenware bowl and centered in it the image, as an inspiration for creative repetition of its circular shape, in a ring of gleaming cowries marking the shoulders of the figure, and, in a secondary ring, the neck.[51]

Black Saints Go Marching In

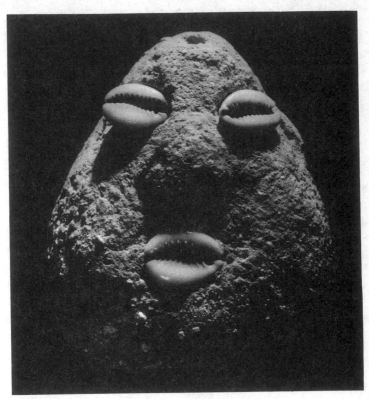

The ways of rendering Elegba in stone and clay were countered in the twentieth century by yet another Afro-Cuban mode, Elegba rendered in concrete. By 1954 the mode was well established in Havana, where Sidney W. Mintz collected an example at a market in the summer of 1956 (Plate 12).[52] Such images, essentially conical in shape, were creole transformations, as it were, of the ancient market cone of laterite. Here the tip of the cone is perforated, to receive a single nail, which is meant to suggest the wonder-working knife of Eshu Odara, who worked miracles with a knife erect upon his head.[53]

The original lateritic shards became two hundred Eshu, and then two hundred more, in the telling of the origin of Eshu-Yangi (Eshu-the-Mound-of-Laterite). And, similarly, Afro-Cuban Eshu images

multiplied wondrously. As the guardian of the threshold and keeper of the gate, not unlike the earthen Legba outside the compound entrances of Dahomey, they were placed in containers and concealed behind the main entrance to a person's house. "Fed, there is no danger, but forgotten, something begins to happen," a Cuban woman told me in 1979.[54]

The tradition of guarding homes with images of Eshu came with black Hispanic people from the Caribbean to New York City and Miami in the decades after World War II. Today clay or concrete images for Elegba in the United States number in the hundreds.

Eshu statuary is strongly rooted in Spanish-speaking New York City. Some fine examples—from the collection of Christopher Oliana, himself one of the founding fathers of the Yoruba religion among mainland blacks in New York City—grace the permanent exhibition of Afro-Americana at the Museum of Natural History.

In the northeast of Brazil at the end of the nineteenth century Eshu-Bara was represented by anthills.[55] Given the incontestable impact of Kongo and Angola cultures upon black Brazil, as well as the importance of the termite mound as a sign of the dead in those portions of Central Africa, arriving Fon, Ewe, and Yoruba slaves may have merged an already well-established mystic usage of earthen mounds with the concept of the lateritic cones of Eshu.

The Yoruba of Bahia and their cultural allies, the Brazilian descendants of the Ewe (Gege) and the Fon, reintroduced the ancient household altar of Eshu—small head and shoulders set within a dish or bowl. From a turn-of-the-century account: "a ball of clay congealed with the blood of a bird, palm oil, and an infusion of sacred herbs, reproduces a human face, the eyes and mouth of which are represented by three small shells or cowries, inserted in the mass before it dries."[56]

At some point a nineteenth-century continuity was complicated by a quest for a novel form, a building up of the image within a bowl in such a manner that it would rise up out of its container and begin to gesture. The latter trend was apparent by 1945 in Recife (though it may well have occurred before that time), where an Eshu-Bara was photographed.[57]

Rio conceals its share of clay Eshu mounted in bowls. But this former Brazilian capital, like Havana, is heir to a modern mode in which concrete is used in the making of such images. Consider a smoothly finished "Eshu Boi" now in the Museu de Polícia (Plate

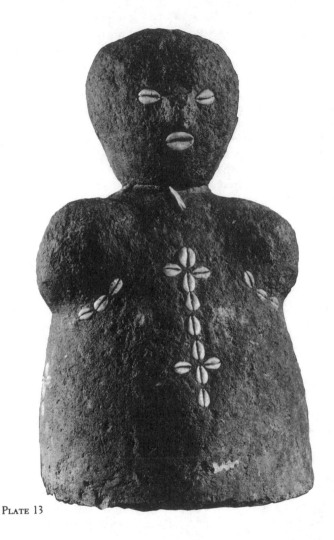

PLATE 13

13) that was probably made before 1941.[58] In Dahomean Yoruba-land, around Ouidah, I have seen large freestanding images for Elegba with mystic signs of the divination deity marked in inserted cowries on the chest of the image that are precisely one of the distinguishing characteristics of the Rio icon. The solid oval head of this image is hinged to an equally solid mass of truncal concrete, with

Flash of the Spirit

the latter's starkness relieved by rounded suggestions of shoulders, arms, and trunk. Affection for Eshu softens the hardness of the medium, not unlike a stone transmuted into a child's stuffed animal, and this is appropriate to Eshu's fusion of valences that are both childlike (insatiable eating) and mature (restitution of what is right to those who sacrifice).

Clay and concrete Eshu have symbolic resonance—sacrificial shells, where embedded, bring to life the spirit who, though reduced to shards, has nonetheless retained the energies upon which the development of our individuality depends.

The powers of Elegba are similarly retold in Nigerian Yoruba wood sculpture, e.g., indigo-painted images of a man and a woman joined by a cowrie-studded leather strap of the kind worn by women devotees, which is deliberately displayed upsidedown. An early European document of the genre appeared in an engraving (Plate 14) in

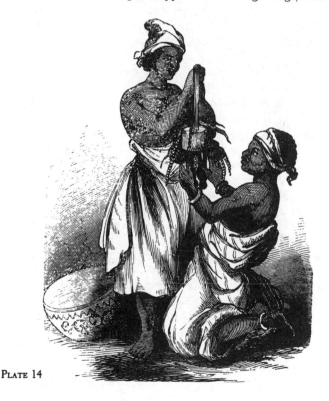

PLATE 14

Black Saints Go Marching In

27

a book about missionary life in the village of Oshielle, eight miles east of the city of Abeokuta. The book was published in 1857.[59] In fact the engraving was based upon a drawing made in Oshielle of an actual specimen of paired male and female Eshu sculptures, which Reverend Townsend, a missionary, took back to Exeter, England, in 1868 (Plate 15).[60] The engraving and the original both show a cylindrical base from which hang strands of cowries and a calabash-of-power *(ado iran)*, communicating Eshu's ability to endlessly multiply his force.

Some Egbado Yoruba villagers say such images represent Elegba and his wife. This complements a deeper interpretation of Eshu as the principle of life and individuality who combines male and female valences. Here both the male and female figures have bulging eyes, which for Yoruba embody the power-to-make-things-happen, the gift Eshu received from God in heaven. This hint of awesome potentiality is softened by the generosity of the woman's gesture, a giving of her breasts, but sharpened by the male's presentation of arms both real (a club or sword) and mystic (a calabash containing power). Their protruding eyes and the male's calabash foretell a miracle that unfolds upon their heads, from which springs up a bladelike element structurally equivalent to the knife-atop-the-head that identifies Eshu in some of his clay and concrete avatars. Here the knives have been transformed into serpent heads, recalling a praise poem for Eshu, who "makes a whistle from the head of a serpent" (Plate 16).[61] As if to emphasize the limitlessness of Eshu's wonder-working, calabash containers of self-multiplying power surmount the serpents' heads.

When a knifelike element rises out of Elegba's head, it is a sign that the display of his powers has begun, the illustration of the wonder *(ara)* from which his special name, Eshu Odara, "the Wonder-Worker," derives.[62] Songs for Odara in Ilodo and Ouidah in West Africa mention this wondrous knife as a reference to the fact that the pointed head of Eshu cannot shoulder ordinary burdens.[63] Slightly modified, these songs reemerged among the blacks of Bahia and Havana and, later, in Hispanic New York City and Miami.[64] Their lyrics conceal a visual pun on the single crimson feather that Eshu wore erect upon his head in the presence of the Almighty. Both feather and knife are described as preventing Eshu's head from being used to support an ordinary burden.

In the wake of this continuing and systematic lore, it was inevita-

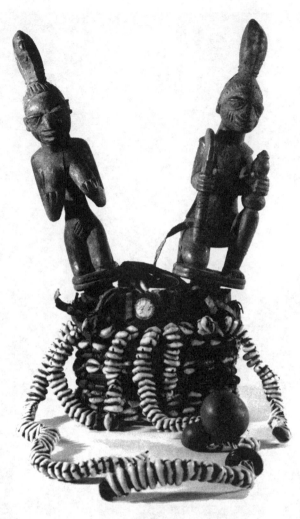

PLATE 15

ble that nails and other objects would be used to simulate the knife
atop the head of Eshu in the clay and concrete sculptures of Havana
and Harlem. The sharply pointed knife *(shonsho abe)* that crowns
the head of Eshu is the striking element of a wooden image of him
that was collected (probably in 1927) by Arthur Ramos in Bahia

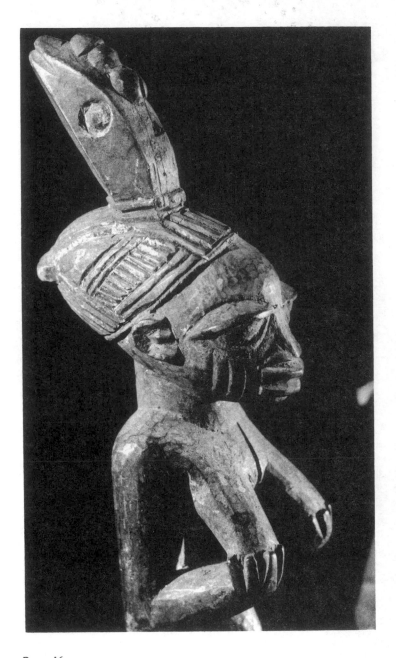

PLATE 16

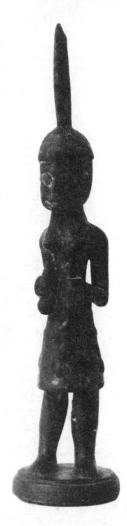

PLATE 17

(Plate 17).[65] The Ramos piece compares nicely with the Townsend images in Exeter (Plate 15). The expressive play of mass that enlivens the Nigerian images is, however, muted in Brazil. There the simple renderings of line and silhouette are indicative of the maker's apparent wish for leanness of expression. The Brazilian Elegba image holds the calabash-of-power, flaunting the power to make things multiply. This charming Afro-Brazilian figure is in the strongest tradition of visually rendering the Eshu knife.

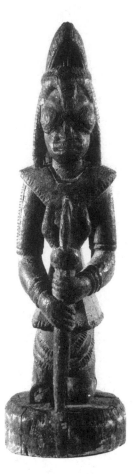

PLATE 18

Further transatlantic reinstatements extend the attributes of
Elegba. His dance-hook or club becomes a simple hook in Cuba,
sometimes painted red and black.[66] The Ulm Ifá divination tray,
one of the oldest known pieces of Yoruba wood sculpture and carved
before 1659 (Plate 19), includes, at "seven o'clock" in the interior
circle, an image of Eshu with tailed headdress, sucking his thumb.
In the upper right-hand quadrant of the outer square there is another
image, perhaps Elegba, smoking a pipe. These are ancient represen-
tations of the flagrant orality of Elegba, hints of a propensity to
absorb and to devour. His pipe remains an important emblem and

so he appears in Cuba, shaped in clay and set in a vessel in the Ewe manner, with a pipe beside him.[67] The icons of Elegba seemingly are infinite. They are figures representing the supreme importance of attaining spiritual coolness through direct sacrifice *(ebo)* and ritual reconciliation *(irele)*, acts that protect the mirroring imperative of the actualization of individuality—points intuited in a final example of Eshu sculpture, an image in wood that once graced the compound entrance of Ogabunna, chief of Ikija quarter, Abeokuta, during the first half of the nineteenth century (Plate 18). Here kneeling suggests submission, sacrifice, and propitiation, while the carefully positioned clublike element and the towering headdress are intimations of *àshe,* and multiplication of the self.

Ifá

Whenever traditional Yoruba encounter change or challenge in the world of Eshu, the limitations of individual calm and wisdom become acute. In such a case a person relies on the accumulated insights of the poetic chants of the Yoruba divination system called Ifá to place his or her individual problem in perspective. Thus Abimbola: "Ifá divination is performed by the Yoruba during all their important rites of passage such as naming and marriage ceremonies, funeral rites and the installation of kings. In traditional Yoruba society, the authority of Ifá permeated every aspect of life

PLATE 19

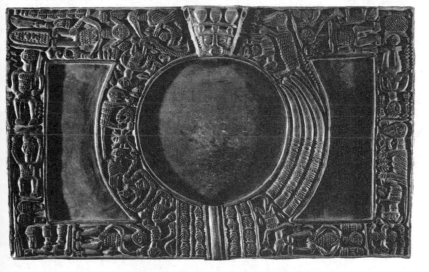

because the Yoruba regard Ifá as the voice of the divinities and the wisdom of the ancestors."[68]

There are many forms of countering uncertainty with divination in Yoruba culture, including the throwing of kola nuts *(obi)* on the ground, the casting of cowrie shells *(owo)*, water-gazing, mirror-gazing, and receiving ecstatic prophecy from a deity speaking through an initiated priest or priestess.[69] Over these systems Ifá rules supreme. The lifetime study demanded to maintain Ifá and the respect traditional Yoruba have for the analytic reach of its verses can be indicated by a single proverb: "Stargazing is no substitute for Ifá's knowledge."[70]

The literature of Ifá divination divides into sixteen main parts called *odu*. Each *odu* bears the name of an ancient prince. To hear the verses is to come into the presence of a royal voice imparting insight and infinite experience. The priest of divination himself is called the father of the secrets *(babalawo)*, and he is allowed to possess, like the Yoruba divine kings, beaded treasure and regalia.

Ikin, "The Sixteen Sacred Palm-Nuts," are held the most ancient and important of the instruments of divination. They come from the sacred palm tree of Ifá *(ope ifa)*. Myth tells us how and why these natural elements became an august sign.

Once Ifá reigned upon the earth and there dispensed his precious wisdom. But one day a son of Ifá arrogantly refused to bow down before his father, whereupon Ifa withdrew to heaven.

When the light in the eyes of Eshu dimmed by the road and disappeared, the world began to die. Similarly, the translation of Ifá to heaven occasioned such a terrifying blast of sterility and drought that starving animals attempted to devour sharp razors scattered on the ground, and river basins were covered with dead leaves. The world again was dying. The children of Ifá climbed the sacred palm tree to beg their father to return, and he gave each of them sixteen palm nuts as a concentrated essence of his healing wisdom, replacing himself on earth with the sixteen sacred palm nuts, the *ikin*. Order and life were again restored.[71]

Thus, like the division of Eshu into myriad fragments of raw laterite, the division of Ifá into sixteen kernels taken direct from nature restores life. These powerful beliefs give sanction and authority to the most important form of Ifá divination, which involves the use of the *ikin* and is usually reserved for crucial moments, such as the investiture of a king.

In such cases, the diviner strews fine divination powder *(iyerosun)* obtained from the irosun tree (or powdered dry bamboo) on an Ifá divination tray, here illustrated by perhaps the oldest known example, carved before 1659 (Plate 19), and smooths it over. Then, with his middle finger, he traces either a single line or two lines in the powder, depending on the number of *ikin-ifá* that remain in his hand when he attempts to pick up sixteen *ikin* in his right hand. If two palm nuts remain, he marks parallel lines on the tray, or, if one *ikin* remains, one vertical stroke, and so on, until by divining four times with the *ikin* in this way, one out of a possible set of sixteen patterns completes itself upon the divination tray.

The sign of a particular section *(odu)* of the verbal literature of Ifá has now appeared. The diviner recites the verses associated with this sign in three parts: (1) an exemplary myth from the lore of the goddesses and the gods; (2) what happens to the deities within each myth, i.e., cautionary tales on the consequences of failure to make sacrifices indicated by Ifá; and (3) application of these themes to the client's problem.[72] The last part usually opens with the phrase "Ifá says," for the client has now placed himself within range of the very voice of the god of divination, speaking through the ritual moves and counters:

> Ifá says that a man should not be covetous and that he should not strive to win a position from the person who holds the position by right. [Ifá also says] that he should make appeasement lest the people of the world take his role from him and give it to another.[73]

The client himself interprets such verses, for the *babalawo* is not allowed to know the precise nature of the client's problem. In the verse just mentioned, he might find evidence that an excess of ambitious maneuvering on his part may have angered certain elders who had secretly caused a swift and inexplicable decline in his fortune. Proper sacrifices would be indicated, and he would offer them gladly, knowing that he was making amends suggested by the gods themselves.

There is another Ifá divining method, involving the use of a divining chain *(opele)* made of string or metal with four half-nuts of the *opele* fruit attached to each half of the chain. Each *opele* nut has a smooth outside surface and a rough inside surface. When the divining chain is thrown, away from the diviner, it falls upon the ground in a rough U shape, with four *opele* seeds on one side, four

on the other, each possibly falling a different way. There are thus sixteen possible forms of presentation, the mystic number of Ifá, and each of these presentation forms of the divining chain stands for an *odu*. If the *odu* that emerges is the one called *Eji Ogbe*, the diviner writes its sign upon the divining tray:[74]

If the *odu*, on the other hand, turns up as *Oyeku Meji*, the appropriate signature to mark in the *iyerosun* dust takes another form. And

PLATE 20

so on. In an example of divining-chain divination in Dahomean Yorubaland at Takon in Benin (Plate 20), all eight seeds have fallen "open," the sign of the richly favorable *odu Eji Ogbe*. This sign has also been permanently rendered in cowrie-shell mosaic (from which one shell is missing) in the floor at the threshold of the owner of the divining chain, to charge the gateway to the house of a chief with good luck and well-being. Thus chain-divining cuts through to *odu* in a manner similar to the use of *ikin*. The "readings" occur faster in the case of the chain, which is more commonly used.

Both systems expose Yoruba to the principal sixteen verses of Ifá divination and thus lead to treasures of African verbal poetry and wisdom. It is believed that Ifá encompasses the whole of the wisdom of the ancestors, the whole of the wisdom of the deities, and thus safeguards "everything that is considered memorable in Yoruba culture throughout the ages." Hence the splendor of the image of Ifá:

> The life of Ifá surpasses water's coolness
> The life of Ifá surpasses water's coolness,
> The speaker-of-all-languages married a woman
> who herself bathed only in water that is cold
> The life of Ifá surpasses water in its coolness.[75]

Wande Abimbola points out that the survival of Yoruba tradition through its turbulent history depended in large measure on a cadre of wise and disciplined diviners steeped in the secrets of the ancestors and of the gods. Thus one can well imagine how cultural treasures were brought across the Atlantic by men who remembered the lore of the *odu*, the divination verses.

In Cuba the amazing continuity of Nigerian *odu* was established in a landmark publication by William Bascom, in 1952, in which he proved that the *babalao* (creole equivalent to the original Nigerian diviners) had reinstated the *odu*, with names and explanatory tales virtually intact.[76] In the process, Yoruba divining trays, divining chains (Plate 21), and sacred sixteen *ikin* were introduced to Cuba.[77]

Of the Cuban divination trays, most are round, like an example from northern Yorubaland (Plate 22), or rectangular, with staring Eshu heads facing each other, and some are called *atefa*, a Ketu word and thus a hint of the Ketu Yoruba origins of the mode. The divination trays of Bahia are also called *atefa*, with the same implications. The Museu de Arte Popular, in Bahia, included in its 1968

PLATE 21

Afro-Brazilian exhibition a magnificent *atefa,* attributed to an un-known nineteenth-century carver (Plate 23). The purity of his han-dling of the ancient themes is manifest in his use of the circle and the head of Eshu (Plate 24), which interrupts the flow of the elabo-rately carved border, as in the case of the ancient Ulm tray (Plate 19).[78] In the Brazilian example, two heads of Eshu stare at each other across the cosmic circle. There are similarly paired segments of ornamental carving filled with depictions of honorific cowrie shells

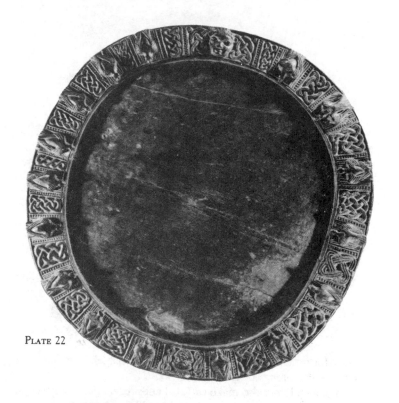

PLATE 22

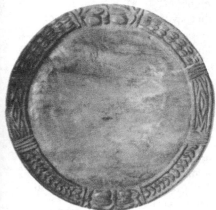

PLATE 23

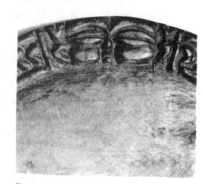

PLATE 24

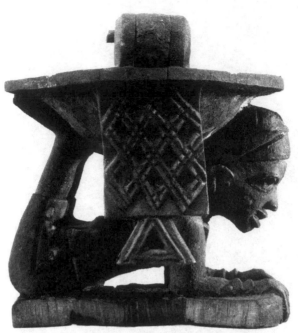

PLATE 25

and V-form elements which may relate cryptically to thunderstones or the Y-like prongs of the thunder ax.

Yoruba sculptors also make caryatid cups *(agere ifa)* as vessels for the sacred *ikin-ifá* or the divining chain.[79]

A Nigerian caryatid figure by Labintan of Otta (Plate 25) supports the Ifá bowl with his head and the soles of his feet. He rests on his elbows and bends up his legs. This marvelously realized gesture conceals, in apparent playfulness, serious submission to predictive grace.

It is important to grasp the style of Labintan because one of his Ifá divination carvings, an *agere* emboldened with strongly postured human figures supporting the bowl on their heads, washed up on the shores of Brazil (Plate 26). It was found on the beach at Calçado do Bomfim, Bahia, wrapped in linen, an indication that it had been used by an Afro-Bahian priest or priestess. Apparently upon the death of the owner, the cup had been tossed into the sea to return with the soul of its departed owner to Yorubaland.[80]

This piece establishes that some Afro-Bahian works of art of the

Flash of the Spirit

turn of the century were actually carved in Yorubaland, in this case Otta. Attribution to Labintan can be demonstrated by shared traits, including deeply drilled human pupils, hooked noses, hairpin ears, sharply pointed chins, identical hinges, and identically shaped shallow bowls.

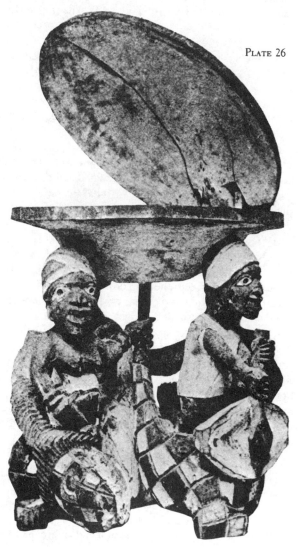

PLATE 26

The ties that bind the "Rome of the Africans," Bahia, to the Yoruba of Nigeria were never more directly instanced. But most of the New World forms of Ifá divination art were indigenously continued and elaborated, giving rise to the *atefa* of Bahia and Havana, the *opele* of western Cuba,[81] and the use and knowledge of the green and yellow beads of Ifá throughout the Atlantic world.

Osanyin

The art and lore of the cult of Osanyin, god of herbalistic medicine, embody a richness of positive assertion comparable to that of Ifá. In Osanyin's name the Yoruba undertook a vast study of the leaves and herbs and roots of the forests, classifying them with regard to their therapeutic properties, and combining them to make the master medicines of initiation and *àshe*.

Osanyin initiates master this taxonomic knowledge, learning what species of forest herbs to collect, mix, and pound to make medicine to soothe a feverish body or to calm an agitated mind. Leaves and roots as elements of healing are to Osanyin what the sixteen *ikin* and the art divination are to Ifá. As we shall see, rich traditions of verbal art and literature also traveled with his worship to the New World.

In Cuba, for example, traditional segments of the black population honor Osanyin and link him to a deeper belief in the spirituality of the forest. There the faithful honor the forest, *el monte* (literally, "the mountain") as a source of healing power. They realize that this standing cathedral of shade and moistness belongs to Osanyin and to God, and so they leave small sacrifices in payment for herbs and roots subtracted from his realm, "for every tree, every shrub and herb has its master, and its protocol."[82] Each *orisha* is served by its own sacralizing herbs, taken with permission from Osanyin, just as each deity is accompanied by his or her Eshu, source of individualizing power and vitality.

And yet for all his glory, Osanyin is physically bizarre, having only one eye, one arm, one leg, which are the stigmata of a quondam selfish life, when Osanyin tried to keep all the medicines and leaves to himself. According to legend:

> Diviner said he was suffering because he could find no food nor sustenance because all of the work which he might be doing with the leaves was being done by Osanyin. Eshu said that he would help. Eshu caused the stones of the house of Osanyin to fall and maim the deity. Lacking a leg and an arm and an eye, he now

Flash of the Spirit

needed diviner, urgently, to collect his leaves and continue with the curing of people. And since that time diviners and Osanyin have been working hand in hand.[83]

It is said that Osanyin also failed to make a proper sacrifice commanded by Ifá and, consequently, lost his voice. Thereafter whenever he opened his mouth to speak, only a comically squeaky voice was heard. Diminished, even vocally, Osanyin is a warning as to what happens to persons who are callously unsharing.[84]

His is an image now indelibly Atlantic. Both in western Nigeria and eastern Benin, as well as in western Cuba and northeastern Brazil, most of his followers speak of his one-legged, one-armed, one-eyed appearance and his tiny, high-pitched voice. This basic image has been complicated by imaginative additions in Cuba and Hispanic New York. Some Afro-Cuban followers of Osanyin say that one of his ears is of monstrous size but hears absolutely nothing, while the other ear is diminutive but picks up the noise of butterflies in flight,[85] a balance of elements coarse and fine that is reminiscent of Eshu's idiom of extremity. As a matter of fact, both Eshu and Osanyin share the attribute of one-leggedness, and like Eshu, Osanyin was once a prince.

Osanyin, so it is believed in Ijebu Yoruba country, was born with beads shining about his body. Moreover, beads are important to Osanyin because he associates their colors with the hues and qualities of the forest herbs. Thus some of the sylvan fronds are said to be bright green, while other herbs are yellow, black, red, or even white, and each hue denotes a special kind of curing power. In some parts of Yorubaland the beads of Osanyin, in their colors and cool glitter, equal the work of multiple, differently colored, healing herbs.[86] I recall an incident at Edunabon in the south of Oyo country in the winter of 1963– 64, when a man regarded an ancient, polished blood-red carnelian bead and pronounced it "cool" *(tutu)*. But the beads of Osanyin are cool not only in the general sense of giving aesthetic pleasure but in a literal sense of referral to leaf like qualities of refreshing taste or smell, and—most important—powers of restoration.

Heralded by gongs, Osanyin is the crippled king who, crushed to half his size, gained insight into the human condition. He comes not in the body of a possession devotee but in that of a tiny doll, given voice and motion by trained ventriloquists who are also Osanyin priests and healers. Ventriloquism, in fact, is one of the marvels of

the cult of the lord of leaves not only in Nigeria but also in Cuba. His tiny voice was once heard also in Brazil, where priests of ancestral spirits attached to their bodies small store-bought rubber dolls of the kind that squeaked when pinched, to suggest the tiny voice of Osanyin—an ingenious "bending" of a modern object in the direction of tradition.

Osanyin ventriloquists appeared in the 1950's in and around certain villages of the province of Havana—Perico, Alacranes, Mantilla:

> The Osanyin image of old Federico was a doll. The old man used to sit behind his door, half ajar, to smoke his pipe. One day I happened to be there, and heard a doll say, "Federico, here comes a woman all dressed in white, looking for a remedy for her husband."[87]

Healing, art, and ventriloquism were thus combined in Osanyin worship to provide a striking, theatrical form of consultation to the blacks of Ijebu, Abeokuta, the Orozco sugar mill in Cuba, and other places where the full tradition has been reported or witnessed. I saw the Osanyin puppet in action in southern Ijebu on various occasions in the early 1960's; wearing a miniature beaded veil and beaded gown, it was made to speak in the tiniest of squeaks by the priest-ventriloquist. The reinstatement of this custom in Cuba may not be the work only of the Yoruba and their descendants: Henry and Margaret Drewall found in a study of the Age (hunting deity) cult in Togo in the summer of 1975 that Age is also "a forest sprite who heals with leaves, has one eye and one leg and whose priest practices ventriloquism."

Certain groups in Nigerian Yorubaland allege that the sound of Osanyin's voice relates "to a little bird that represents him." According to this tradition, this bird not only speaks when the deity is consulted, but also lives in the sacred calabash of Osanyin kept upon his altar.

Voice-throwing and bird imagery are integral to the cult of Osanyin, and they explain an important province of Osanyin art: myriad forms of a wrought-iron staff surmounted by one or more birds in iron. Ifá says there are sixteen styles of the Osanyin wrought-iron staff. One kind carries a single "head" (a single bird poised at the summit of the staff), while another carries two heads and still another displays three heads and so on until the highest number is achieved, sixteen birds in iron. The last is especially prestigious, "for

the highest people calculate their power by sixteen." The divination literature tells us that proliferating bird motifs allude to an ancient time, when Osanyin was magician of the gods, working miracles with one, then two, then three, then four, and, finally, sixteen heads, or birds.[88] The persistent equation of bird with head, as the seat of power and personal destiny, is of the essence in comprehending elaborations of this fundamental metaphor, including staffs (1) showing a single iron bird set upon a single disk of iron surmounting several bells of iron, the *osun* staff or *orere*, (2) a bird set over a radiating display of miniature iron implements for the iron god, Ogún, sometimes interspersed with miniature emblems of other "hard" deities, (3) a superbly fashioned bird in a commanding position over a circle of smaller, less elaborately decorated birds. The three staff types appear in various New World cities, notably Rio, Bahia, Gonaïves (Haiti), Havana, and New York, but rarely simultaneously.

The myth of the maiming of Osanyin tells us why he needs Ifá and warns us that the knowledge of the leaves must be shared. But the obverse is equally true: Ifá needs Osanyin. Without the lord of leaves and his many medicines, Ifá's effectiveness would be seriously diminished. And so the diviner-herbalist and the herbalist come to share the *osun* staff, an extraordinary "text" wrought in iron on the power to comprehend and check disease.

Odeleogun, a master blacksmith of Efon-Alaiye who flourished toward the end of the last century, is believed to have made our Nigerian example of the genre (Plate 27). It is a work that gracefully illustrates the *osun* structure: a single iron bird over a single iron disk that covers and conceals parts of the four inverted iron bells radiating out from a single point along the staff below the disk and formally "answered" by four more bells, hanging right side up, below this point.

Osun, transmuted into *ase* by the Popo and the Fon of what is now Benin, have been enriched there by generations of expressive elaboration since 1659 and earlier. There the single bird often rests upon the canonical disk, but the latter element can be fashioned to seal completely the mouth of a single inverted conical container, under which appears a small sphere or sometimes (as in this instance) a hard-shelled seed, which is pierced by the axis of the staff (Plate 28).

From Ekiti (northeastern Yorubaland) to Dahomey the associa-

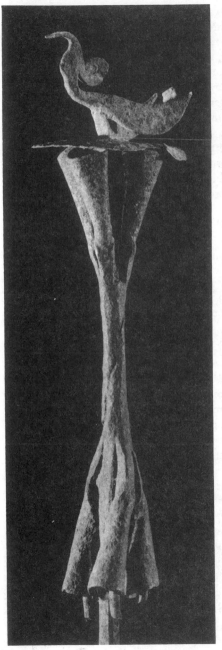

PLATE 27 PLATE 28

tion of the presiding bird figure with war on witchcraft is more or less consistent. An informant at Igogo-Ekiti in the summer of 1965 alleged that a bird atop a healer's staff shows "the mothers" how powerful the healer is with his herbs. Dahomean chiefs in the city of Abomey told me in 1968 that the bird atop the *ase* staff (Plate 28) represented the power of King Glele in overcoming not only the armies of Mahi but the "bird" (i.e., sorcerous potentiality) of the leader of the enemy forces as well. In addition, a healer at Ipokia, capital of the Anago Yoruba, revealed in December 1962 that the bells on such staffs are sometimes interpreted as metaphoric leaves; the disk is meant to cover the leaflike bells so that uninitiated eyes cannot see what is inside them.

A seed as an occasional element on the *osun* or other Osanyin-related staffs, and the use of bells, express the lore of the guards of Ifá. It is told that Ifá brandished a certain seed before the witches of feathered form, saying, "Witch is not fierce, she cannot eat the hard seed."[89] It is also told that Ifá, informed by Eshu of the secret vulnerabilities of "the mothers," brandished, among many effective objects, the leaf called *agogo igun* (bell of the vulture's beak) "so that everything he asks for, by means of agogo bells will be obtained."

Thus the metaphor of a text in iron is not to be taken lightly; the bird is both the mind of the healer and a warning to the mothers that he knows their forms and the powers that they inform; the disk covers his secret antidotes to their deadly propensities; and the bells and the seed are guards or extensions of the neutralizing impact of herbalistic medicine.

The association of a bird with the head or mind of a person is revealed during the initiation of a person into the service of the Yoruba gods in Cuba and Cuban-influenced portions of Miami and New York City. The full ceremony includes one of the most impressive reinstatements of the literature of Osanyin on New World soil—a chanting of some sixteen to twenty-one songs, many based on the same melody. These songs are among the most ancient and precious testaments of Yoruba oral literature that we have in the Americas; they go back at least to the late eighteenth century, and one includes a reference to the immortality of God, unmovable stone under water *(oyigiyigi ota l'omi o oyigiyigi ota l'omi)*. [90] These songs accompany the preparation of the leaves of Osanyin, to complete "the water of the calm," the "water of the cool" *(omi ero)* needed for sacralizing the postulant and the paraphernalia he or she will receive.

And then comes the moment when the *àshe* received by the initiate is sealed in a small incision cut at the uppermost portion of his shaved head and within the container of his personal *osun* bird-staff with disk and bells:

> to make osun is an extremely secret, sacred matter. . . . Once the person serving as a barber has shaved the initiate's head entirely, he proceeds to paint it white, indigo blue, red and yellow [each color forming a concentric band around the center of his crown]. . . . when the initiator or initiatrix has finished the application of the colors, he or she cuts small incisions at the uppermost portion of the crown and there inserts four important materials, *obi kola, eru, tushe,* and *osun* ["the indispensable seeds of the consagration, seeds imported from Africa"].[91]

The four basic seeds—*osun, eru, tushe,* and *obi kola*—placed within the private bird-staff *(osun)* of the initiate seal the same protective forces that went into his head inside the inverted cone or container beneath the bird of the *osun* staff. This establishes the bird in iron or metal as the eternal companion and guardian of the initiate. Elements of the ancient "text" are reintegrated here—bird, head, seeds, and bells.[92]

Many Cuban *osun* are strongly African in style, as attested by the older examples of *osun* staffs in the National Museum in Havana.[93] The latter are remarkable not only for the retention of inverted cones or a single cone in metal under the disk that supports the bird, but also for a shaping of the bird more or less as a flattened, iconic element. Lydia Cabrera published in 1954 a photograph documenting this older style—well-nigh concealed behind a welter of cult detail—at the top of a many-tiered altar to Eshu.[94] Careful study of this area reveals the unmistakable silhouette of an Africanizing *osun* staff, with its flat, gracefully curving bird at the summit over the disk and inverted cones.

By 1954 creole transformations had already occurred. The new forms had absorbed Western industrial or cultural fragments—the hubcap of an automobile, a metal rooster from a weather vane or discarded garden furniture, store-bought jingle bells—and invested them with new meaning. The rooster replaced the flattened bird of the elders, the hubcap sometimes became the base, and the jingle bells recalled the *agogo* gongs. Most important, the single inverted cone underneath the disk became a metal cup (into which the spirit-protecting seeds were placed). It is this modernist form that

Flash of the Spirit

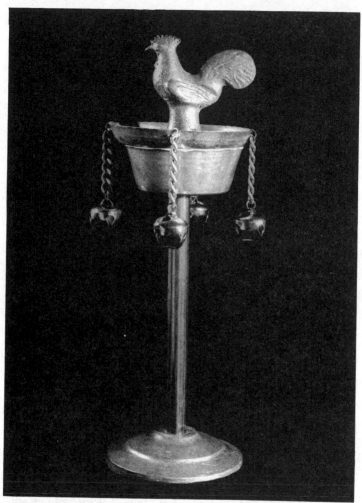

PLATE 29

is most frequently seen today in the Cuban-influenced *botánicas* of Miami, New Jersey, and New York (Plate 29). In these stores, where herbal charms and medicines frequently are sold, the sign of Osanyin appropriately reappears.

There is a further reinstatement of Osanyin iron across the Atlantic that involves staffs with a senior bird of mind or healing posi-

PLATE 30

tioned at the summit of the staff, above a round of minor birds (Plate
30). Odeleogun of Efon-Alaiye made our Nigerian example, proba-
bly in the last quarter of the nineteenth century.[95] This strong and
elegant bird-staff carries within its forms a universal thought: the
triumph of the mind over the annihilating circle of destruction and
disease. The double, spiraled plume of the bird at the summit sug-
gests double power held at once, and displays the ever-multiplying
presence of Osanyin, or other healing spirits like Erinle.

An echo of this form in Bahia in Brazil is lean and simplified, and
was made by an Afro-Brazilian blacksmith, José Adario dos Santos,
at his atelier on the Ladeira da Conceição above the port of Salvador
in the spring of 1968 (Plate 31). A single stylized bird surmounts six
raking bars of pointed iron, suggesting, in one version, Osanyin

Flash of the Spirit

PLATE 31 PLATE 32

above the crossroads of Eshu and iron, or, in another, the bird of
Osanyin above the sharpened points of Ogun's iron, or, in still
another, the bird of Osanyin in the branches of a tree.[96] These ideas
receive a full embodiment in Rio de Janeiro, where a bird-staff in
iron for Osanyin was collected, perhaps around 1941 (Plate 32).
Here the bars below the senior bird suggest again the branches of
a tree, each displaying a single minor bird beneath the commanding
spirit at the summit. There seems to be a lesson in the cherishing
of this ancient image: the senior bird of mind and healing, "the bird
that shows the 'mothers' how powerful the healer is about his
herbs,"[97] teaches that the woods and their medicines are grander
than any document, and that one who assumes this privileged forest
is hers or his alone will be answerable to God.[98]

Black Saints Go Marching In 51

Ogún

The art of Ogún reflects his nature as a "hard god," a deity of war and iron. He lives in the flames of the blacksmith's forge, on the battlefield, and more particularly on the cutting edge of iron.[99] He addresses the forest with a sharpened machete; his spirit moves in the clearing of the bush, in the hoes and knives of cultivators. His worship is a means of thanksgiving for the ambivalent civilizing force of iron and iron-made implements. Ogún served the very creator of the world, so it is believed, by clearing the primordial forests with his iron, making the first sixteen roads that radiate from the ancient holy capital, the roads upon which the original sixteen sons of the first king traveled forth to found the sixteen originating kingships.[100]

Praise-chants for Ogún, those collected in ancient towns like Ire and Ketu and Ilesha, illustrate his ambivalent nature: his power to destroy as well as to construct:

[from the towns of Aramoko and Ilesha]

Ogún, master of the world, support of the newborn child
Ogún is virile
Ogún, master of the yam I cut . . .
Ogún, with coronet of blood
Burns the forest, burns the bush
Leaves the forest screaming in the sound of flames

[from Ire town]

Ogún cuts, in large or small fragments
He kills the husband on the face of fire
He kills the wife on the hearth
He kills the little people who flee outside
Even with water present in the house,
he washes himself with blood.
Sudden as lightning, he terrifies the lazy.

[from the town of Ilesha]

Ogún promenades, serpent poised about his neck
Ogún, King of Ire, lord, great sovereign of iron.
With stripes about his body,
Such as one sees only on the skin of the wild doe
Unless it be Akisale, born of the Gaboon viper
Unless it be Akisale, born of the python.

[from the town of Ketu]

Ogún, allied to the man with a quick hand
Ogún, owner of high fringes of palm fronds
Ogún ties on his cutlass with a belt of cotton
Ogún of the sharp black cutlass

Hoe is the child of Ogún
Axe is the child of Ogún
Gun is the child of Ogún

Ogún, salute of iron on stone
The blacksmith of all heaven.[101]

Ogún therefore lives in the piercing or slashing action of all iron. Lord of the cutting edge, he is present even in the speeding bullet or railway locomotive.

He is honored by liturgical jewelry, iron or brass. For example, in the region of Ilesha, whence came many captives to western Cuba and northeastern Brazil, important priests, Aworo and Owari, wear each year during the Obanifun festival a splendid brass pendant of miniature metal emblems, symbolizing iron's self-multiplying powers and potentiality (Plate 33).[102] This fine display of metal emblems is the pendant of Ogún *(amula ogun)*. Our example comes from the old Ilesha forge of Oginnin Ajirotitu.

According to the recollection of the late blacksmith's surviving son, Oginnin completed this pendant for Ogún at some point between 1900 and 1925.[103] Richly patinated, the signs of the *àshe* of Ogún are here specially made in brass, the customary medium used by Oginnin.

PLATE 33

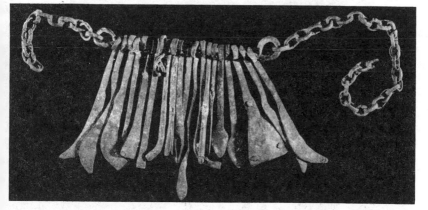

The *amula* bristles with twenty miniaturized Ogún emblems: three curved swords of the kind special to the Ogún cult; an iron hairpin called *ikoti;* an implement given as *oyiya* (obscured in the photograph); a flaring instrument used for tapping palm wine; a smaller version of the same implement; a strip of chain symbolizing Ogún's uniting force; the curved clapper of an iron bell; a miniature *agogo* bell for Osanyin; pincers for Osanyin and for Ogún; a snake "fighting for Ogún"; the penis of Ogún, partially obscuring a further curved clapper or, alternatively, a curved stick for drumming; a needle; two iron arrows; a large ceremonial iron bell; a knife for the patron deity, Owari; a sword for Owari.[104] The emblems, counting the heavy chain from which they hang, make up twenty-one separate pieces, a multiple of the characteristic number of Ogún, seven.[105]

Major and minor versions of the same basic implements sometimes appear together here, and a constellation of further objects united by a kind of visual pun—i.e., penis-stick-needle—further deepens our appreciation of the infinity of Ogún's power, for implements in iron are to his cult as pieces of lateritic stone are to Elegba, or palm nuts to Ifá.

The imaginative force of this visual tradition swept across the Yoruba New World. For example, evidence of Yoruba emblematic

PLATE 34

Flash of the Spirit

PLATE 35

iron appeared in Cuba no later than 1868: "in Guanabacoa an iron bar was found, one third sunk into the ground, with a crescent-form ornament at the top, from the sides of which hung four hooks with blood-sprinkled trinkets in the form of shovels, hoes, knives, and hammers".106

Ogún art in Cuba today includes the bucket-shaped iron cauldron (caldero de ogún). Such objects (Plate 34) are full of various expressions of ironwork, such as nails, iron bows and arrows, horseshoes, and fetters, thus fusing token pieces of his medium within the programmatic arrangements of the amula with an iron cooking vessel, as if to prepare a mighty broth of iron.107 Note that the illustrated cauldron for Ogún is tightly wrapped with chains of iron, echoing a major element of the amula. The Cuban migration to North America has resulted in the establishment of the caldero de ogún tradition in Miami and New York, with fanciful additions, such as a shrine in the New York area in 1979 that has a caldero de ogún with an actual pistol (Plate 35).108

Ogún is one of the most popular of the orisha among Brazilian

blacks. Again, as in Nigeria and the Benin Republic, Brazilians honor Ogún by placing upon his altar separate pieces of iron as well as special miniaturized examples of his implements, called in Bahia *ferramentas de ogún* (Ogún irons), which, like giant beads or pendants, are often pierced and threaded through a length of wire or piece of chain or thread. Recife is a rich source of such objects, but Salvador is perhaps the Brazilian city most famous for Yoruba symbolic iron. There, in the summer of 1968, I found José Adario dos

Santos making *ferramentas de Ogún* at his forge on the Ladeira da Conceição above the harbor.

Earlier, in the spring of 1965, Richard and Emerante Morse collected one of his works in the Mercado Modelo (Plate 36), illustrating how Dos Santos follows firm Yoruba canons of expression while at the same time designating modern tools of iron as extensions of Ogún's realm. Here Dos Santos suspends seven iron implements—knife, sword, hoe, spear, knifelike object, shovel, pick—from the iron bow of the hunter-god, Oshoosi, Ogún's mythic brother and companion. The number of the pendants is significant, for in the *candomblés* of Bahia the deity is praised as "Seven Ogún" (Ogún Meje),[109] which alludes to the multiplication of his *àshe* in tools of iron, and this reflects the influence of Nigerian Yoruba praise poetry and lore, as in an Oyo ballad of the hunters where the deity of war and smithing is saluted with the phrase "seven iron signs of the god of iron." But there are also emblems with twenty-one miniature pieces of iron in Bahia, as at Ilesha and in Dahomey.

Ogún's absorption of industrially made iron implements in his arsenal of ritual attributes is paralleled by the advance of the same elements into the realm of Afro-Brazilian myths:

> [Ogún] . . . wished to find his brother [Oshoosi]. He entered his father's forge and there made seven instruments—pick, pick-axe, axe, scythe, spear, cutlass, and shovel. He carried them over his shoulder and entered the forest. . . . [By means of these implements] he forced his way into the forest until he found his brother . . . put him on his shoulders, and returned home.[110]

Thus, across the Atlantic, iron instruments are all, in the end, the children of Ogún, carried on his broad and mighty shoulders. He directs their energies to benefit those who earn his love through ties of kinship and those who make sacrifices and festivals in his name. The icons of Ogún are not, however, for the lazy or the irreverent. Ogún marches only with the spiritually vital and the quick of hand.

Oshoosi

The brother of Ogún, Oshoosi, himself quick and strong, ultimately emerged as the deity of the hunters, the fabled archer of the gods.

The power of this deity is manifest in the speed and accuracy of his arrow, in prideful assertion of mind and muscle that have been wonderfully honed by the disciplines of forest hunting:

He is all alone and very handsome
Handsome even in quality of voice.
Vital, he arises in the morning,
Bow and arrow already about his neck.
Small or hugely-built, the hunter is stronger than most men
Oshoosi quickly unleashes his arrow.
We see him only to embrace a shadow.[111]

When this man of determined muscle becomes a shadow, all that remains is his hunter's fly whisk *(irukere)*, his arrow *(ofa)*, and his bow *(orun)*. His arrow and his bow have been specially rendered in honorific iron or brass since time immemorial. These metal representations of a single arrow heraldically crossing a single bow at its center (Plate 37) form, in Nigerian Yorubaland, part of the traditional Oshoosi sacrificial altar *(ojubo oshoosi)*. In the winter of 1964 I visited such a shrine, under the famous Olumo Rock of the Egba and Egbado metropolis of Abeokuta. An early European notice of a shrine for Oshoosi is dated 1857: "a huge iron bow, heavy with the weight of hundreds of strings of cowries hanging from it, and from small iron cylinders in which are miniature arrows."[112]

The relationship between the cult of Oshoosi and the actual practice of archery in traditional Yorubaland can only be surmised, given present evidence, but it is worth mentioning that in the nineteenth century the English explorer Lander claimed that the Oyo Yoruba "have the reputation of being the best bowmen in Africa," and that Yoruba arrows carried iron heads.[113] This provides another, practical reason for the close association between Oshoosi and the lord of iron.

In Bahia, Oshoosi represents the pantheon of the hunters of the Yoruba. He is one of the *orisha* most worshipped by persons of Ketu Yoruba descent. Therefore, the search for antecedents to aspects of Bahian worship of Oshoosi logically begins in Ketu in the People's Republic of Benin. There Deoscoredes dos Santos found that the fly whisk for Oshoosi and its associated lore were similar to Bahian expressions. More important, he found in Ketu a strange, bramble-like shrine, the *ojubo oshoosi,* for sacrifice to Oshoosi that is similar to certain altars in Bahia for the same deity.[114] If the hunter's fly whisk illustrates the medicine that Oshoosi carries with him into the forest, the bramblelike sacrificial shrine—dry, leafless branches placed in a careful pile on the earth—mysteriously brings the forest to the village.

PLATE 37

Metal bows and arrows for Oshoosi, fashioned in the Nigerian ideographic pattern, took root in Bahia. Among the blacks of Bahia the emblem was sometimes called *damata oshoosi*, based on a praise-verse that describes the archer as a man who combines the strength of three hunters *(ode meta)* within a single person. It is a praise-verse that came to western Cuba as well as to northeastern Brazil. The interconnections between Oshoosi and Ogún fit the fact that the sign of the lord of the hunters is frequently shown together with the pendant iron implements of Ogún both in Brazil and Cuba. Afro-Bahian versions are straightforwardly additive; they have a metal bow and arrow, the bow of which serves as a bar on which to suspend the seven or twenty-one pendant miniature implements of Ogún (Plate 36). The arrow is the vertical accent and is soldered to a stand

Black Saints Go Marching In 59

PLATE 38

or is sharpened at both ends so that it can be driven into the earthen floor of a traditional shrine or altar.

In Cuba combined signs of Ogún and Oshoosi have flourished since the nineteenth century, and most of these are simplified statements. But occasionally craftsmen have made elaborate fusions of art for Oshoosi and Ogún, as in an apparently twentieth-century exam-

ple now in the Institute of Ethnography in Havana (Plate 38). Here the sign of Oshoosi, like a flag of Nimrod, presides over the emblems of Ogún Alagbede (Ogún the Blacksmith). The metal sign of Oshoosi is set atop a kind of carousel of rotating avatars of iron—lengths of chain, a horseshoe, a pick, an ax, a hammer, an arrow, a sledgehammer, a hook, a scythe, and many other objects. Particularly affective is the garlanding of the whole with ornamental pieces of chain, the ancient Yoruba ideogram for the unifying power of the deities. Since World War II similar objects, usually reduced in scale and degree of elaboration, have appeared in the Hispanic barrios of some cities in New England, New Jersey, and New York.

Wherever Oshoosi is honored, the canon of his icon has remained intact. He seems to have lifted, invisibly, his bow and arrow, and taken aim, as if to protect the panoply of Ogún's iron, as if to return the debt established when Ogún marched with these implements to find his brother in the forest.

Obaluaiye

Obaluaiye's power to heal or conjure smallpox (or other dread disease) makes his cult feared and respected in Yorubaland. He is an earth deity who strikes down the arrogant and the immoral alike with "spears" of pestilence and fever. Informants have spoken of the danger of walking alone when the sun is hot at noon, when Obaluaiye and his followers, all dressed in scarlet, are believed to haunt the earth, and of the danger of wearing red or loud patterns for fear the deity, enraged at the appropriation of his prerogatives, might harm them.[115]

British colonial authorities banned the cult in Nigeria in 1917, when Obaluaiye priests were accused of deliberately spreading smallpox.[116] But members of the cult, confident of their insights and their moral worth, refused to be intimidated. They took their worship underground. They worshipped Obaluaiye under different names, e.g., the Lord (Oluwa). The strength of his lore in modern Nigeria is illustrated by the continuity of the old belief that it was dangerous to call him by his name, for one would thereby spread his dread disease, *shoponnon* (smallpox). Today even some English-speaking Yoruba use the circumlocution "S.P." when alluding to smallpox.[117]

The terror can be harnessed, however, to shock the thoughtless into social awareness and concern:

If you are rich, you do not laugh at the poor—
Little people can become grand
When you come into the world
You own neither a wife, nor a car, nor a bike
Nothing you have brought and
No one knows the future.[118]

These verses suggest that epidemics—the fiery, annihilating hand of Obaluaiye—can bring about social conscience because they could topple the rich and the powerful. Once aroused by arrogant behavior, the spirit of Obaluaiye is dangerously difficult to appease: "The glowing embers are difficult to stamp out."[119] Obaluaiye is thus a complex god, who inspires a complex set of verses in which the themes of terror and moral retribution are interwoven in a thousand different ways. The following conveys some sense of the peculiar beauty of the poetry chanted in his name:

Wild animal, with whom we have been entrusted
Your bird cannot strike my bird.
King of precious beads, death who flees at dawn.
Leaf poised upon the surface of the water.
Black hunter, physique covered by a gown of raffia
Falls mightily, blocks the road, as a thorn.
Thorn penetrates, man enters town with limp.
No one should walk alone at noon.[120]

The images caught within these verses are almost filmic, so swiftly realized are the shifting nightmare changes. Obaluaiye emerges, dressed in broomlike strands of raffia straw, then is suddenly transformed into a mighty force—falling like a tree that blocks the road, and then becomes a thorn.

The thorn is a metaphor for the pestilential needle of his morally aroused vengeance. Hence a hapless person—foolish enough to ignore warnings not to walk alone at noon when the sun is at its strongest and the sands, domain of the deity, literally heat up between his toes—is pricked by the thorn. We recoil in horror, knowing that with his limp he brings doom to the village.

Thorn imagery suggests the specially planted species of cactus dedicated to Obaluaiye and found on public shrines in the Ketu Yoruba area of eastern Benin.[121] It also leads to two of the mystic weapons of his arsenal of disease: an arrowlike object *(esin)* wrapped in scarlet cloth and kept on his shrine; and a lance *(oko)*, sometimes plain, sometimes decorated with cowrie shells and special tassels.

Both are extensions of the idea of something that pricks the flesh and inflames with lethal pain. Obaluaiye's full complement of attributes also includes the club, one of the most ancient and rudimentary of the weapons of the Yoruba—in this case, the rather generously sized specimen known as the *kumo*, covered with rust-colored camwood paste.

There is a line of poetry praising the deity as a man covered with raffia fiber, as if he were a walking broom—a Yoruba traditional whisk broom with a short handle and long fiber. As a matter of fact, extensive broom imagery characterizes the cult of Obaluaiye.

The Yoruba whisk broom, sacralized by the addition of medicines and camwood paste sprinkled on the straw, is one of the more formidable and famous of Obaluaiye's emblems. Ifá tells us that when he is enraged, Obaluaiye takes this special broom and spreads sesame seeds *(yamoti)* on the earth before him, then sweeps the seeds before him, in ever-widening circles. As the broom begins to touch the dust and the dust begins to rise, the seeds, like miniature pockmarks, ride the wind with their annihilating powers: the force of a smallpox epidemic is thereby unleashed.[122] According to Dos Santos, the cult name for this horrific broom, *shashara*, is said to represent a fusion of two roots in Yoruba, "pitting with smallpox" *(shasha)* and "human body" *(ara)*.[123]

The worship of the deity is widely known in the Benin Republic under the Fon term *Sakpata*. Some of the more beautiful of the verses in his honor have been elaborated at his festival in Abomey, Benin. The Dahomean elaboration of his cult traveled, with the Yoruba version, to Cuba and to Brazil, and there they reinforced themselves. For example, the deity is known by a creole Yoruba term in Cuba, "Babalú Ayé," the title of a famous Afro-Cuban café song of the 1940's, but his broom is called by the Dahomean term *ha* (spelled *já* in Spanish), and is richly beaded and decked with cowries (Plate 39), as in Dahomey, here illustrated with royal beaded Yoruba-Cuban fly whisks for the gods.

Dahomean style is also reflected in the shaping of the smallpox broom in Brazil. The original *ha* of the region of Abomey has a special medicated handle covered with crimson cloth decked with rich, ornamental bands of cowrie-shell embroidery. Emerging from the handle are the long, bound center fibers of the leaf of the *palma vinifera*. There is a hint of the "bush" in the manner in which the fibers of the *ha* explode this way and that in a twisting of strands

PLATE 39

at the working end of the instrument, whereas the fibers at the base are tightly bound together. The smallpox priest who carries this mystic broom is dressed in special garments, including a bonnet and armbands, all embellished with cowrie-shell embroidery.

The latter elements of Dahomean ritual dress, brilliantly miniaturized and recombined in the making of the creole smallpox brooms of Bahia, give rise to one of the most beautiful objects of the black Atlantic world (Plate 40). The *ja* of Dahomey in the process of transformation into the *shashara* of Bahia acquires the noble still-

ness of a column, so neatly cut and tightly bound are the fibers, which are enclosed by bands of ornamental leather often sited near the bottom and at the middle of the broom fibers as well as at the handle. These bands are richly appliquéd, in the Dahomean manner, with cowrie shells. They dress the object with the logic of a Dahomean priest's attire. In the end a whisk broom, glittering with crimson, white, black, and other colors, becomes a kind of abstract jewelry, made of shells and straw and leather.

These changes parallel an apparent shift in function. When Obaluaiye appears, dressed in his appropriate raiment, in the dances of the temples of Bahian blacks, he rarely carries, so it is reported, his club or arrow. Instead, he bears a lance or broom with motions underscoring a gentler mood. The broom is "danced" with gestures that are smooth and orchestrated, as if to suggest a sweeping away of terror, light-years removed from the scattering of sesame seeds amid dark clouds of dust. In short, the Afro-Bahian *shashara* is more a royal scepter than an object of use—hence the almost speculative manner in which its ancient functions are recalled.

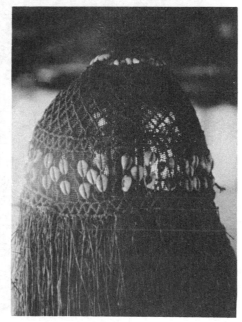

PLATE 40 PLATE 41

But there is nothing muted about the intimation of African forest energies and fierceness projected in the impressive all-raffia crown *(ade iko)* (Plate 41) and all-raffia gown *(ewu iko)* that are prepared by specialists in Bahia for possession-devotees to wear when the spirit of Obaluaiye fills them. This is a form of dress that directly recalls

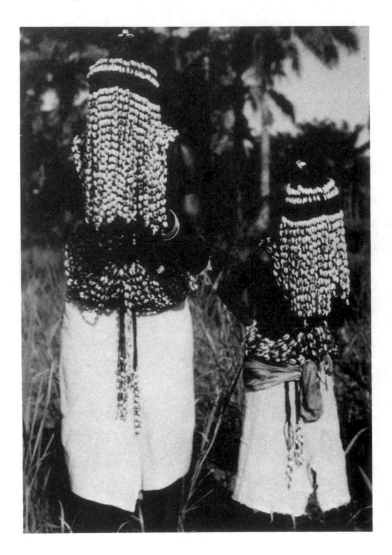

PLATE 42

not only the Nigerian verse about "black hunter, physique covered by a gown of raffia" but also the conical shape and veil of both Dahomean smallpox deity costuming and one of the main forms of Yoruba royal headgear (Plates 42 and 43).

The roots of the Afro-Bahian raffia gown are therefore various.

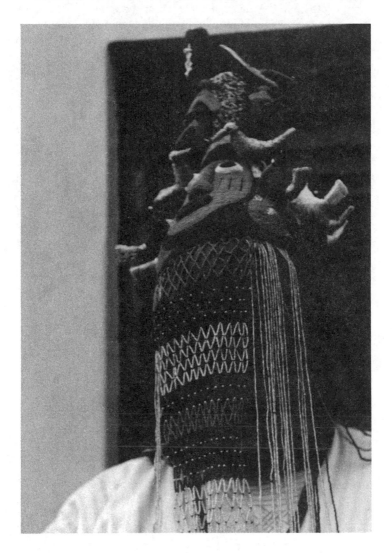

PLATE 43

North of the Fon in the Benin Republic there is a famous shrine to the mother of Obaluaiye, Nana Bukúu, on a platform by a baobab tree, overlooking the Yoruba settlement of Dassa-Zoumé (Plate 44).[124] Here there is a standing cylinder of clay over which has been fitted a raffia garment, communicating the presence of a spirit and bringing to mind the image of a whisk broom given animate solidity and form. Obaluaiye is an earth deity and here the body of his mother, as it were, like Elegba, acquires a flesh of laterite, a flesh covered over with raw fiber, the dress of spirits across West Africa. The summit of this strange image is surmounted by a raffia crown with a stemmed finial, also in raffia—details matched by the style of the Afro-Bahian crown for Obaluaiye (cf. Plate 44 with Plate 41).[125]

According to the Lagosian cult of Ejiwa, the earth deity gave Eshu, when the latter was scarred with smallpox marks, a garment made of raffia, of a thickness sufficient to keep flies from swarming about his wounds. Hence, Ifá tells us, the Ejiwa (Eshu) masquerader to this day appears completely shrouded in raffia.[126] Lagos, of course, was intimately linked to Bahia in the Atlantic trade, as were territories to the north of the Fon. The primary image of the Ejiwa cult is a most suggestive clue in the search for the origins of the idea of concealment by raffia of the signs of smallpox. In fact, Afro-Bahian informants explicitly claim that the raffia veil of Obaluaiye hides a face ravaged by the disease.

Nana Bukúu

Nana Bukúu is the mother of Obaluaiye, and such is her importance in Dahomey that there she has come to be considered the grand ancestress of all the Yoruba-derived (Anagonu) deities of the pantheon of the Fon. The name of Nana is famous from Ife in Nigeria to Siade and Tchari in Ghana. It is believed that none other than the kings of Asante and Dagomba sent gifts to her shrines in time of war. These kings sought her blessing because of her fabled powers to bring a city victory, to render in ruins the cities of one's enemies. She herself was a superlative warrior, utterly fearless, who razed the mythic city of Teju-ade.[127]

Nana Bukúu is the courage and accomplishment of women, sublimed to the form of an *orisha*. She knows terrifying secrets. She shares with her son, Obaluaiye, the smallpox god, master symbols: raffia-made regalia. Nana and her son are both represented by special

PLATE 44

staffs made of palm-frond fibers tied together, which collectively symbolize the ancestors and cryptically communicate awesome levels of initiation.

Her primary icon is the *ileeshin* (a Ketu term). It is essentially from Ketu, this ancient settlement, its cultural provinces, and neigh-

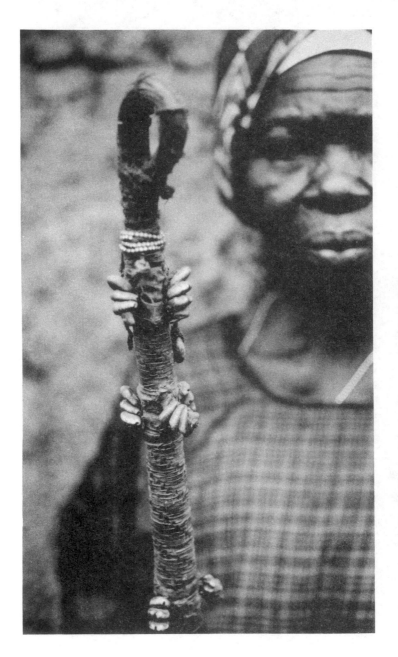

PLATE 45

boring territory that the cult of Nana was brought to Bahia, where she is spectacularly honored with the *ileeshin*. Made from the same materials as the broom of Obaluaiye, the *ileeshin* is, however, an entirely original instrument with its own logic of form and function. It is not loosely structured at its summit like the *ha* of the Fon. Instead, its strawlike elements almost disappear beneath rich coatings of camwood paste and leather-covered sections often dyed the darkest blue (Plate 45). The summit of the staff is striking—it curls back upon itself, like the tail of a leopard, leaving a strange oval space outlined at the top. This noose-shaped tip is believed to embody Nana's *àshe*, Nana's intimidating powers:

> The *ileeshin* cannot touch a man or boy. Its tip is dangerous. And if a woman holds it, all during the time that it rests in her hand she must not speak any evil of an animal or a man. But, if a cruel and horrible person stands before her, she can take the *ileeshin gogo*, thrust it out horizontally before her and strike its looped tip against the belly of the man.[128]

Instantly the man would fall back, arms outspread in a gesture of pain and shock, stomach instantly bloated.[129] Then he would die. Attacking an evil person in the region of the belly, causing it to swell even as the person dies, suggests that Nana presides over the giving —pregnancy—and the taking away of life itself. She is equally capable of bringing children into the world or causing doom, depending on a person's goodness or lack of character.[130]

The nooselike tip of Nana's staff is glossed by a legend recorded by Dos Santos:

> Nana has possessed a certain staff from the beginning of her life on earth. The name of the staff was *Ìbírìrí*. She was born with this staff; it was not given to her by anyone. . . . when she was born the staff was embedded in the placenta. Ornamental cowries decked this curled staff, and fine ornaments. After it was born it curled into a noose (*ó sì ká kóróbójó*). Then they cut it from the placenta and they put it inside the earth. But surprisingly, as the infant grew, the staff grew, too. It was the very staff that Nana used when she went to war against the Teju-ade and it was her son who dug it out of the earth. That is why they call it *Ìbírìrí*, my son-found-it-and brought-back-to-me. She used this staff as a medicine of victory. Many modes of mystic potentiality open up for the person who holds this staff. If the people of a town know to use this staff they will be able to prevent war. . . .[131]

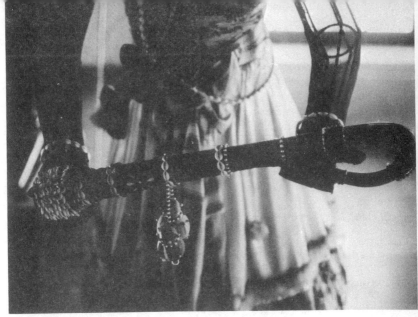

The Yoruba staff was creatively transformed in northeastern Brazil, where the *ileeshin* is called *ibiri*. Appropriately, this emblem of the mother of the smallpox deity is fashioned in Bahia by the Asogba, the supreme head of the devotees of Obaluaiye. The Asogba consecrates, makes, and entrusts to the priestesses mounted by Nana the *ibiri* of Bahia, and conceals powerful medicines in the base of the object. Our example (Plate 46), photographed in the Museu de Arte Popular in Bahia in 1968, captures the degree of artistic independence of the Brazilian form: there is at once a diminishing of the Ketu tradition of heavily coating the fibers of the object with red camwood and a heightening of the Ketu manner of encircling the straw with strips of leather. A war medicine becomes a work of art.

Yemoja (Yemayá)

Yoruba riverain goddesses are represented by round fans *(abebe)*, crowns *(ade)*—some with beaded fringes—and earthenware vessels *(awota)* filled with water collected from the river or from the sea, rounded stones, and sand. Those who worship these powerful underwater women long ago devised an artistic strategy, the use of the round fan as an emblem embodying the coolness and command of these spirits of the water.

Myths explain the meaning of the roundness of the fans. According to the verses of Ifá, the round fan was a fashion of the goddesses of ancient Ife.[132] And it came to pass that Ifá, god of divination, after a quarrel with the river goddesses, departed from the holy city, whereupon a terrifying famine struck the world. Ifá hid in the forest, in a round house made of leaves and saplings (oddly recalling Pygmy structures of Central Africa). As the crisis worsened people consulted diviners. Speaking through the sacred divination instruments, Ifá said that only the river goddesses themselves, including Yemoja, noted for her use of a round fan, could persuade him to return. Each female spirit took a fan, like the round one of Yemoja, and together they all went into the forest seeking the spirit of Ifá, throwing stones at anything solid that they saw. When they threw stones at the round house of Ifá, he shouted, "Who is throwing stones at my house!" *(Tani só kò lò run!)*. They replied, "We are, and we wish to see you." When they saw him standing before his round house, they immediately started to fan him, then begged him as they fanned him, gave him a special feast and fanned him again. And Ifá was persuaded to return and the famine ended.[133]

This is a retelling of a myth with a thousand voices, the myth of conflict that threatens to destroy the world and of the discovery of antidotes in mystic coolness. In another version two round droplets of water remaining in the mouth of a single fish reconstitute the peace that brought back order into the world.[134] Here, in the legend of Yemoja and Ifá, a special rounded fan—like a giant soothing drop of water—restores peace and calm, associating itself with the image of Ifá's cool round house made of herbs and leaves. An indelible current of association links the roundness of habitations to the roundness of things pertaining to riverain goddesses.[135]

But the coolness of the riverain goddesses is problematic. Vengeance, doom, and danger also lurk within the holy depths *(ibu)* of the rivers where the goddesses are believed to dwell. In the nineteenth-century Yoruba civil wars, warriors from Ibadan and Ijaiye, after killing the king of Owu, were terrified by what the aroused spirit of the murdered king might do. So they temporarily dammed the river Oshun, buried the king's body in the river basin, and then released the waters.[136] The logic: to bury the king deep beneath the rippling surfaces of the river would muffle the roar of his spirit and neutralize and appease his awesome powers of *àshe*. Similarly, the cool, dark depths of the river may shield mankind from the full blast

of the fiery powers of witchcraft harnessed by the river goddesses.

What is more, a fan can be dangerous if brandished by a person steeped in moral and medicinal lore. For Yemoja and all the other riverain goddesses, especially Oshun and Oya, who presides over the river Niger, are famed for their "witchcraft." They are supreme in the arts of mystic retribution and protection against all evil.

Many riverain goddesses are visualized as women with swords. The sword, together with the negative uses of the fan, may be said to form in part an image of what Judith Hoch-Smith calls "radical Yoruba female sexuality":

> Without the concept of witchcraft, power would have flowed naturally through society, lodging only in socially structured positions, most of which were held by men in the traditional Yoruba patrilineage. However, the concept of witchcraft permitted great quantities of power to become lodged in women, who in turn were thought to use that power against the institutions of society. In this sense, witchcraft symbolizes the eternal struggle of the sexes in Yoruba society over control of the life-force.[137]

Witchcraft, in fact, militates against not only total male dominance but the threat of class formation and drastically unequal distribution of wealth. At the core of the all-powerful council of male elders, the Ogboni Society, lies the awesome image of their deity, Earth, all-devouring, all-seeing. It is believed that man as such and woman as such asked themselves, "Who is supreme?" And out of the earth came the white-hot message: I AM SUPREME![138] And Earth was, in a manner beyond sex or class or any consideration contaminated by singleness of expectation. Just as we arrive among the western Yoruba in the presence of God to discover that "he" is not he, nor she, but a pure force—*àshe* of *àshe*—so the impartial laserlike precision of the punishing vision of Earth, who was here before the goddesses and before the gods, implies a power beyond "her" sex.[139]

Imperially presiding in the palaces beneath the sands at the bottom of the river, the riverain goddesses are peculiarly close to Earth. In the positive breeze of their fans, the ripple of their water, there is coolness. In the darkness of their depths and in the flashing of their swords, there is witchcraft. And within the shell-strewn floor of their underwater province there is bounteous wealth. Yoruba riverain goddesses are therefore not only the arbiters of the happiness of their people but militant witches. Their negative power is alluded to in oral literature:

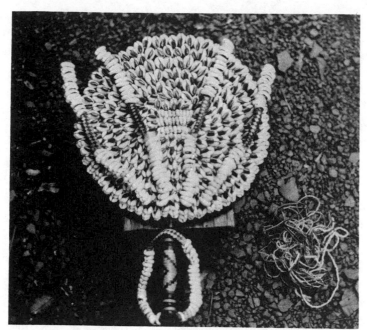

PLATE 47

Yemoja, the wind that whirls with force into the land.
Yemoja, angered water that smashes down the metal bridge.[140]

But this is power used against the human arrogance of Western
technocratic structures. The natural goodness within the evil of
these water spirits is invoked by righteous devotion. Thus, in Cuba,
when a divination priest warned women that a certain river goddess
had become dangerously angry, senior priestesses, like Yemoja and
her circle before Ifá, would face the altar of the offended spirit and
fan her image with strong concerted motions.[141]

Like an Ipokia shrine of the river goddess Yewa and the forest
dwelling of Orunmila, and like the ancient fans of Ile-Ife, the Afro-
Cuban ritual fans are round. They are decorated with a richness of
material—beads, cowrie shells, jingle bells, even peacock feathers—
surpassing that of the originals. For example, a Ketu Yoruba round
fan for the goddess Are, wife of the founding deity Ondo, tutelary
spirit for many groups of the western Yoruba, is luxuriously embroi-
dered with cowrie shells (Plate 47). The structure and allusiveness

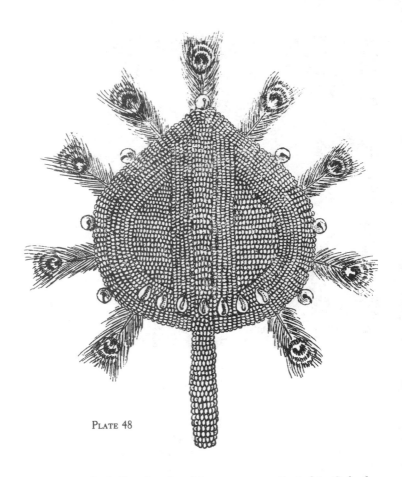

PLATE 48

of the round, shell-embroidered fan were complicated in Cuba by metallic or feathered embellishments. Thus a fan for the goddess of the sea, Yemayá, made in Cuba before 1952 but probably in this century, displays a brilliant surface entirely covered with beads in geometric sections (Plate 48). The design includes a lunette on the right, a lunette on the left, both separated by an ascending column of beaded surface that continues the axis of the handle to the very tip of this pointed fan. Seven cowrie shells in a smooth curve decorate the bottom portion of the fan. Nine peacock feathers, with seven jingle bells, add both pleasing sound and swaying movement. (Nine is one of the numbers of Yemayá in Africa, as in the Abeokuta

praise verse, "open river, divided into nine parts.")[142] The feathers are seductively beautiful, but they all carry a charge associated with some birds, namely, witchcraft. The shells suggest the goddesses' money—all underwater creatures, who are close to the sources of the traditional cowrie currency and to the corals from which, in the ancient imagination, much wealth derived, are believed to be quite rich. The bells provide a gentle watery tinkle recalling a poem praising the goddess of the river Oshun that mentions copper bracelets chiming against each other underwater.[143]

The religious history of the blacks of Rio is a palimpsest marked by Kongo, Yoruba, and Roman Catholic infusions, as will be elaborated on in the following chapter. Suffice it to say here that in the fusion of these elements—in the rise of the macumba religious groups of Rio—the arrow or the dagger and the heart of the Most Holy Virgin have combined with the imagery of Yemayá in the belief that both the Virgin and the goddess of the sea share qualities of sacred love, faith, and purity. In the creole fusion-image of Yemayá and the Virgin Mary, "sung points" strike through in the macumba shrines of Rio to an oceanic presence behind a Roman Catholic mask:

> O Virgin Mary
> Like a flower superb
> Celestially harmonious . . .
> Reigning monarch of the seas.[144]

In a superb white metal fan for Yemayá, probably made in the present century (but no later than August 1939, at which point it was accessioned by the National Historical Museum in Rio), the heart of Mary is returned to the sea in a petaled flower image (Plate 49) of Yemayá, with reflections of the latter's underwater wealth and celestial love suggested by pendants of miniature hearts and nineteenth-century Brazilian coinage. There is the crucial detail of the touching of the bottom of the heart by a sharpened, arrowheadlike point at the top of the handle of the fan, as in the "drawn point" that accompanies Rio sacred songs for Yemayá/the Virgin Mary. This is, of course, the seal of Nossa Senhora das Dôres, blending with the Yoruba tradition of honoring powerful underwater denizens with honorific fans. Finally, the scalloped edge circumscribes the entire composition with a sign of water.

The petals surrounding the inner heart suggest a floral image within water, which is implied by the wavy edge of the fan.[145] Each

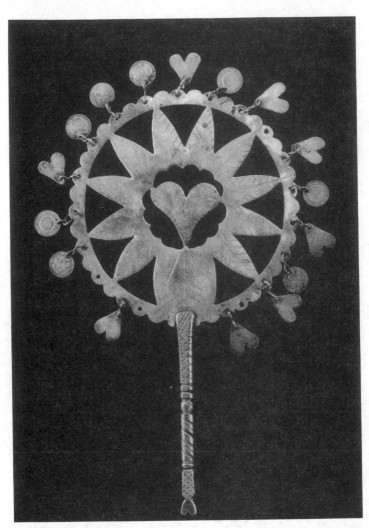

PLATE 49

New Year's Eve thousands upon thousands of black and white worshippers descend from the hills above and around the city of Rio and crowd the famous beaches of Copacabana and Ipanema in one of the most celebrated of the festivals for Yemayá in the western hemisphere. And one of the acts rendered, then, in her honor,

involves the tossing of sacrificial flowers into the breakers of the sea. Pierre Verger has photographed flowers in a container to be sunk beneath the waves in honor of Yemayá in Bahia. The image of flowers within the depths is another recollection of tradition in Yoruba New World worship. It recalls the ending of the festival of the riverain goddess, Oshun, with the throwing of flowers into her stream at Oshogbo, in Nigeria.[146]

Oshun

Divination literature tells us that Oshun was once married to Ifá but fell into a more passionate involvement with the fiery thunder god, who carried her into his vast brass palace, where she ruled with him; she bore him twins and accumulated, as mothers of twins in Yorubaland are wont to do, money and splendid things galore. She owned a wealth of bracelets, staffs, needles, earrings—all in brass, the metal the Yoruba regard as most precious. When she died, she took these things to the bottom of the river. There she reigns in glory, within the sacred depths, fully aware that so much treasure means that she must counter inevitable waves of jealous witchcraft by constant giving, constant acts of intricate generosity. Even so, she is sometimes seen, crowned, in images of warlock capacity and power, brandishing a lethal sword, ready to burn and destroy immoral persons who incur her wrath, qualities vividly contrasting with her sweetness, love, and calm:

> She greets the most important word within the water
> She is the orisha you see healing by means of water that is cool
> Iworo bird with brilliant plume upon her head
> Titled woman who heals the children . . .
> Witness of a person's ecstasy renewed
> She says: bad head—become good!
> Mistress of àshe, of full predictive power,
> She greets the most important matter in the water.
> Strong woman who burns a person.
> She cures without fee; gives honey to children
> Has lots of money, speaks sweetly to the multitude.
>
> Nowhere is the kingly power of Oshun not renowned
> Oshun has a mortar made of brass
> Sweet is the touch of an infant's hand
> Kare, King of the holy depths
> She dances, she takes the crown . . .

The chiming bracelets of her dance.
She smites the belly of the liar with her bell.
Mother, O Mother of cool water,
You, who sired the soothing osun herb.[147]

Ecstatic praise literature. It is easy in the context of these verses and Oshun's reputation for great beauty to appreciate why she was romantically transmuted into the "love goddess" of many Yoruba-influenced blacks in the western hemisphere. But there are dark aspects to her love and the singers of her praises in Nigeria do not hesitate to mention them: her masculine prowess in war; her skill in the art of mixing deadly potions, of using knives as she flies through the night:

Woman wearing manly crown, oh so rare
Owner of a piercing knife, I take my haven by your side
You own the inner court, where witch-owl lays her eggs.
You kill this owl, and make of her a strange cuisine . . .
Arriving, trouble vanishes in coolness.
Yeye Kare . . .
You hollow out sands beneath the sea,
You're putting money in there
The water sounds, *wanran-wanran-wanran*, like the bracelets
 of Oshun.[148]

But Oshun's darker side is ultimately protective of her people. This accounts for the famous material expression of her positive witchcraft among Cuban and New York Hispanic blacks, the *oshun kole* ornament that is hung from the ceiling of the house of its owner: "Oshun Kole lives in a calabash adorned with five turkey buzzard feathers, a calabash which is suspended from the ceiling."[149] The spray of "witch feathers" renders this suspended vessel into a kind of elevated devouring force. Like certain charms suspended from the rafters of reception porches used by some northern Yoruba chiefs and kings, the *oshun kole* is believed to protect the habitation from all evil. Our example, dated 1968 (Plate 50), was made in Hispanic New York and indicates a change in continuity from Nigeria via Cuba: the buzzard feathers have been replaced by store-bought plumes; the calabash is missing; and a single strand of brilliant copper-colored *oshun* beads with cowrie shell has been added.

Elderly informants of Lydia Cabrera remembered the use, at the turn of the century, of crowns with beaded fringes for Oshun in

Flash of the Spirit

PLATE 50

Havana. The praise-verse "Crowned Woman, O so rare" is brought
to life by a proliferation of crowns for priests and priestesses of
Oshun and riverain spirits in Brazil, many with veils that fall across
the wearer's face in the ancient Yoruba manner.

Oshun's positive witchcraft gave rise to feathered charms in Cuba
and New York. Her sovereign powers are celebrated by the crowns
for Oshun in Brazil. But perhaps the most significant of her New
World emblems are her round metallic fans. The idea of Oshun
among the Ijesha Yoruba of Nigeria is brilliantly realized in circular
fans of polished brass with chased and hammered figuration. One of
the finest examples of the genre comes from Ilesha, the capital of
the Ijesha; it was made in sheet brass around the turn of the century
by the master brassmith Oginnin Ajirotitu Arode Onishona (Plate
51).

The symbols on the Oginnin fan are remarkable for their richness
of allusion. First there is a link between the riverain goddess and the
ultimate powers of Earth made explicit in praise literature. Here the
closeness of the goddess of the water to the Supreme Being is
manifested by the handle. From the bottom of the handle hang
three chains, the mystic number of Earth. There are also two pairs
of three small hearts chased within the surface of the handle. Alto-
gether there are three statements of the power of Earth, who wit-
nesses two-party vows and covenants.

The son of Oginnin explained the many meanings embedded in
this fan as his father had explained them.[150] The summit of the

Black Saints Go Marching In

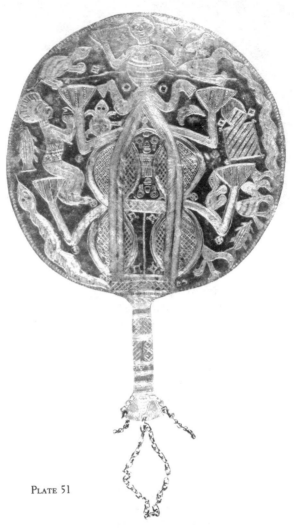

program of decorative detail is dominated by the figure of Oshun
herself, shown with hands held high above her head, "to greet a
person with the sign of gladness, not by song." She unifies the world
by holding a length of chain about her head, an action called I-tie-all-
my-people-together *(mo so awǫn enia mi po)*. Fish, in which her
spirit moves within the river, appear as motifs, left and lower right.

82 Flash of the Spirit

Alluding to the feathered avatars in which she and her circle fly, there is a "bird of the river" *(karo)* standing beneath the fish on the right. Serpents also appear; they are messengers of Ogún's iron—"fighting evil men."

For all the signs of witchcraft and the clash of iron, lessons of the cool and antidotes to evil and to envy are richly given, too: a giant rat *(okete)*, "not for the gods but for the cooling of the witches"; a tortoise *(ajapa)*, "sacrifice to Osanyin, master of the medicines by which we live"; a cock; a hen; a Muslim writing-tablet ("carved with Ogún's iron"); and the image of a young woman with a bridal hairdo who brings a calabash filled with kola "for the greeting of the gods." These all connote giving and assuagement, acts that still the wind and calm the surface of the water. And all these images float timelessly about the central icon of the paired heads of Owari and Obanifun, spirits of war and creativity. The tip of the cartouche in which these male valences are contained touches the vagina of Oshun. The implication of the fan's program of symbols is precisely this: without constant rhythms of giving and responsibility, the fruitful union of Owari/Obanifun and Oshun would be no more and the withering famine described in many myths would return.

The buzz of mythic voices was silenced, as it were, when the brass fans were brought to Bahia. The chasing of symbols upon the surface in the Ijesha manner was apparently lost. All that remains of the originating tradition is the characteristic shaping of the fan in the round manner of the ancients and the use of polished metal as the medium. But metal fans for the river goddesses in Bahia have a creole richness of their own, as attested by a fan for Oshun made by Clodimir Menezes da Silva in August 1968 (Plate 52). They fuse basic Yoruba style (round outline, metal medium) with an element of Dahomeanizing design (the use of what might be termed "metal appliqué," i.e., the bolting together of various levels of sheet metal to form a composition, as in the great metal standing figures of Abomey). In addition, some artists actually sometimes seal sacred liquid within the hollow, syringelike handle of the fan. In other words, the handle loses its flattened textural quality in the manner of Ilesha and becomes a polished cylinder, a vial. Thus the artists of Bahia have extended the image of the fan of Oshun and the riverain goddesses with an object that mimes, as it were, the balancing of a single, multipetaled sacrificial flower on the rolling, scalloped, chiming waters of Oshun.

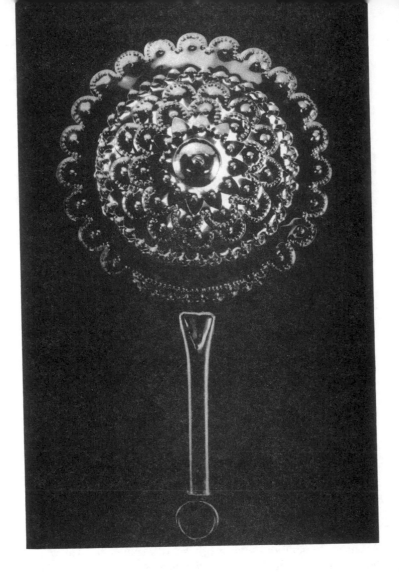

Shàngó

The tempestuous mythic third king of the Yoruba, Shàngó is an Oyo deity. He is the thunder god, and his consort is the whirlwind, the goddess Oya, who is also the goddess of the Niger River. As an alleged medieval monarch, he has come to symbolize the powers of

the Oyo kings. His royal cult plays an integral role in the installation of each king of the Oyo. In the palace of the Oyo kings there is a special priestess, Iya Naso, who is charged with palace worship of the thunder god, and her disciple Iya Aaafin Iku is responsible for Shàngó's sacred ram (the motion of whose horns are poetically compared to the thrust and parry of the lightning bolt).[151] These palace customs reach a climax at the annual Beere festival when a masked priest, said to represent Shàngó's own ancestral spirit, Alakoro, perambulates the palace walls while gesticulating and, in his robe of blazing red and shining mask of polished brass, looking like a crimson ghost. Before each of the main gates to the palace he gestures to heaven and then to earth, to heaven and earth again, and moves on to the next point of blessing.[152]

Once upon a time, as myth would have it, Shàngó was recklessly experimenting with a leaf that had the power to bring down lightning from the skies and inadvertently caused the roof of the palace of Oyo to be set afire by lightning. In the blaze his wife and children were killed. Half crazed with grief and guilt, Shàngó went to a spot outside his royal capital and hanged himself from the branches of an ayan tree. He thus suffered the consequences of playing arrogantly with God's fire, and became lightning itself.[153] Like Eshu at the Cuban crossroads, in the lightning bolt Shàngó met himself. He became an eternal moral presence, rumbling in the clouds, outraged by impure human acts, targeting the homes of adulterers, liars, and thieves for destruction. "He dances in the courtyard of the impertinent," as composers of his praise-poetry envision his transformation of lightning into moral action. Praise singers among the western Yoruba realize a vision of his spirit in poetry charged with flashing images:

> Water by the side of fire at the center of the sky
> A strange thing, on the road to Teji Oku
> He strikes a stone in the forest, stone bleeds blood
> He carries a heavy stone upon his head without a cushion.
> Shàngó splits the wall with his falling thunderbolt.

> He makes a detour in telegraphic wire
> Leopard of the flaming eyes
> Lord who wears the sawtooth-bordered cloth of returning
> ancestors *(egun)*
> Storm on the edge of a knife.

Earthworm, despite no eyes, plunges deep into the earth
He dances savagely in the courtyard of the impertinent
He sets the liar's roof on fire
He carries fire as burden on his head
The gaze of this leopard sets the roof on fire

Father, grant us the intelligence to avoid saying stupid things.
Against the unforeseen, let us do things together.
Swift king, appearing like the evening moon.
His very gaze exalts a person.
I have an assassin as a lover.
Beads of wealth blaze upon his frame.
Who opens wide his eyes
Leopard of the flaming eyes
Fire, friend of hearth.
Leopard, of the copper-flashing eyes
Fire, friend of hearth.
Lord with flashing, metallic, eyes,
With which he terrifies all thieves.[154]

The power of Shàngó streaks down in meteorites and thunder-stones, stones both symbolic and real. The *àshe* of Shàngó is found within a stone, the flaming stone that only he and his brave followers know how to balance unsupported on their heads. Flaming stones have become a metaphoric burden: the possession priest or priestess often balances a vessel containing burning oil upon his or her head. The earthworm, one of the first of God's messengers of *àshe*, plunges like lightning into the soil and, ventilating the earth, creates sustenance for plants. Likewise, Shàngó, as pestle, crushes the fritter that it may properly be prepared, just as Shàngó's favorite yams and maize must first be pounded. Only by being broken down do substances yield nourishment. Only through chastisement does the liar ideally change and grow.

Shàngó sits upon a sacred inverted mortar *(odo)* when he fills the body of his possession-devotee. *Àshe* within his meteoric stones also flashes within his eyes, the eyes of the possessed, whose gaze is believed capable of igniting houses. Shàngó's *àshe* flashes danger-ously in the amazingly wide-open eyes of thunder priests and in the gaze of the royal leopard, who will kill all felons and enemies of the state.

The metaphoric and moral range of this poetry is matched by that of the images of the altars of Shàngó.[155] The thunder ax *(oshe)* is

Flash of the Spirit

one of his most pervasive attributes. The character of Shàngó's moral retribution and the control of this power by his followers are represented in one of the earliest *oshe* brought to Europe, a fine specimen taken to England before 1853 by Lt. W. R. Bent of the Royal Navy (Plate 8). It is now in the Royal Albert Memorial Museum in Exeter. Twinned thunderstones appear above the head of a female follower of Shàngó. There they are balanced, like the meteorites that Shàngó carries upon his head. Character and propitiating coolness *(irele)* are exemplified in her poise; she kneels to show honor, holding her breasts as an offertory. She wears the characteristic red and white beads of the thunder god that refer to, among other images, a line of the praise-poem, "water by the side of fire at the center of the sky." The two colors also suggest the friendship of fiery "red" Shàngó and Obatala, deity of creativity, whose honorific color is white.

Metaphoric fire balanced on the head of the thunder-god follower is an image that traveled to Bahia, in Brazil, where actual dancing with loads of fire has been reported:

> In the cycle of festivals for Shàngó in the shrine of São Gonçalo there is an impressive ceremony, only realized there, wherein the daughters of Shàngó, possessed by their orisha, dance with a vessel that contains material in flames, upon their heads. The fire does not harm them, nor does it burn the hands with which they secure the burning vessel. Later, while still moving in the dance, they eat flaming balls of cotton dipped in oil.[156]

These miracles indicate to believers that Shàngó's possession of his followers is actual, not a sham. The balancing of twin bolts of meteoric fire on the head of the devotee is also meant to convey a promise of moral vengeance. This powerful dual metaphor spread to the far corners of the Atlantic Yoruba world. It appears with particular strength in Bahia (Plate 53), where in the late nineteenth century the butterflylike shape of the thunderstones balanced on the represented worshipper's head revealed influence from Ketu, where thunder axes frequently are shaped this way.

Some Western Yoruba believe that when Shàngó blinks, a lightning bolt will crash down at that instant. And when a devotee is infused, in spirit-possession, with Shàngó's *àshe,* the devotee's eyes will bulge. Notice the cause and effect. This fine piece of nineteenth-century Yoruba sculpture in Brazil also shows the servitor with hands on her stomach, making of her midriff an offertory vessel of life and continuity.

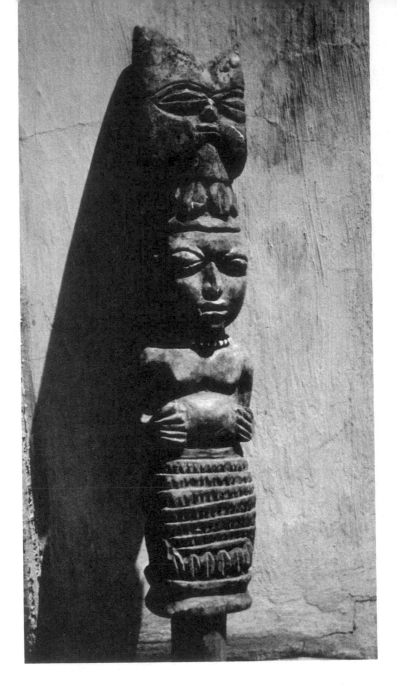

PLATE 53

PLATE 54

Afro-Cuban association of the thunder god with Saint Barbara sometimes gave rise on the island to superbly complex renderings. Our example (Plate 54) dates perhaps from the end of the nineteenth century, and apparently was collected in the region of Havana. The artist affirmed the Catholic aspect but transcended it. He dressed a Shàngó follower in a red and white chasuble, deliber-

ately creating raking angles in the phrasing of the garment, so as to harmonize it with and mirror the higher angulation of the thunderstones. The calm, pert face of the devotee has slight indications of the markings of Yoruba patrilineal descent groups. This compact little sculpture is a fusion of images from two cultures and two visions under God.

Many Brazilian and Cuban *oshe* reflect trade ties and strong ethnicity. But there is another kind of thunder ax made in the Americas, among United States blacks who dropped their Anglo-Saxon names in favor of Ifá-indicated Yoruba titles or self-assigned names. Adefunmi, the founder of the Yoruba Temple in Harlem in 1960, a Detroit-born black, learned Yoruba initiatory art and lore in Matanzas, Cuba, and brought an originally Afro-Cubanizing form of Yoruba *orisha* worship to Harlem. But Adefunmi's imagination was restless, and he ceaselessly studied the Yoruba language, handbooks with illustrations of the classical art of the Yoruba, lectures by New York–area Africanists, and many other sources. In the process, the art of New York Yoruba became a willed phenomenon, a self-conscious renaissance that was distinguishable from modern Afro-Cuban work. In this body of art works are precise, detailed representations of the ideas of the *orisha*. For example, Adefunmi's *oshe*, carved in Harlem in 1965–68, follows the canon in its essentials— the twin thunderstones carried on the head as a mystic burden, the bulging eyes of *àshe*, the frozen mouth—but the figure gestures asymetrically, with a miniature *oshe* in the left hand and a thunder rattle in the right (Plate 55). The figure is not frozen in a pose of giving but in a stance of combativeness.

This figural wariness is appropriate to the condition of blacks in the crisis decade of the 1960's. Awolowo, another prominent member of the Harlem Yoruba Temple, shaped in c. 1968 a remarkable plaster image of Shàngó, the thunder king (Plate 56) wearing a kind of *oshe*-coronet and holding before his body a royal Yoruba fly whisk and a miniature *oshe*. His face is traditionally impassive even as he stares. The sweep and velocity of the lines tracing the folds of the royal garment are unprecedented in the classical statuary, and represent the application of a rich inventive mind to the problems of artistic identity.

Shàngó's complex artistic embodiments—warrior and lover, "water by the side of fire at the center of the sky," "I have an assassin as a lover"—extend back to antiquity. As early as 1659 Shàngó's

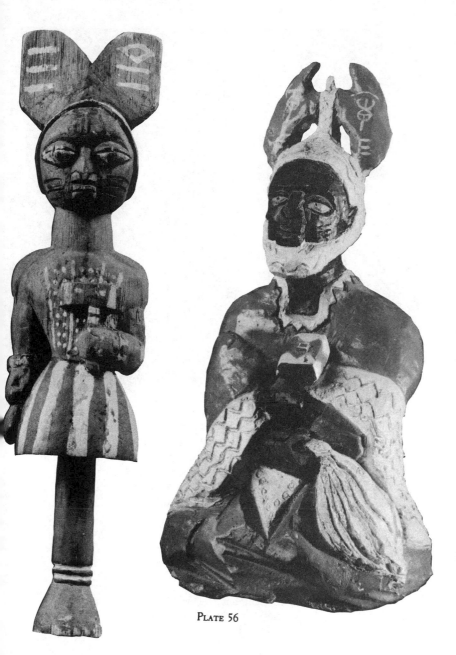

PLATE 55

PLATE 56

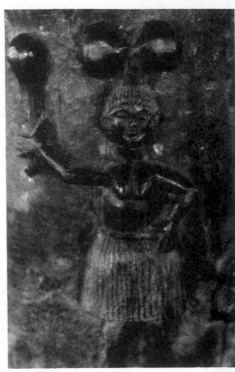

PLATE 57 PLATE 58

upsurge into the world had been stylized by particularities of sculpture—the fertilizing thrust of the thunderstone into the earth indicated by an image carved in wood, pointing to his penis with one hand while indicating the source of that energy by pointing to the sky with the other hand (Plate 57). Eva Meyerowitz examined an old brass armlet decorated with Shàngó emblems in Dahomey (now Benin), where the traditional owners told her that the object had originally come from Oyo-Ile. On this probably ancient piece, possibly from the city of Shàngó, the sky-and-penis gesture of the thunder god reappears:

> One figure presses both his hands against his cheeks, showing his tongue which is of enormous size, while the other carries an object in his one hand which suggests a meteorite or thunderbolt, while his other hand points to his sexual organs.[157]

Flash of the Spirit

This strong phrasing came to Cuba:

> There is no more vehement nor energetic spirit [than Shàngó].When a devotee is mounted by the spirit of Shàngó, he charges three times, head leading, spinning like a ram, towards the drums. Then he opens his eyes to abnormal width and sticks out his tongue, to symbolize a fiery belch of flames, and raises his thunder-axe on high and clamps his other hand upon his scrotum.[158]

The ancient dual gesture is so persistent that not only does Alakoro perform a modified version, pointing to the sky and to the earth twice, before the gates of the Oyo palace, but it is emblazoned in relief upon a thunder pedestal (odo shàngó) found in Bahia, dating, probably, from the second half of the last century (Plate 58). Here the figure of a priestess makes the dual gesture, rattle to sky, hand to waist.[159]

The coming of the icons of the Yoruba to the black New World accompanied an affirmation of philosophical continuities. Selected fragments of the liturgies remained alive in songs about the wonder-working blade atop the head of Eshu-Odara, the irons of Ogun flashing moral vengeance in hearth and home, and the murmur of the chiming bracelets of Oshun beneath the undulating surface of the river. These verses lived in chants, and in icons of the goddesses and gods on New World domestic altars.

There is, in all of this, the vision of the Yoruba Atlantic world, a metaphoric capture of the moral potentiality inherent in certain powers of the natural world—thunder, oceans, herbs, and stones—and a demonstration that creative persons have shaped certain images, pillars of lateritic clay, implements of iron, metal fans, brooms decorated with leather and cowrie-shell embroidery, so that they illumine the world with intuitions of the power to make right things come to pass.

Time and again, in Yoruba Atlantic art and dance, in the image of the servitor shaped in wood or directly embodied in ritual participation, the ancient praise-poems and divinatory insights were materialized, and made visible. One final example:

> A magnificent beaded (probably nineteenth century) Nigerian Yoruba tunic for a thunder-god possession-priest (ewu shàngó) displays the lord of thunder with characteristic axe and rattle, surrounded by four birds of nocturnal power [Plate 59]. Here is

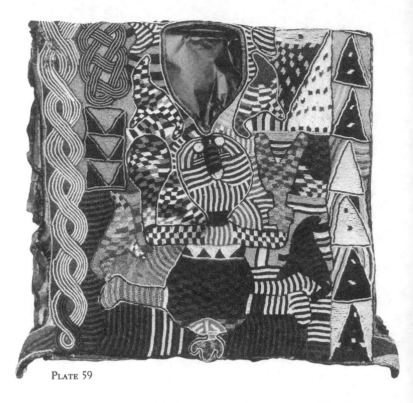

PLATE 59

Shàngó, beads of wealth blazing on his frame. Here is Shàngó, with triangularly represented elements of lightning, each with eyes to seek and find the rooves of the ungodly.

There is a telling opposition to be noted here—the clash between the hard-edged, sharply pointed thunderstones and the smooth curves of richly elaborated interlace which almost certainly stands for serpents intertwined, ancient Yoruba image of coolness, peace, and power. These interwoven forces come down like lightning, like the zig-zags glittering on the moving body of the Gaboon viper, harbinger of God's *àshe,* like the earthworm, another founding form of God's *àshe,* ventilating earth, opening up the soil as with myriad lightning strikes.

Fire (thunderstones, flashing with pinpoint metallic eyes) and water (domain of becalmed serpents, superbly coiled about themselves) meet at the center of the sky. There Shàngó, axe and rattle handsomely attendant, faces the present and the future on behalf

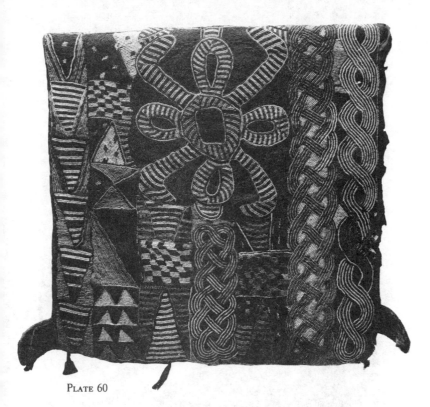

of his numerous followers. On the back of the tunic [Plate 60], facing the past, he whirls as an ancestor-inquisitor *(egúngún)*, lappets flaring in the wind, a virtual dervish in striped strips of narrow-loom 'country cloth.' There he spins, a righteous whirlwind, a storm on the edge of the knife dividing this world from the next.

This spectacularly allusive tradition, the Yoruba beaded royal tunic, was renewed in Cuba in new form. It reached a peak of decorative quintessence in the making, perhaps in the last quarter of the nineteenth century, of a sumptuously beaded garment *(bandel)*, for the mother-drum of a set of three Cuban-Yoruba *batá* drums [Plate 61]. Striking changes are apparent. Instead of Shàngó in a field of fiery and acquatic forces, there is a vivid creole fusion of distinct goddesses and gods. Olokun, god of the sea [Plate 62], appears at the summit of the composition, eyes fashioned out of flashing mirror shards. The ax of the thunder-

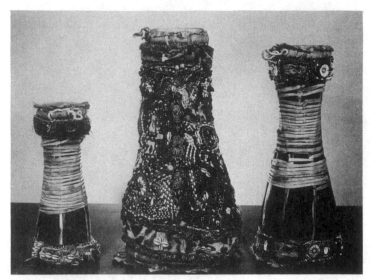

PLATE 61

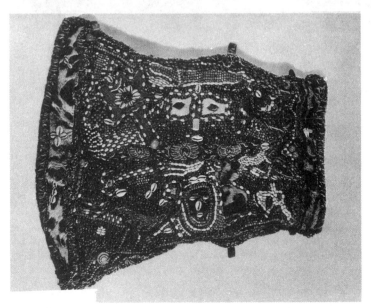

PLATE 62

god reappears at left, here centered with a shell-studded jewel of copper color, symbolizing Oshun and her world of wealth. The ancient eyes of Eshu-Elegbara, cowrie shells, stare forward from an implicit cross-roads at the bottom of the tunic. Left, there appears a bird of Yemayá, intuiting her powers; right, another thunder ax; and handsome segments of leopard pelt allude to *orisha* of the forest. And there is a segment of green and yellow beads for the deity of divination. The attributes of the deities of the Yoruba, one against the other, protect in unison the body of a drum. The drum itself brings back the rhythmized voices of the ancestors of the Yoruba in Cuba. Like a Trajanic frieze, unfolding history, this beaded drum tunic brings back sacred forces from the Old World to the New.[160]

In conclusion, the grand message of Yoruba Atlantic art, wherever it is found, but especially in Nigeria, Togo, and Benin, the United States, Cuba, and Brazil, handsomely counterpointed, in music, by the rising worldwide popularity of Sunny Adé and other players of Yoruba juju music, and especially evident in the Yoruba Renaissance art and architecture (Plates 63, 64, 65) of Oyotunji, South Carolina,[161] in the 1970's is this: sheer artlessness may bring a culture down but a civilization like that of the Yoruba, and the Yoruba-Americans, pulsing with ceaseless creativity richly stabilized by precision and control, will safeguard the passage of its people through the storms of time.

PLATE 63

PLATE 64

PLATE 65

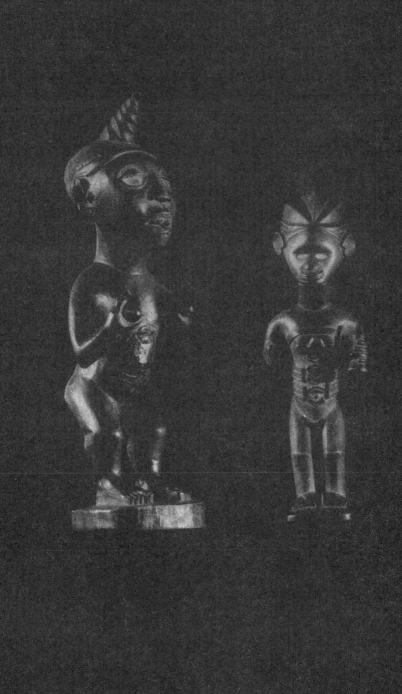

Two

THE SIGN OF
THE FOUR MOMENTS
OF THE SUN

Kongo Art and Religion
in the Americas

Spelling Kongo with a *K* instead of a *C*, Africanists distinguish Kongo civilization and the Bakongo people from the colonial entity called the Belgian Congo (now Zaïre) and the present-day People's Republic of Congo-Brazzaville, both of which include numerous non-Kongo peoples. Traditional Kongo civilization encompasses modern Bas-Zaïre and neighboring territories in modern Cabinda, Congo-Brazzaville, Gabon, and northern Angola. The Punu people of Gabon, the Teke of Congo-Brazzaville, the Suku and the Yaka of the Kwango River area east of Kongo in Zaïre, and some of the ethnic groups of northern Angola share key cultural and religious concepts with the Bakongo and also suffered, with them, the ordeals of the transatlantic slave trade.

The slavers of the early 1500's first applied the name "Kongo" solely to the Bakongo people.[1] Then gradually they used the name to designate any person brought from the west coast of Central Africa to America. Similarly, the meaning of "Angola" broadened over the centuries. "Ngola" once referred only to the ruler of the Ndongo part of the Kimbundu culture in what is now the northern part of Angola. According to historian Philip Curtin, "[Angola's] first European meaning referred quite precisely to the immediate hinterland of Luanda." Then the term became the name of not only modern Angola but sometimes the whole west coast of Central Africa, from Cape Lopez in northwestern Gabon to Benguela on the coast of Angola proper.[2]

The broadening of the meanings of "Kongo" and "Angola" over the span of the Atlantic trade reflects the expansion of European slave trafficking into the heart of Kongo and Kongo-related societies during the seventeenth, eighteenth, and nineteenth centuries. Thousands of persons were abducted from this culturally rich area. And as opposed to a prevalent view of Africans—as belonging to different "tribes," speaking different "dialects," thrown together in the holds of slave ships, and hopelessly alienated, one from the other —Africans from Kongo and Angola shared fundamental beliefs and languages. When they met on the plantations and in the cities of the western hemisphere, they fostered their heritage. Kongo civilization and art were not obliterated in the New World: they resurfaced in the coming together, here and there, of numerous slaves from Kongo and Angola.

Kongo presence unexpectedly emerges in the Americas in many places and in many ways. Take, for example, vernacular English and singing. In the South of the United States, important Ki-Kongo words and concepts influenced black English, especially the lexicons of jazz and the blues, as well as of lovemaking and herbalism. Many a Ki-Kongo-derived word has been described by etymologists as "origin unknown." The word "jazz" is probably creolized Ki-Kongo: it is similar in sound and original meaning to "jizz," the American vernacular for semen. And "jizz," suggestive of vitality, appears to derive from the Ki-Kongo verb *dinza*, "to discharge one's semen, to come." *Dinza* was creolized in New Orleans and elsewhere in black United States into "jizz" and "jism."

The slang term "funky" in black communities originally referred to strong body odor, and not to "funk," meaning fear or panic. The black nuance seems to derive from the Ki-Kongo *lu-fuki*, "bad body odor," and is perhaps reinforced by contact with *fumet*, "aroma of food and wine," in French Louisiana. But the Ki-Kongo word is closer to the jazz word "funky" in form and meaning, as both jazzmen and Bakongo use "funky" and *lu-fuki* to praise persons for the integrity of their art, for having "worked out" to achieve their aims. In Kongo today it is possible to hear an elder lauded in this way: "like, there is a really funky person!—my soul advances toward him to receive his blessing" *(yati, nkwa lu-fuki! Ve miela miami ikwenda baki).*[3] Fu-Kiau Bunseki, a leading native authority on Kongo culture, explains: "Someone who is very old, I go to sit with him, in order to feel his *lu-fuki*, meaning, I would like to be blessed

by him." For in Kongo the smell of a hardworking elder carries luck.[4] This Kongo sign of exertion is identified with the positive energy of a person. Hence "funk" in black American jazz parlance can mean earthiness, a return to fundamentals.

In the black American metaphysical traditions of conjuring and healing with herbs and roots, there are words and phrases that cannot readily be traced to European origins. One of the most important words in black United States conjure-work, "goofer," refers to grave dirt, often inserted in a charm. In Kongo territory, earth from a grave is considered at one with the spirit of the buried person. "Goofer dust" harks back to the Ki-Kongo verb *kufwa* ("to die"). Another important word in the lexicon of the charm makers is toby. A toby is a good-luck charm. In form and function it almost certainly derives from the *tobe* charms of Kongo. The original charm was "made up of a mixture of earth from a grave plus palm wine, and is believed to bring good luck."[5]

More important than the impact of Ki-Kongo on the languages of blacks throughout the Americas, though, is the influence of Kongo civilization on their philosophic and visual traditions. Aspects of Kongo culture retained by blacks enslaved in the Americas inspired these men and women to come together as brothers and sisters in Kongo-American societies virtually devoted to the very idea of being Kongo.[6] At the turn of the century in Montevideo, Uruguay, the outwardly festive look of a Kongo dance society could conceal, as Vicente Rossi observed in a study of the origins of the tango, *Cosas de Negros* (1926), a serious reaffirmation of autonomy:

> There is something there, in the middle of the circle of black men, something that they alone see, feel, and comprehend . . . the voice of native soil, a flag unfurled in harmonic syllables.
> There is something there, in the middle of the dancing ring of black men and it is the motherland! Fleeting seconds of liberty have evoked it, and, once brought into being, it fortifies their broken spirits. . . . they have, forgetting themselves, relived the [Kongo] nation in one of its typical expressions . . . in sudden homage, with an expanded power of observation . . . they dance around the vision.[7]

So powerful an act of cultural recollection would have inevitably reminded some black Montevidean elders born in Kongo of the grandeur of Mbanza Kongo, the ancient ideal capital, heart of the ancient kingdom, where "all were born, each clan still has its street

and each one has relatives to receive him."[8] For the Bakongo envisioned their capital as an ideal, noble place where "a strong chief, supernaturally inspired, assures every citizen his due."[9] Mbanza Kongo was sited at the top of a hill, and its location reflects a vision of the cosmos deeply ingrained in the Kongo mind:

> The N'Kongo [i.e., an inhabitant of the capital of Kongo] thought of the earth as a mountain over a body of water which is the land of the dead, called Mpemba. In Mpemba the sun rises and sets just as it does in the land of the living . . . the water is both a passage and a great barrier. The world, in Kongo thought, is like two mountains opposed at their bases and separated by the ocean.
>
> At the rising and setting of the sun the living and the dead exchange day and night. The setting of the sun signifies man's death and its rising, his rebirth, or the continuity of his life. Bakongo believe and hold it true that man's life has no end, that it constitutes a cycle, and death is merely a transition in the process of change.[10]

The Bakongo symbolized the daily journey of the sun around the mirrored worlds of the living and the dead by means of the spiral shape of the *kodya* shell. They also expressed the same idea, architecturally, with the concentric spaces of the royal enclosure *(luumbu)*. A newly elected king would make a circular tour of his domain, symbolically passing through the worlds of the living and the dead, thereby acquiring mystic insights proper only to a Kongo king.[11]

In 1960, while most Western journalists were writing copy about the "Congo crisis," Bakongo women were styling their hair in splendid concentric, spiral patterns to celebrate the restoration of black rule and the circularity of the royal enclosure of the ancient ideal capital. Thus the women of Kongo had both invoked the greatness of Mbanza Kongo and communicated their hope that Kasa-Vubu's tour of the country had given him mystic power.[12]

The Bakongo viewed their capital as an ideal realm in which images of centering prevailed. It was a world profoundly informed by a cosmogram—an ideal balancing of the vitality of the world of the living with the visionariness of the world of the dead. Charms and medicines were constantly produced in the search for the realization of a perfect vision in the less than perfect world of the living. It is true that, unlike the Yoruba, the Bakongo lack a complex

Flash of the Spirit

pantheon of deities, but they have, instead, a complex system of *minkisi* ("sacred medicines"), which they believe were given to mankind by God. The religion of Kongo presupposes God Almighty *(Nzambi Mpungu)*, whose illuminating spirit and healing powers are carefully controlled by the king *(mfumu)*, the ritual expert or authority *(nganga)*, and the sorcerer *(ndoki)*.

The king had the power to execute convicted felons and enemies of the state. As supreme authority, he was expected to live decorously, to embody impartiality.[13] The ritual experts, or *banganga* (plural of *nganga*), were various. Some healed with charms—these were *banganga nkisi*. Others healed with roots and herbs and were called *banganga mbuki*. Still others, *banganga ngombo*, ministered to the needs of clients by means of divination. Some, the *banganga simbi*, worshipped powerful and mysterious spirits *(bisimbi)*, "the highest class of the dead," immortal beings who, because of their good works, are believed to be blessed with the power to resist the organic process. Others who were "chosen" were transformed, during initiation, from recovered patients to practicing herbalists, and became members of the healing society of Lemba, a band of healers in existence since the 1660's.[14]

Now the king and the ritual experts controlled mystic powers for the common good. By contrast, the *ndoki,* or sorcerer, was a caricature of the individualist who, lacking social conscience, bases his security upon the insecurity of others. The belief in the existence of evil, in witchcraft—in utterly selfish action devoid of mercy—remains alive in Kongo. Dialectically, it strengthens the need for the wisdom of the ancestors and the elders who know the necessary antidotes. Not all bad luck or deliberate evil, however, was effected by witches. Offended ancestors could also intervene powerfully in the affairs of the living. Again, in such instances Bakongo turned to ritual authorities for guidance.

Versions of some of the ritual authorities responsible for Kongo herbalistic healing and divination appeared in the Americas and served as avatars of Kongo and Angola lore in the New World. Kongo ritual experts in Cuba took the appropriate ancient name *banganga;* those in the United States were known largely as "conjurors" and "root-persons"; and others in Brazil were called *pae de santo* and *mae de santo,* names apparently originating in Yoruba worship—*babalorisha* and *iyalorisha,* "father of the saint" and "mother of the saint." These ritual authorities were largely responsi-

ble for the dissemination of Kongo religious and artistic culture throughout the New World.[15]

The influences of and improvisations upon Kongo art and religion in the western hemisphere are most readily discernible in four major forms of expression: cosmograms marked on the ground for purposes of initiation and mediation of spiritual power between worlds; the sacred Kongo medicines, or *minkisi;* the use of graves of the recently deceased as charms of ancestral vigilance and spiritual return; and the related supernatural uses of trees, staffs, branches, and roots.

Tendwa Nzá Kongo: The Kongo Cosmogram

Wyatt MacGaffey, a scholar of Kongo civilization and religion, has summarized the form and meaning of the essential Kongo cosmogram as follows:

> The simplest ritual space is a Greek cross [+] marked on the ground, as for oath-taking. One line represents the boundary; the other is ambivalently both the path leading across the boundary, as to the cemetery; *and* the vertical path of power linking "the above" with "the below." This relationship, in turn, is polyvalent, since it refers to God and man, God and the dead, and the living and the dead. The person taking the oath stands upon the cross, situating himself between life and death, and invokes the judgement of God and the dead upon himself.[16]

This is the simplest manifestation of the Kongo cruciform, a sacred "point" on which a person stands to make an oath, on the ground of the dead and under all-seeing God. This Kongo "sign of the cross" has nothing to do with the crucifixion of the Son of God, yet its meaning overlaps the Christian vision. Traditional Bakongo believed in a Supreme Deity, Nzambi Mpungu, and they had their own notions of the indestructibility of the soul: "Bakongo believe and hold it true that man's life has no end, that it constitutes a cycle. The sun, in its rising and setting, is a sign of this cycle, and death is merely a transition in the process of change."[17] The Kongo *yowa* cross does not signify the crucifixion of Jesus for the salvation of mankind; it signifies the equally compelling vision of the circular motion of human souls about the circumference of its intersecting lines. The Kongo cross refers therefore to the everlasting continuity of *all* righteous men and women:

Flash of the Spirit

Nzungi! n'zungi-nzila Man turns in the path,
N'zungi! n'zungi-nzila He merely turns in the path;
Banganga ban'e E ee! The priests, the same.[18]

A fork in the road (or even a forked branch) can allude to this crucially important symbol of passage and communication between worlds. The "turn in the path," i.e., the crossroads, remains an indelible concept in the Kongo-Atlantic world, as the point of intersection between the ancestors and the living.

Here is one precise version of the *yowa* cross:[19]

Yowa:
the Kongo sign of cosmos
and the continuity
of human life

The horizontal line divides the mountain of the living world from its mirrored counterpart in the kingdom of the dead. The mountain of the living is described as "earth" *(ntoto)*. The mountain of the dead is called "white clay" *(mpemba)*. The bottom half of the Kongo cosmogram was also called *kalunga*, referring, literally, to the world of the dead as complete *(lunga)* within itself and to the wholeness that comes to a person who understands the ways and powers of both worlds.[20]

Initiates read the cosmogram correctly, respecting its allusiveness. God is imagined at the top, the dead at the bottom, and water in between. The four disks at the points of the cross stand for the four moments of the sun, and the circumference of the cross the certainty of reincarnation: the especially righteous Kongo person will never be destroyed but will come back in the name or body of progeny, or in the form of an everlasting pool, waterfall, stone, or mountain.

The summit of the pattern symbolizes not only noon but also maleness, north, and the peak of a person's strength on earth. Correspondingly, the bottom equals midnight, femaleness, south, the highest point of a person's otherworldly strength.

Members of the Lemba society of healers had initiates stand on a cross chalked on the ground, a variant of the cosmogram. "To stand upon this sign," Fu-Kiau Bunseki tells us, "meant that a person was fully capable of governing people, that he knew the nature of the world, that he had mastered the meaning of life and death." He

thenceforth could move about with the confidence of a seer, empowered with insights from both worlds, both halves of the cosmogram.[21]

Drawing a "point," invoking God and the ancestors, formed only a part of this most important Kongo ritual of mediation. The ritual also included "singing the point." In fact, the Bakongo summarize the full context of mediation with the phrase "singing and drawing [a point]," yimbila ye sona. [22] They believe that the combined force of singing Ki-Kongo words and tracing in appropriate media the ritually designated "point" or "mark" of contact between the worlds will result in the descent of God's power upon that very point:

sikulu dya nene	A mighty noise
dyakulumukina	causing to descend
Na Nzambi a Mpungu	Lord God Almighty[23]

The cosmogram of Kongo emerged in the Americas precisely as singing and drawing points of contact between worlds. On the island of Cuba, when Kongo ritual leaders wished to make the important Zarabanda charm (Ki-Kongo: nsala-banda, a charm-making kind of cloth), they began by tracing, in white chalk, a cruciform pattern at the bottom of an iron kettle. This was the "signature" (firma) of the spirit invoked by the charm. It clearly derived from the Kongo sign except that the sun disks were replaced by arrows, standing for the four winds of the universe.[24]

Signature of
Nkisi Sarabanda, western Cuba,
twentieth century.

One of the major functions of the cosmogram of Kongo, to validate a space on which to stand a person or a charm, remains in force in certain Afro-Cuban religious circles. Kongo-Cuban priests have said, "All spirits seat themselves on the center of the sign as the source of firmness."[25] Songs (mambos) are chanted, as in Kongo, to persuade this concentration of power upon the designated point. Kongo-Cuban priests activated old, important charms by singing-and-drawing a sacred point. They chanted sacred texts in Spanish

Flash of the Spirit

and creolized Ki-Kongo while lowering a charm from the ceiling of a shrine to a chalked sign drawn upon the floor:

> To bring down the bundle was a tedious and delicate operation. "[the bag] was attached to the ceiling, was enormous, and weighed a hell of a lot." Juan O'Farril clearly remembers all the songs that accompanied the descent of the sacred bundle. The latter, with his steward and godmother, swept the earth, singing, . . . until the ground was immaculate and ready to receive the sacred bundle. The priest asked for chalk *(mpemba)*, and traced the cross-within-the-circle "signature" at the precise point where the bag was to touch the ground.[26]

And all the while that this bag of medicine was coming down the priest was singing the *mambo*, the song to bring it down:

Mpati! mpati! mpati!	Power, power, power
Mpemba, simbi ko?	Kaolin is a simbi spirit, is it not?
Mpemba, simbi ko?	Kaolin is a simbi spirit, is it not?[27]

The song was a warning. It suggested that the charm was like lightning, descending in slow motion, a spirit, a *simbi*, a force that could not be touched or seen until the nganga had completely lowered it to its appropriate point of relevation.

There are numerous charm-connected cosmograms chalked on earth in Cuba, including one with pieces of silver placed at the ends of the axes of the cross to complete the ancient Kongo pattern:[28]

The development of mystic ground-drawings in Cuba parallels the development of Afro-Christian crosses, chalked on the floor as critical "points," among the Trinidad Shouters. Related ground-drawings for a Shaker "mourning" ritual on the island of St. Vincent, north of Trinidad in the Windward Islands, receive their basic structure from the cruciform, with disks at the end of each line and each design circumscribed. Within each St. Vincentian ground-drawing largely alphabetically derived ideographic signs float like sidereal dust—signs such as ⊤ for travel, or ⊹ for baptism, or ♌ for Jericho. A crisscross of spiritual signs of power and mediation is remarkable in this Afro-Caribbean calligraphic art, as instanced by a chalked design made for a St. Vincentian mourning ritual, published by Jeannette Henney in 1968:[29]

St. Vincentian
"mourning" ritual
ground-drawing

Black ritual leaders among the Shouters of Trinidad have also elaborated an art of spiritual mediation using ground-signs: geometric patterns filled with myriad mystic ciphers and notations. Consider a drawing documented in 1960 by George Simpson. It breaks the circular seal of Kongo-influenced ways of reaching spirit with graphic signs. Here the sequence of the shapes is virtually architectural, building to the climactic pattern of a star. Every element is filled with spiritual notations, miniature cosmograms, the numbers of certain Psalms, and ciphers received in trance:[30]

Trinidad ground-drawing.

Flash of the Spirit

The result is visual glossolalia, a galaxy of points, indicating spiritual encounter and enlightenment. As Jeannette Henney reveals, "each pointer [sign-maker] has a different alphabet." A woman working with the spirit on St. Vincent can "point souls,"[31] by means of chalking mystic signs upon the floor in a state of spiritual enlightenment. Her meanings will not be grasped by all. In these rituals involving ground-writing for the "pointing" of souls, on St. Vincent and among Trinidad Shouters, there is overlap with the Kongo ritual of "singing and marking a mystic point" (iyimbila ye sona), which is suggestive of a trace of Kongo influence, however mixed with Christian signs and concepts.

In Rio de Janeiro, where there was a heavy importation of Kongo and Angola slaves, we meet simple cruciforms, chalked on the floor of shrines and altars, that have become complex signs fusing diverse Kongo, Yoruba, Roman Catholic, and other references. These signs comprise the blazons of the spirits honored in Rio de Janeiro macumba, a mixture of Kongo, Yoruba, Dahomean, Roman Catholic, Native American, and Spiritualist allusions.

In Rio at the beginning of this century there were two main African "nations" with their characteristic worship: followers of the deities of the Yoruba in rites called candomblé and followers of largely Kongo and Angola medicines and spirits, called originally cabula but latterly macumba after absorption of further influences: "All that was needed to produce macumba as it exists today was the adoption, along with . . . Yoruba elements, of the caboclo [inland Native American] spirits, the Catholic saints, and the spiritists' dead."[32] The French spiritualism of Allen Kardec—whose Book of Mediums was widely read in Brazil—especially influenced macumba.

Macumba priests, in the beginning, invoked spirits through simple chalked designs drawn on the ground and called "marked points" (pontos riscados). Many reflected dual Kongo and Roman Catholic influences, and were essentially cosmograms drawn in the form of a Latin cross. Nevertheless, some are used in a Kongo manner to "center" consecrated water and other important liquids in vessels for spirits (Plate 66). The Afro-Brazilian term for these visual invocations of spirit, pontos cantados e pontos riscados, or "sung points and marked points," recalls the Kongo custom of simultaneously singing and marking the centering of spirit (iyimbila ye sona).

As time passes, the ancient cruciforms are complicated by aspects

PLATE 66

borrowed from the iconography of the Yoruba and enriched by the attributes of Roman Catholic saints identified with Yoruba deities. Even Satan was identified with a Yoruba deity, Eshu, to challenge goodness creatively. Thus the "signatures" of Eshu, associated with the crossroads, sudden changes of fortune, and "devilish," that is, unpredictable, behavior, are circular blazons in which Satan's pitchfork, a pinwheel sign of sudden change and motion, a crossroadslike sign, and additional mystic points are recombined:[33]

Ponto Eshu Vira-Mundo *Ponto Eshu Vira-Mundo* *Ponto Eshu Tranca-Gira*

And then interpreted imaginatively: "When Eshu's trident is up, the work is for the good; upside down, the work is for evil."[34]

Kongo "points" can at once invoke Almighty God and call upon the noble dead. But Rio macumba "points" summon a bewildering multitude of Yoruba goddesses and gods and their matching saints, plus Amerindian spirits, plus departed black elders *(paes velhos),* who return in the voice and body of their devotees. More than a

114 Flash of the Spirit

hundred spirits are invoked today in Rio through the use of such signs.[35]

Most *pontos riscados*, traced in chalk on shrine floors or in sand on the beaches at Ipanema, Copacabana, and elsewhere in Rio, became fleeting signs of spiritual invocation and encounter. But some were permanently rendered. The collections of the Rio Museu de Polícia include a calabash drinking cup (Plate 67), richly lacquered black, which is incised with the *ponto riscado* of Pai Velho, a black Kongo ancestor of special power and insight.[36] His *ponto* warns the world that no one except a person in his spirit, or an appropriate officiant, can use this cup. The *ponto*, essentially a Latin cross within a Star of David within a circle decorated with six minor stars, compares interestingly with the "sung point" for the same spirit:

> He is swung in a circle (is initiated)
> Ancient Father, sovereign one
> Dark stone coming down
> He turns, Great God Almighty-Oduduwa
> Ancient Father, sovereign one
> Dark stone, falling, coming down.[37]

The descent of a meteorite, the spirit of Pai Velho, recalls the lore of Kongo where shooting stars have been interpreted as spirits darting across the sky.[38] The song provides a context for the stars that surround and decorate the cross or cosmogram of Pai Velho.

Plate 67

PLATE 68

There is a superb *ponto riscado* for Ogún/St. George, also in the Rio Police Museum, rendered in scarlet thread on a lime green sash of silk (Plate 68) worn with a mirroring sash on which appears the Roman Catholic signature of the same fusion-deity. Representing Ogún's roads, lines radiate from the center of this cosmogram. They are also crossroads, the element of Eshu—hence, perhaps, the cryptic pitchforks at the termini of three indicated axes.[39] This rich sign on silk captures a complex history of cultural contact and experience in a form of geometric thought. The blending has carried us far indeed from Kongo and from the kingdoms of the Yoruba, but without their encounter in the richest minds of Rio this sign might never have been invented.

Minkisi

The cosmograms of Kongo also reappeared in the Americas in the form of the *nkisi*-charm. An *nkisi* (plural: *minkisi*) is a strategic object in black Atlantic art, said to effect healing and other phenomena. Nsemi Isaki, himself a Mu-Kongo, wrote c. 1900:

> The first *nkisi*, called Funza, originated in God, and Funza came with a great number of *minkisi* which he distributed throughout the country, each with its respective powers, governing over its particular domain.[40]

He defined *nkisi* as

> the name of the thing we use to help a person when that person is sick and from which we obtain health; the name refers to leaves and medicines combined together. . . . It is also called *nkisi* because there is one to protect the human soul and guard it against illness for whoever is sick and wishes to be healed. Thus an *nkisi* is also something which hunts down illness and chases it away from the body.
>
> An *nkisi* is also a chosen companion, in whom all people find confidence. It is a hiding place for people's souls, to keep and compose in order to preserve life.[41]

The belief in an inner spark of divinity or soul within the *nkisi* leads the Bakongo to suppose that the *nkisi* is alive:

> The *nkisi* has life; if it had not, how could it heal and help people? But the life of an *nkisi* is different from the life in people. It is such that one can damage its flesh *(koma mbizi)*, burn it, break it, or throw it away; but it will not bleed or cry out . . . *nkisi* has an inextinguishable life coming from a source.[42]

Minkisi containers are various: leaves, shells, packets, sachets, bags, ceramic vessels, wooden images, statuettes, cloth bundles, among other objects. Each *nkisi* contains medicines *(bilongo)* and a soul *(mooyo)*, combined to give it life and power. The medicines themselves are spirit-embodying and spirit-directing.

Spirit-*embodying* materials include cemetery earth—considered at one with the spirit of a buried person—or equivalents such as white clay *(mpemba)*, taken from riverbeds, or powdered camwood, the reddish color of which traditionally signals transition and mediation to Bakongo. Spirit-embodying materials are usually wrapped or concealed in a charm, but such objects as mirrors or pieces of porce-

lain attached to the exterior of the *nkisi* may also signify power—the flash and arrest of the spirit.

The vital spark or soul within the spirit-embodying medicine may be, according to the Bakongo, an ancestor come back from the dead to serve the owner of the charm, or a victim of witchcraft, captured in the charm by its owner and forced to do his bidding for the good of the community (if the owner is generous and responsible) or for selfish ends (if he is not).[43]

Spirit-*directing* medicines instruct the spirit in the *nkisi*—by way of puns and symbols—how to hunt down evil or, say, make a person more decisive in daily affairs. Seeds, stones, herbs, or sticks represent action as aspiration. The spiritual commandments of certain medicines are the prerogatives of the head of a clan. Therefore, some significant *minkisi* bear major Kongo clan names such as Nsumbu and Mbenza.

Nkisi Nkita Nsumbu exemplifies the outward simplicity and inner complexity of Kongo charms.[44] It is a somewhat heavy bag of folded raffia cloth, tied at the neck with a cord. Double *kunda* wooden bells tied to the neck of the charm suggest its inner powers, as *kunda* are believed to activate medicines and drive out specters. When *Nkita Nsumbu* is unwrapped (Plate 69), revealing its medicines, it is like looking through clear water at the pebble-strewn bottom of a river.

The medicines are embedded in whitish kaolin. The gleaming whiteness of the bottom of the charm, beneath the seeds and pieces of crystal and stones and other things, suggests the lower half of the Kongo cosmogram. *Nkita Nsumbu* is extraordinary for its large quantity of rock crystals, perhaps because as the Bakongo explained to Karl Laman at the turn of the century: "*Nkita* throws stones at the sick person."[45] The righteous purpose of the charm —to protect a person from diseases of the skin, which, according to the Bakongo, are caused by supernatural knives and needles thrown at him—may account for the presence of the blade of a knife among the assembled "medicines." Puns on assuagement and healing may lie concealed in the syllables of the the Ki-Kongo words for the beans, plant buds, and various kernels that rest upon the whitish river clay.

The square-shaped black stone with a concave center near the top of the illustrated center of the charm is used to pulverize kaolin to make a paste that is applied around the eyes of a ritual expert, granting him mystic vision. The foot of a hen and other claws

PLATE 69

suggest the captivating power of the spirit in the charm. A pear-shaped seed called *kiyaala-mooko* ("who holds out hands") is probably included because of its resemblance to the image of two cupped palms joined and extended in a gesture of generosity. According to a Kongo proverb, "he who holds out his hands does not die" *(kiyaala-mooko kufwa ko).* Finally, the gleaming white egg near the center of the photograph, according to Fu-Kiau, "is a symbol of danger, the kind of egg used by Kongo sorcerers to conjure up tornadoes and to bring down thunder."[46] Mystically stoning the immoral with diseases of the skin, protecting the righteous, and creating storms and other natural phenomena, Nkisi *Nsumbu* is believed to represent the world in miniature.

Other Kongo charms are informed by this metaphor of cosmos miniaturized, such as *Nkisi Mbumba Mbondo,* which protects persons from swellings of the body or inflicts such illnesses on deserving criminals or enemies. The container of this *nkisi* is European cotton

PLATE 70

covered with thick red camwood impasto (Plate 70). White buttons of porcelain and glass are sewn on the charm for glitter. A braided raffia string has been crisscrossed around the bottom and wound tightly at the top to suggest the arrest of spirit. Around the top, which resembles a neck, is a necklace of five strands of green, blue,

and white glass beads. This Tervüren Museum charm is capped by resin, in which feathers have been inserted in the manner of certain feathered headdresses worn by important chiefs and priests in Kongo. Feathers in Kongo connote ceaseless growth as well as plenitude. So if the earth within the charm affirms the presence of a spirit from the dead—from the underworld—feathers capping the charm suggest connection with the upper half of the Kongo cosmogram which represents the world of the living, and the empyrean habitat of God.

The mediating function of *minkisi* is dramatically represented by charms carved in the shape of a dog. In Kongo these are sometimes Janus-like, staring in opposite directions, emphasizing their roles as seers extraordinaire. According to the Bakongo, "between the village of the living and the village of the dead there is a village of dogs."[47] Fu-Kiau extends the metaphor: "Mirror *(talatala)* and dog *(mbwa)* symbolize the same thing among Bakongo."[48] Thus a dog or doglike *nkisi* is often used by Kongo mystics to see beyond our world.

In Kongo mythology, Ne Kongo himself, the progenitor of the kingdom, prepared the primordial medicines in an earthenware pot set on three stones above a fire. Clay pots have therefore always been classical containers of *minkisi*. The Royal Museum of Central Africa in Tervüren, Belgium, has a collection of pottery-*minkisi*, including one smeared with white clay to represent the other world, and another covered with a mirror to symbolize the water between the realms of the living and the dead. These vessels are filled with spirit-embodying earths and spirit-directing stones and shells.

Kongo-inspired *nkisi* vessels and bundles were profuse in western Cuba in the nineteenth century. Many *minkisi* produced in Cuba and in Afro-Cuban barrios of the United States today—especially those in Miami and New York—are contained by large three-legged iron cooking pots. Afro-Cubans call such *nkisi* vessels *prendas* (pawns), reflecting the ritual obligations shared by the owner of the charm and the spirit within. Here is a Cuban *nganga* composing his *prenda*, re-creating the Kongo cosmos in miniature:

First one draws a cross, in chalk or white ashes, at the bottom of the kettle. The kettle must be new. One places over this sign five Spanish silver reales, one at the center, the others at each end

of the cross . . . one places to the side a piece of sugarcane filled
with sea water, sand and mercury, stoppered with wax, so that the
nkisi will always have life, like the flow of quicksilver, so that it
will be swift and moving, like the waters of the ocean, so that the
spirit in the charm can merge with the sea and travel far away.

The body of a black male dog may be included to grant the
charm the sharp sense of smell associated with that animal
. . . on top of these objects is poured earth from an ant-heap and
small pieces of wood. Sticks [from some twenty-seven species of
trees] are placed around and leaves and herbs also added . . . After
completion of this level, one throws over it chili, pepper, garlic,
ginger, white onion, cinnamon, a piece of rue, pine seed. The
work is completed by the addition of the skull of a woodpecker
or buzzard.[49]

This charm is informed by the structure of the sign of the four
moments of the sun. And in it are commingled objects associated
with flight, through quicksilver, and avatars of earth and sea. Makers

PLATE 71

Flash of the Spirit

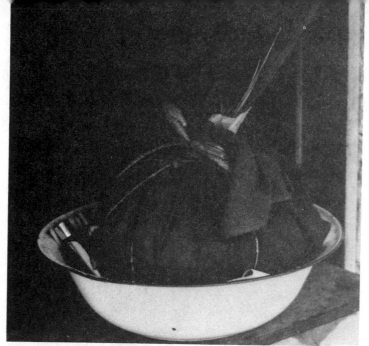

of important Afro-Cuban *prendas* knew exactly what they meant by
the ingredients they used:

> The *prenda* is like the entire world in miniature, a means of
> domination. The ritual expert places in the kettle all manner of
> spiritualizing forces: there he keeps the cemetery and the forest,
> there he keeps the river and the sea, the lightning-bolt, the
> whirlwind, the sun, the moon, the stars—forces in concentra-
> tion.[50]

One of the most celebrated and feared of all the *minkisi* of Cuba
was inherited by J. S. Baró, a black ritual expert who lived in Maria-
nao, a suburb of Havana. It was an *nkisi*-kettle (Plate 71), probably
originally made by his ancestors in the second half of the nineteenth
century and replenished several times in the twentieth.[51] Baró's
nkisi bears a deliberately long and impressive name: Tree-of-the-
Forest-Seven-Bells-Turns-the-World-Round-the-Midnight-Ceme-
tery—a name replete with cosmological allusion. Its ascending struc-
tural sequence—round container, encircling sash, luxurious spray of
plumes—mirrors that of *minkisi* forms still seen today in Kongo
(Plate 72). Tree-of-the-Forest-Seven-Bells contained bones and

The Sign of the Four Moments of the Sun 123

earths for the capture of spirit, and beads, and stones, and other matter to tell the spirit cryptically what to do. It was even believed to be enlivened by the "flash of the spirit," the glitter of a falling star, mystically absorbed, as in the case of another famous Cuban *prenda*, Seven Stars:

> They celebrate this prenda not in the house but in the forest.
> . . . the stars come down to this charm. There is an hour in the
> night when the nkisi is left by itself in the forest, so that the stars
> may come down, to enter into its power. When you see some-
> thing brilliantly coming down—it is a star, entering an nkisi.[52]

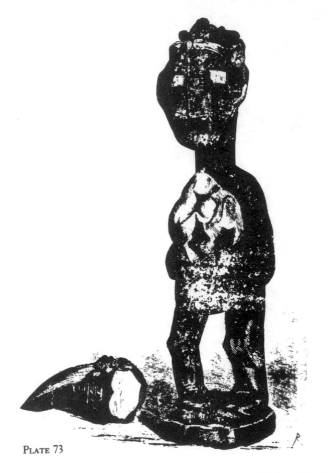

PLATE 73

Flash of the Spirit

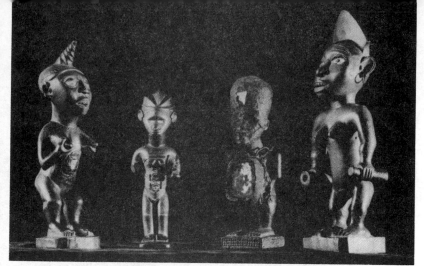

PLATE 74

In addition to *prendas*, Kongo-Cubans of the nineteenth century made *minkisi*-figurines to mystically attack slaveholders and other enemies, and for spiritual reconnaissance. Lydia Cabrera has described them: "magic doll-like figurines about 50 centimeters high, carved in wood . . . with magic substance inserted in a small cavity."[53] Among these figurines figured a so-called *matiabo* image, documented in 1875 (Plate 73).[54] It was strongly Kongo-influenced, and came equipped with horn *(mpoka)*. *Matiabo* were runaway slaves who sometimes joined forces with rebel forces in Cuba's nineteenth-century war of independence against Spain. They probably used such charms—even as human figurines mounted on antelope horns were used in Kongo—to expose sorcerers, heal the sick, and locate game (in Cuba the quarry was approaching Spanish soldiers).

As in many examples of classical Kongo sculpture (Plate 74), the knees of the *matiabo* image are bent, symbolizing vitality; the eyes sparkle with visionary glass; and medicine has been inserted at the abdomen and in the horn, the latter stoppered with a piece of mirror, again for mystic vision.[55]

In Haiti, Western Hispaniola, ingenious reformulations of *nkisi* charms, sometimes called *pacquets-congo*, rival Afro-Cuban charms in density and allusion.[56] The more elegant *pacquets* are wrapped in silk (Plate 75) instead of ancestral cotton (Plate 72) or raffia cloth; are tied with broad silk ribbons (secured with pins) instead of cord;

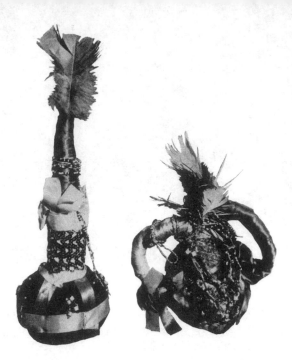

PLATE 75

are adorned with sequins as well as beads; and sometimes crowned with plumes made of metallic cloth instead of actual feathers. Two *pacquets-congo* made in 1979—one with a feathered stem called Simbi-of-the-Leaves *(simbi makaya);* the other, shorter, with arms akimbo called Queen-of-Kongo *(reine kongo)*—are the work of a *vodun* priestess and her entourage living on the western outskirts of Port-au-Prince, and represent visual creolization of traditional *nkisi* forms (Plates 75, 76). Just as the cruciform ground-signs of Kongo expanded to absorb the blazons and iconographic detail of a bewildering number of Yoruba and Dahomean deities in Brazilian *pontos*, so the persistence of a basic stem-on-globe-shaped-base structure, as evidenced by a comparison of *Nkisi Mbumba Mbondo* (Plate 70) in Kongo with an important kind of *pacquet-kongo* in Haiti called *Simbi Macaya* (Plate 75), cannot hide enormous amounts of creative change. The narrow cords, which bound up the spherical base of the charm in Kongo, have become in Haiti a rich interplay of broad silk ribbons, one of which, horizontal, emphasizes the girth of the charm, while the others, vertical, break up the sphere into armillary-

Flash of the Spirit

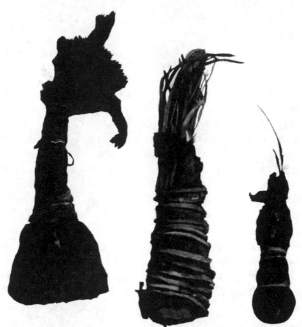

PLATE 76

Courtesy Tervüren Museum, Belgium

like aesthetic sections.[57] The binding of the charm with these rib-
bons, carefully secured with pins, emphasizes the capture of forces
guarding the households that own such charms.

The Kongo spirits of the dead, *bisimbi*, are believed in part to
preside over the making of *pacquets-congo* in Haiti.[58] A priest in
vodun told Alfred Métraux that *pacquets* were "guards," capable of
exciting and heating up the deities in favor of their owners. Deprived
of such "points," the deities lose their force. Haitian *pacquets*, like
prendas and *minkisi*, are therefore sometimes interpreted cosmo-
grammatically. They are "points," mediating protective grace be-
tween the living and the dead.

The strong Kongo-Angola influence on the people of Brazil ac-
counts for another *nkisi* tradition in the New World—Brazilian
charms for love and war. The *ponto de segurar* ("securing point")
was a small charm in a cloth container that was designed to arrest
a spirit or attract a person to its owner. The tight crisscrossing cords
—three along one axis, six or more along the other—decisively
represent the enclosure of spirit.

The Sign of the Four Moments of the Sun 127

Charm from black Rio:
ponto de segurar,
twentieth century, probably
made before 1941.

The form and function of *pontos de segurar* resemble those of miniature Haitian charms called *pwe* ("points"), and both types are analogous to the Kongo-Cuban *nkangue* charms. Cuban *banganga* make *nkangue* to "tie" a lover for a client, to keep that person from straying from the client's arms. *Nkangue* literally means "one who arrests" in Ki-Kongo, and, in the charm-making process, originally referred to the moment when the *nganga*—having chanted all incantations and completed filling and binding the charm—says, "I close the door," and the spirit is said to be arrested in the charm as in a tiny habitation (Plate 77). This Afro-Cuban diminutive object —only two inches long—contains a *carga* ("charge") of cemetery earth and powdered bones.[59] Around its carefully folded cloth container, string has been wound tightly. It compares with the symbolically tight binding of Kongo charms (Plate 76). Lydia Cabrera, an authority on the folklore of Cuba, maintains that Afro-Cuban *banganga* often tie *nkangue* with four or seven symbolic knots to suggest various sacred meanings. The shape, size, and binding elements of *nkangue* are similar to those of *muselebende* love charms of Manianga in northern Kongo today. *Muselebende* literally means "to make like a leopard" *(kala nsele bende)*—"for the leopard is a very serious animal; so, when the soul of a lover is put into that charm, it takes the lover by force as does a leopard."[60]

Until very recently the United States was held to be virtually devoid of African-influenced visual traditions. Yet I have discovered

PLATE 77

Flash of the Spirit

that in black communities throughout the States there is a surprisingly strong *minsiki*-making tradition. Not that the heritage always came direct from Kongo and Angola. The well-known practice during slavery of "seasoning" blacks by residence on West Indian islands before bringing them to continental plantations meant that, in some instances at least, the Kongo *nkisi* tradition was probably already transformed before reaching the United States via Charleston, New Orleans, and other parts.[61]

The Kongo heritage is clearly evident in the making of love charms in black American communities—charms whose purpose is to bring back errant lovers. And to the degree that they involve the folding in and tying up of a name, they recall Afro-Brazilian *pontos de segurar*, Afro-Haitian *pwe*, and Afro-Cuban *nkangue*. Robert Bryant, a black from New Orleans, describes the making of an Afro-American love charm:

> Get a strip of red flannel about a foot long and three inches wide, together with nine new needles. Name the flannel after the absent person. . . . Fold the flannel three times *towards* yourself, so that half of it is folded, saying with each fold, "Come (fold) on (fold) home (fold). . . . Then turn the other end towards yourself and make three more folds: "Papa (fold) wants (fold) you (fold)." Then stick the nine needles in the shape of a cross, working each one toward yourself and sticking each three times through the fabric, saying with each shove such phrases as "Ma (stick) ry (stick) Smith (stick). Won't (stick) you (stick) come? (stick)[62]

Fu-Kiau glosses Robert Bryant's charm as follows:

> The whole action of folding cloth toward my body and inserting pins—this is exciting a girl toward me. This is a kind of *nkisi* which we use to bless or punish, wrapped up in a small sachet or cloth container called *futu*. It also sounds like *Nkisi Mpungu*, one of the more powerful *minkisi* known in Kongo, which you use when you want to make love with a person who doesn't really see you as a lover. You chant three times her name, three times your name. Each time you call her name, and each time call your name, you stick a pin into the charm. This has to be done very carefully, however, for there exists the danger that if one of the needles break, the lover may become deranged. Folding the cloth, to "tie," the lover or person in the charm is called *futika* (to hem, fold, bind, tie up) *nkisi va taba*, folding a part of the cloth that wraps up an *nkisi*. The entire action, folding and

sticking in a needle while calling a lover's name—all that process is called *siba ye kanga*, "calling and tying," taking her name, or his name if the charm is for a woman, and putting it in the object with the inserted needles *(zinongo)* and folding gestures. The *futu* (sachet) is like a house, and when I have completed the *siba ye kanga*, I "close the door." He can't go out, he's put inside the charm, he cannot act now by himself.[63]

Robert Bryant's charm is therefore very Kongo; it reaffirms the "point," verbally and materially renders it. Moreover, his practice strongly recalls the making of *n'kondi*, those famous Kongo statues bristling with half-inserted blades and pins and nails and wedges, each of which may represent a vow or legal agreement.

From nineteenth-century Missouri comes another Afro-American *nkisi*, which was believed to be informed by "the flash of the spirit," and which was supposed to bring its owner good luck:

A more complicated "luck ball" was one made for Charley Leland. This contained, briefly, four lengths of white yarn doubled four times (four is a "luck number"), four lengths of white sewing silk folded in the same way (to tie your friend to you, while the yarn ties down the devils) and with four knots tied to the whole. Four such knotted strands were used, giving sixteen knots in all. These skeins were made up into a nest, whiskey spit upon them to keep the devils from getting through the knots, and *into it was put tin-foil (representing the brightness of the spirit who was going to be inserted in the ball)* [emphasis added].[64]

Fu-Kiau glosses Charley Leland's charm:

The "Charley Leland luck ball" sounds like the kinds of *minkisi* we make in Kongo against powers or authorities, to sway these powers in our direction, helping us to find a job. Folding the cloth symbolizes "tying" the company or persons to your concern. If they say "come back and we will discuss your job in three days," you tie three knots on the charm, measuring the time, to aim the power of the charm, upon the person or company, with accuracy. If, in another instance, I wish to reply to a prospective employer in six days and I tie only four knots, the *nkisi* can have no effect. The knots *(makolo)* have incantations in them; their number records matters of time or space involved in the private affair of the owner of the charm, and they therefore constitute a kind of African ritual mathematical system. The folds, the knots, the insertions in this kind of charm excite the spirit, excite the patron or the lover in your favor.[65]

Flash of the Spirit

The Ki-Kongo verb "to fold" *(futika)* also means "to bind, to tie up in a packet," a double meaning that one may intuit in the Afro-Missourian charm, which was intended to bind the owner to his friends, arrest his enemies in their tracks, and enhance his luck.

Bakongo returning from Kinshasa to their villages consult, in many cases, *banganga* for charms such as Charley Leland's.

According to Kongo mythology, the very first *nkisi* given to man by God was Funza, distributor of all *minkisi,* himself incarnate in unusual twisted-root formations. So "when you see a twisted root within a charm," Fu-Kiau Bunseki comments, "you know, like a tornado hidden in an egg, that this *nkisi* is very, very strong—you cannot touch it; only *nganga* can touch it."[66] The association of twisted roots with enormous reserves of power persists in black America, where such charms are called "high" or "big."

The most famous Afro-American charm of this kind is High John the Conqueror, a gnarled and twisted root. If it has a long extension it is considered male; if its salient is short, it is considered female. In *Voodoo in New Orleans,* Robert Tallant writes: "Thousands of Negroes carry Johnny the Conqueror roots, not only in New Orleans, but all over the country, for quantities of them are sold in Harlem, in Chicago, in Atlanta and Charleston."[67] A man named Abner Thomas told Tallant that "for love and gambling the *power* of Johnny is considered supreme."[68] He added: "There is Big John and Little John. . . . High John is the same as Big John; that is the strongest."[69] So, not surprisingly, the blues of the Mississippi delta —an area not far from New Orleans—sometimes make cryptic references to Kongo-influenced charms:

> I got a black cat bone
> I got a mojo tooth
> I got John the Conqueroo
> I'm gonna mess with you
> "Hoochie Coochie Blues"[70]

Finally, there are anti-hex roots galore throughout black America today that are usually wrapped in red flannel, "so that nobody can put evil on you—if they do it will turn on *them.*" To the Bakongo these American charms appear to derive from *minkisi wambi* and *minkisi wa nsisi*—"danger *minkisi*"—which are contained in crimson cloth.

Nzo a Nkisi: The Grave

Nowhere is Kongo-Angola influence on the New World more pronounced, more profound, than in black traditional cemeteries throughout the South of the United States. The nature of the objects that decorate the graves there, as well as in places as diverse as Haiti and Guadeloupe in the West Indies, reveals a strong continuity. That continuity might be characterized as a reinstatement of the Kongo notion of the tomb as a charm for the persistence of the spirit. Recall the container of the Kongo charm or sacred medicine, charged with activating ingredients—a human soul, spirit-embodying and spirit-directing objects.

In the case of a burial site, the coffin and the mound are the obvious containers; the soul of the deceased is the spark. In addition to the tombstone or headstone, there are decorative objects that, both in Kongo (Plate 78) and the Americas (Plate 79), cryptically honor the spirit in the earth, guide it to the other world, and prevent it from wandering or returning to haunt survivors. In other words, the surface "decorations" frequently function as "medicines" of admonishment and love, and they mark a persistent cultural link between Kongo and the black New World.

Plate 78

Flash of the Spirit

PLATE 79

Both Kongo and Kongo-American tombs are frequently covered *with the last objects touched or used by the deceased.* Here is the Kongo rationale for this striking practice:

> Plates and cups and drinking-glasses are frequently selected for placement on the surface of a tomb. It is believed that *the last strength of a dead person is still present within that sort of object* . . . My own mother died while I was away. When I return to my village, and visit her grave, I shall touch her plate and cup. After I touch them, later I will dream . . . according to the way my mother wanted. By touching these objects automatically I comprehend the *mambu* (affairs, matters) my mother was willing to transmit to me.[71]

In black North America the last-used objects of the dead are also believed to be specially charged with emanations, traces of the spirit. One can chart the continuity of this belief from plantation times (1845–65)—"Negro graves were always decorated with the last article used by the departed"[72]—to St. Helena Island, Georgia, 1919, and Brownsville, Georgia, c. 1939: "They used to put the things a person *used last* on the grave. This was supposed to satisfy the spirit and keep it from following you back to the house."[73] The Kongo believe that the deposit of such objects safely grounds the spirit, keeping it from harming the living remains. The arrest of the spirit in last-used objects (*kanga mfunya*, literally, "tying up the emanations or effluvia of a person," or in another translation, "tying up the anger of the dead") directs the spirit in the tomb to rest in peace and honors its powers on earth.

A similarly spirit-directing "medicine" surmounts many tombs in Kongo and Kongo-influenced North America: the image of a white chicken *(nsusu mpembe).* In Kongo it is thought by some that the powers of "the white realm," the kaolin-tinted world of the dead, are released by the sacrifice of a white chicken. In fact, the placement of images of white chickens on Kongo graves symbolizes the presence of the dead within the honorific whiteness of their realm. Again an image both honors the dead and situates their spirit properly. Thus, a nineteenth-century drawing shows a hen carved in wood placed atop a funeral carriage in Kongo. (It was later laid to rest upon the surface of a tomb.)[74] No later than 1816 the custom had been noted in the Caribbean: "the white washing of tombs is repeated carefully every Christmas morning and formerly it was customary on these occasions to kill a white cock and sprinkle his

blood over the graves of the family."[75] And on Sapelo Island, off the coast of Georgia, in 1939, a source reported: "They kill a white chicken when they have set-ups to keep the spirits away."[76] Myriad pressed-glass chickens form *nsusu mpembe* surrogates on twentieth-century Carolina graves, and upon a modern tomb for a child in western South Carolina, dated 1967:

> an enormous white rooster guards the tomb, itself sparkling with a careful covering of white driveway gravel and enlivened with further living touches: a pair of miniature shoes in metal, and a small lamp for mystic illumination, like a night light for the bedroom of a child, who will wake up in glory and walk to God, in silver-colored shoes, feet crunching on glittering white gravel.[77]

Another mediating force on Kongo tombs is the seashell, believed to enclose the soul's immortal presence. Witness a Kongo prayer to the *mbamba* seashell:

> As strong as your house you shall keep my life for me. When you leave for the sea, take me along, that I may live forever with you.[78]

Kongo seashell imagery lingers lyrically in the words of Bessie Jones, a twentieth-century black artist of St. Simons Island, Georgia:

> The shells stand for the sea. The sea brought us, the sea shall take us back. So the shells upon our graves stand for water, the means of glory and the land of demise.[79]

Today the gleam of seashells illumines and identifies Kongo- and Angola-influenced graves from St. Louis, Missouri, through Algiers, across the Mississippi at New Orleans (Plate 80) to Jacksonville, Florida, and from the United States to Haiti (Plate 81) and Guadeloupe. In Guadeloupe the black custom is especially dramatic, with sometimes entire mounds covered over with large conch shells.[80] But nowhere is this Kongo-American custom more beautifully practiced than in the Carolina low country (Plate 82), where the tombs of both early twentieth-century men and women and black soldiers who perished in the tragic conflict in Vietnam are honored by this ancient Kongo emblem of perdurance. The contrast between such burials and Anglo-American tombs (Plate 83) is obvious and striking. In fact, the Kongo-inspired tradition, in further creolization, wherein a cover of gleaming white shells from the sea is replaced by

PLATE 80

PLATE 81

PLATE 82

PLATE 83

walls of gleaming white bathroom tile—correlated with purity and water—may explain, at least in part, the phenomenon that both modern Kongo and Haitian (Plate 84) cemeteries boast structures built in this striking medium.

Trees planted on graves also signify the spirit; their roots literally journey to the other world. Hence Kongo elders plant trees on graves

PLATE 84

PLATE 85

(Plate 78), explaining: "This tree is a sign of spirit, on its way to the other world."[81] The mooring of spirit with trees on graves appears in southern Haiti, where the rationale is phrased this way: "Trees live after us, death is not the end."[82] In the continental United States, at Hazelhurst, Mississippi, we learn that "at the funeral preachers are given a chance with their carefully composed sermons. It is then that the evergreen is planted on the grave. These trees are identified with the departed, and if the tree flourishes, all is well with the soul."[83] In other words, the tree stands sentinel above the grave as the immortal presence of the spirit, an image that graces countless Afro-American burials—for example, those in western South Carolina (Plate 79) or Dallas, Texas (Plate 85), where stone and tree represent together the departed person.

Among other Kongo influences on New World black burials are deposits of lamps to light the way to glory (evoking earlier Kongo bonfires lit on graves for this purpose); bottle-enclosed mounds (mirroring similarly represented miniature enclosures on Kongo tombs) to keep evil from the spirit and to prevent the latter's emanations from wandering back to the living; deposits of pipes of all kinds, representing voyage, through smoke or water, from this world to the next; and modern emblems of spiritual mediation, echoing the thought behind the addition of wheels upon a modern Kongo tomb (Plate 86); the rendering of an automobile in concrete, headlights invisibly blazing for eternity (Plate 87); or a toy metallic airplane, such as the one on a Carolina grave (Plate 88), meant to help the spirit to "get to heaven fast."[84]

The Sign of the Four Moments of the Sun 139

PLATE 86

PLATE 87

Plate 88

VURNARD
JACKSON
JAN. 7, 19
NOV. 1

Plate 89

A little-noted fact, taken for granted by casual observers, is that numerous Afro-American traditionally decorated graves are adorned with flowerpots, either *turned deliberately upside down* and embedded carefully in the soil or set right side up but adorned with green floral paper *turned deliberately inside out,* revealing the gleam of the inner tinfoil (Plate 89) in intimation of the flash of the departed spirit. Both traditions are gestures to the dead. The inversion of pierced white basins and other vessels is common in many Kongo cemeteries. Indeed, the verb "to be upside down" in Ki-Kongo also means "to die." Moreover, inversion signifies perdurance, as a visual pun on the superior strength of the ancestors, for the root of *bikinda,* "to be upside down, to be in the realm of the ancestors, to die" is *kinda,* "to be strong," "because those who are upside down, who die, are strongest."[85]

Bottle Trees

In addition to the massive reinstatement of Kongo and Angola traditions of grave decorations in the western hemisphere, there is a persistent Kongo-derived tradition of *bottle trees*—trees garlanded with bottles, vessels, and other objects for protecting the household through invocation of the dead. Our earliest reference to the custom, dated 1776, is from the coast of northern Kongo at Loango:

> All, after having cultivated their field, take care, in order to drive away sterility and the evil spells, to fix in the earth, in a certain manner, certain branches of certain trees, with some pieces of broken pots. They do more or less the same thing before their houses, when they must absent themselves during a considerable time. The most determined thief would not dare to cross their threshold, when he sees it thus protected by these mysterious signs.[86]

Just fifteen years later, in 1791, the coming of this custom to the black Americas had been detected on the island of Dominica in the West Indies. Thus Thomas Atwood marveled at the confidence of the blacks of the island

> in the power of the dead, of the sun and the moon . . . nay, even of sticks, stones, and earth from graves hung in bottles in their gardens.[87]

Flash of the Spirit

PLATE 90

Atwood was one of the first to note, without realizing the full cultural and historical implications of what he was observing, the rise of the creole tradition of the bottle tree. It flourishes today in the Caribbean—the Berbice area of Guyana,[88] in the Djuka (Suriname maroon) *kandu* tradition of tying bottles and other objects to trees to protect a house or property from thieves (Plate 90),[89] and on the island of Trinidad, where the custom has been enshrined in a short story by Samuel Selvon:

The Sign of the Four Moments of the Sun 143

Plate 91

> When the mango tree began to flower, Ma Procup tied colored
> bottles and animal bones to the trunk. . . . Roaming boys spotted
> the mangoes, hesitated when they saw the dangling bones and
> bottles. "Obeah," one of them muttered, "I not climbing that
> tree."[90]

It is, however, in the United States that most Kongo-derived bottle
trees are to be found—from the Sabine River area in eastern Texas
to the coast of South Carolina, with concentrations in Virginia,
southern Arkansas, northern Mississippi, and southeastern Alabama.
Eudora Welty has described a variety of them:

> a line of bare crepe-myrtle trees with every branch of them
> ending in a colored bottle, green or blue [Plate 91] there could
> be a spell put in the trees, and she was familiar from the time she
> was born with the way bottle trees keep evil spirits from coming
> into the house—by luring them inside the colored bottles, where
> they cannot get out again. . . . Solomon [a black man] has made
> the bottle trees with his own hands over the nine years . . .
> sometimes the sun in the bottle trees looked prettier than the
> house did.[91]

Today the function of similar expressions presiding over Kongo
graves (Plate 92) is the blocking of the disappearance of the talents
of the important dead. Lifting up their plates or bottles on trees or
saplings also means "not the end," "death will not end our fight,"

PLATE 92 PLATE 93

the renaissance of the talents of the dead that have been stopped, by gleaming glass and elevation, from absorption in the void.[92]

In Mississippi these trees (Plate 93), shorn of life, bearing cold, glittering bottles—visual statements, again, of death and arrest of the spirit—simply block or ward off evil. The custom compares with that in Texas, where "grave glass will keep the 'evil spirits away' or 'keep away the man's spirit.' "[93] In that sense Afro-American bottle trees are fugitive specters from a graveyard realm, just as bottle-lined burials are horizontal bottle trees.

The Sign of the Four Moments of the Sun 145

Courtesy Smithsonian Institution, Washington, D.C.

PLATE 94

Coda: Two Afro-American Artists

The same cultural forces that sparked the reemergence of the Kongo *nkisi* tradition in the New World may well account for the medium and the glitter of the late American artist James Hampton's *Throne of the Third Heaven of the Nations Millennium General Assembly* (Plate 94). *The Throne of the Third Heaven* represents a unique fusion of Biblical and Afro-American traditional imagery. Lynda Roscoe Hartigan has closely studied this amazing monument, a complex of a hundred and seventy-seven paired architectural pieces set about a central throne crowned with the legend FEAR NOT.[94] She argues inspiration from the Book of Revelation and she is right —therein the Son of Man says, "Fear not . . . fear none of those things which thou shalt suffer"; therein is described a throne set in heaven, with four and twenty seats about the throne; elders clothed in white and crowned in gold, beasts full of eyes and four of these with six wings full of eyes within. It is a vast and intimidating messianic vision. But the genius of James Hampton was to take and abstract these images—seated elders in white and gold, and wings with eyes—and fuse them with the throne itself. The winged furniture of another world therefore appears before our eyes, informed by flash and poetic flight.

Revelation did not tell James Hampton *how* to impart glitter to his sacred throne. For that he relied on Kongo-American modes of decoration, covering curved or spherical forms, light bulbs and jars of glass, and cast-off furniture with gold and silver foil. The selection of tinfoil, as the covering of the sacred, strikingly recalls the foil-wrapped flowerpots, glass jars, and coffee tins on graves in Louisiana,

Flash of the Spirit

Carolina, and Florida; the metallic cloth on *pacquet congo* in Haiti; the insertion of tinfoil to attract spirit into a charm; and many other sources.

Hampton was born in 1909 and reared in Elloree, South Carolina, in the heart of an area of strongly decorated Afro-American graves. As he made his sacred furnitures, c. 1950–64, in Washington, D.C., apparently for the founding of a religion he never lived to practice, his genius was to shape the images of Revelation as if they were vast receptacles of the spirit, wrapped in gold and silver tinfoil, for siting on a Carolina tomb and perpetually suggesting, in the sparkle, the attainment of God's glory.[95]

While James Hampton was piecing together his *Throne of Third Heaven*, Henry Dorsey, a stonemason of Brownsboro, Kentucky, was transforming the walls and reaches of his property with decorations of celebratory humor (Plate 95).[96] He fashioned a series of interlocking material puns on mediation and transcendence by recombining objects taken from their original industrial functions, thus giving them new meanings. He playfully related one kind of motion to another. His was a consciousness determined in part by knowledge of the structure of traditional Afro-American graves. Dorsey shaped his decorations as a gift, a proffered personal idiom of transcendence, fashioned out of plumbers' pipes and plastic dolls and wheels and doors and axles and pulleys and tires and even an upside-down agitator from a washing machine (Plate 96).

The pulsating metaphors of this playful universe were gathered in frequently climactic combinations, e.g., a man, under a wheel banner, who is forced to leap onto a horse through a giant hoop under a tiny wheel into a cabin with a doll over a door opening on a phantom booth (Plate 97). Or: a doll on a horse on a stafflike metal stem appears to gallop through the branches of a tree, with a stray tire, hung on other branches, as on a bottle tree. Henry Dorsey may never have heard of Mbanza Kongo or Loango—he did not have to. I suggest that he was their progeny by virtue of the culturally open and responsive spirit of his imagination.

When Henry Dorsey hoisted a liquor jug and fan blades (Plate 98), he was not only quoting, indirectly, the image of the bottle tree but adding new dimensions to the form to satisfy his restless mind and to entertain his neighbors. He was vaunting his control of the forces of motion in the modern world. Like the spectral pulleys,

PLATE 95

PLATE 96

PLATE 97

PLATE 98

wheels, and switches on a modern Kongo drum,[97] he brought together a liquor jug, the blades of an electric fan, and a metal disk to form a material constellation of objects divorced from their functions in the real world and given different meanings by his imagination. With such constructions he begged the questions "What does it *do?*" and "What does it *run* on?"

The sculptures ran on combinatory wit and humor, not on electricity (though, to be sure, toward the end of his career, Dorsey took the plunge into electrokinetic art, characteristically mastering fully the intricacies of electrical wiring). The operating currents were, in fact, traces of the theory of correspondences that shaped his mind. What his works did, as in Kongo when seed and claw were commingled in *minkisi,* was to send to spirits punning messages of positive execution. Dorsey, for example, devised a shining white metal hubcap with images of Jesus, Mary, and Joseph that whirled. The birth of Jesus, the expansion of Christianity throughout the world, were conjured up in the flash of moving chrome. Brilliant gyres in motion were to Henry Dorsey what winged silver thrones were to James Hampton, what mirror-embedded constructions were to black Georgians and the Bakongo.

Henry Dorsey was born the grandson of Maria Prewitt, one of the most famous black women of Oldham County, Kentucky, who lived for a hundred years.[98] She was born a slave in the early 1820's and died in 1924. Her second husband was Louis White, a black man. One of their children was Alice White, who married Clarence Dorsey, a black farmer of Brownsboro. Their son, Henry, was born in 1897.

In the summer of 1922, while Henry was working in the kitchen of a tearoom on Fourth Street, in Louisville, improper ventilation caused the room to overheat terribly. Dorsey fainted. When he regained consciousness in a hospital, he found himself well-nigh tone-deaf. As if to compensate for the nightmarish loss of one of his senses, Dorsey set off on an odyssey of escape and self-rediscovery.[99] He was twenty-five years old. He rode the rails, as a hobo, as far west as San Francisco. He worked his way south as a roustabout on a steamboat, down the Mississippi to New Orleans. From New Orleans he traveled east, working on the railroads of Mississippi and Alabama. He sometimes saw, in the segregated South of the 1920's, things cruel and horrible:

Flash of the Spirit

Henry, he saw a black man have a falling-out with the boss about something, and the boss take this man on the hand-car with him, killed him, and buried him near the railroad in the woods, and come back on the hand-car all alone. I'll tell you, he seen awful tough things in his travels.[100]

His travels through Louisiana, Alabama, and Mississippi took him through bottle-tree territory, past cemeteries gleaming with the traditional deposits, past black houses with automobile tire sculptures in their yards, past other fleeting images of artistic motion redistilled in the folk propensity to sing of bluesy strains of love and yearning. Such was the grief and joy of being black in the U.S. South in the 1920's. And then one day, just before the Great Depression, Dorsey came back home. He had trained in Brownsboro as a stonemason and, despite the Depression, "was lucky enough to have as much work as he could do."[101] Dorsey married Laura Johnson, a black woman, and lived in the house that his father had inherited from the Dorsey clan. Henry and Laura had four sons and two daughters. By 1956, approaching sixty and feeling his infirmities, he showed his brave and generous nature by countering his physical ailments with images suggesting important cheerful matters. These deliberately entertaining figurated constellations, in iron and plastic and other media from the industrial West, were to occupy him for the rest of his life. He died November 8, 1973. His wife, Laura, died soon thereafter. And the decorated house they lived in remained enigmatic to their neighbors. Few had walked around the house, seen it whole, put Dorsey's labors in cultural perspective.

It was out of an interaction of house and cemetery, clan and person, that the art of Henry Dorsey emerged. The key to his intent was a sign by his door that said, "You are welcome as the flowers of May" (a tag line Joyce himself used in *Ulysses:* "Alo! *Bonjour,* welcome as the flowers of May"[102]).

Dorsey taught us to master things rather than to complain about them, to subdue them with artistic weapons of humor and generosity. This is instanced by the care with which he traced the dates of the birth of his own children on a concrete tablet discreetly recessed into a wall on the chimney behind his house. (Plate 99). The tablet shows, for example (Plate 100), that his late son, Zack, was born on 29 May 1930, with the citations of the other children's initials and dates of birth. The *D* in the Dorsey of Zack's name is decorated with

PLATE 99

PLATE 100

a tiny commemorative white piece of shell; the *D* in the name of a surviving daughter, Costella A., is similarly embellished. The tablet attests to his historical consciousness. In the beginning he felt these things privately, behind his house, but then, c. 1956, he felt the need to counter his existential void with celebrations of names in a far more assertive and public manner. He began to decorate the front of his house for the entertainment of the world.

The decoration of his house with motifs of industrial detritus can be partially characterized as an idiosyncratic act, and partially as an appreciation of the sensibility implicit in the embellishment of graves with porcelain objects and of trees with bottles.

The evidence of Dorsey's contact with these traditions exists within his own county, at least with respect to burials; and his travels through black Mississippi and Alabama sharpened his consciousness forever and told him, visually, who he was and where he was coming from.

The old black families in Oldham County had buried their loved ones with china figurines, last-used cups and saucers, and other material representations of spirit. In 1967– 68, when the builders of Interstate Highway 71 sliced through one of the oldest black burial sites—the very cemetery in which Alice White Dorsey, mother of Henry, had been laid to rest—the tombs were moved. Guy Dorsey, a surviving brother, remembered: "When they come, they took up graves, took up dolls, plates, cups, china, all sorts of things. Put 'em in boxes 'n buried them with the bodies at Peewee Valley."[103] Eva Dorsey Williams, Henry's sister, added: "It broke my heart, for Mother to be moved that way."[104]

So Henry Dorsey knew all about black burials. He had buried his own father, Clarence Dorsey, and carved the latter's headstone (Plate 101) and dated it 1937. The design of this stone—sphere over sphere—provides us with a master icon.

The theme of mirrored circles informs one of his early motion-sculptures, dating from the 1950's (Plate 96). It is a tractor tire that has been transformed into a tondo, framing ice trays clustered about an upside-down washing-machine agitator to form a never-never propeller. The precision and intricacy of these interlocking metaphors of motion reveal a genius for parallel construction.

In the genial decoration of the ample grounds of Dorsey's house there were multiple hints—the suspension of metal plates on iron trees of pipe (Plate 98) and the making of a garden of hubcaps,

PLATE 101

suspended like metal zinnias on metal stems—that he had seen and was impressed by the flash of bottle trees in the South.

His charm reflected resistance to suffering, through visual contentments and splendidly humorous elaborations. This was made clear by his reaction to the rejection by his brothers and sisters of a headstone that he made in 1963 with his own hands for his late and beloved sister, Bernice. The other members of the family quietly purchased a commercially rendered granite marker and placed it on

her grave. Characteristically, Henry did not dwell on the hurt, did not destroy his headstone in a fit of meaningless pique. Instead he took the handcrafted headstone and set it up, in a corner of his yard, atop a boilerlike coffer of iron (Plate 102), a mock tomb anchored on his earth. He flanked this "grave" with an abstract silhouette of a locomotive—not unlike the isolated wheeled structure that haunts the funeral processionists of Clementine Hunter's c. 1948 painting, *The Funeral on Cane River.* [105] Dorsey's locomotive is half edifice, half vehicle, for it has only one wheel and is rooted to the ground with miniature supports.

PLATE 102

PLATE 103

A train beside a tomb leads us to a master metaphor: his house as spirit-train. The placing of tractor wheels at certain corners of his house and along the edges of his property implied that the earth itself was wheeled, could be mentally set in motion. Indeed he set his name in motion many times over in the decoration of his house's façade (Plate 103). He wrote his initials, "H.D.," in pierced green and yellow bleach bottles, threading them, like giant beads, on pipes. He placed this dazzling projection above another act of self-commemoration, a frieze proclaiming:

<div align="center">

Henry Dorsey

1956 PRODIGAL SON ALICE'S BOY

</div>

And then he set this above paired wheels. The point where the frieze is dated "1956" is marked with a cluster of seashells (Plate 104). The symbolic shells, lifted out of Afro-American funerary context, become doubly death-defying, a celebration *before* his death of the permanence of his name. PRODIGAL SON refers to his travels in the South, ALICE'S BOY to coming home. His life is unified and framed with shining shells. As his good-natured vision ripened, Dorsey advanced his art.

He mastered electrical work. Now he was working with actually moving pulleys, wheels, and wires. Now he was rendering explicit what was once implied. By this time, the late 1960's, writers had come to his door, attracted by the continuous notices of his work in the press of Louisville:

> He seems to have a complete understanding of the maze of electrical cords and fan-belts and bicycle-wheels-made-into-flywheels. He fashioned the thing out of empty space, defining it with cast-off icons. He built it and he certainly knows its music.[106]

He was painting metaphoric motion, an aspect of the black imagination that led James Hampton to fasten wings on every major portion of *The Throne of the Third Heaven,* that inspired black musicians

PLATE 104

The Sign of the Four Moments of the Sun 157

to add the sound of disappearing trains to complete an atmosphere of yearning in their blues. Hampton set the rubric FEAR NOT above his composition; Dorsey sited a smiling clown head, a figure of laughter and self-effacement, high within his series of motion-compositions, like a benediction.[107]

Dedicating himself to work that was play, to labor that was festive, displaying his art in a communal round, Dorsey rescued objects thrown away by persons trained to see only single functions in them, recycling them in a deeper sense (Plate 105).

My appreciation of Henry Dorsey and his art in this chapter on Kongo and Angola influence on New World art is a declaration of marvelous things to come, as black artists everywhere awaken to the implication of this current in Atlantic black art history. The tone of Dorsey's work, his concern with righteous mediation, reflects continuous contact with the *mambu* (matters) of the graveyard—one block down the street on which he lived. His ancestors had indicated ways of realizing spiritual transcendence through material metaphors. To the degree that he extended their insights he extended the Kongo Atlantic world.

The house of Henry Dorsey remains a secular *nzo a nkisi*, a charm for the denial of hurt, for the redirecting of spirit, to greet provocateurs with laughter and generosity, teaching us how to endure, how to bestow honor, even as the ancient Greeks taught their progeny to honor the gods, parents, and strangers.

Henry Dorsey discovered reflections of the Kongo *nkisi* tradition on his own. The man in touch with his origins, so the Bakongo say, is a man who will never die *(mu kala kintwadi ya tubu i mu zinga)*. Thus the house of Henry Dorsey stands, at the end, as an intimation of the meaning of existence in terms as the Bakongo might have phrased them: If you know where you are going, and where you are coming from, you can decorate the way to other worlds—the road to the ancestors and to God; and your name will merge forever with their glory.

PLATE 105

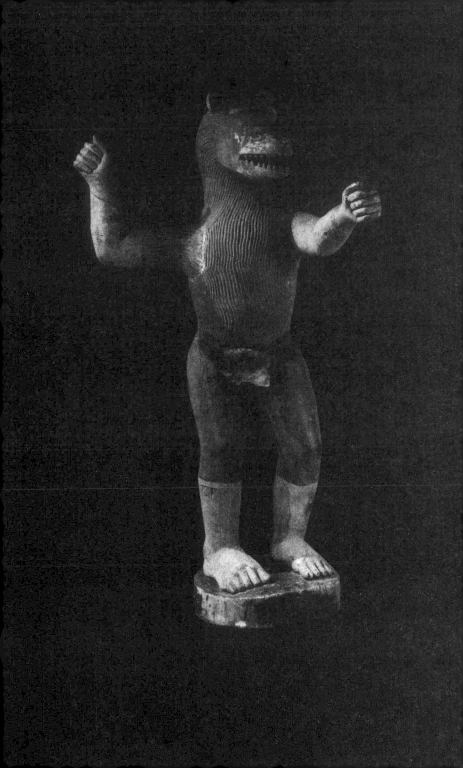

Three

THE RARA
OF THE UNIVERSE

Vodun Religion and
Art in Haiti

Voodoo, according to the *Oxford English Dictionary*, is "a body of superstitious beliefs and practices including sorcery, serpent worship and sacrificial rites, current among negroes and persons of negro blood in the West Indies and Southern United States, and ultimately of African origin." Superficially understood by Westerners since the eighteenth century, voodoo *(vodun)* has been reviled as abominable primitivism and vulgarized and exploited in countless racist books and films. *Vodun,* which was first elaborated in Haiti, however, is one of the signal achievements of people of African descent in the western hemisphere: a vibrant, sophisticated synthesis of the traditional religions of Dahomey, Yorubaland, and Kongo with an infusion of Roman Catholicism. What is more, *vodun* has inspired a remarkable tradition of sacred art.

France took formal possession of the western third of the Caribbean island of Hispaniola in 1697. Soon thereafter this part of the island—modern Haiti—developed a vigorous indigo and sugarcane plantation economy. Western Hispaniola, built on the backs of black slaves, became the most profitable French colonial possession in the world, necessitating an enormous increase in the importation of slaves. In 1697 there had been three Europeans to every African in western Hispaniola, but a hundred years later the proportion had radically changed: there were approximately eleven blacks to every white.[1]

The men and women of African descent who populated Haiti came primarily from Kongo and Angola, but also from Dahomey, Yorubaland, Bamana, and Mande territories in West Africa, with assortments of Igbo, too. As C. L. R. James remarks in *The Black Jacobins:*

> Two-thirds of the population of French San Domingo (at the commencement of the Haitian revolution in 1791) had made the Middle Passage. The whites had emigrated or been exterminated. The Mulattoes who were masters had their eyes fixed on Paris. Left to themselves, the Haitian peasantry resuscitated to a remarkable degree the lives they had lived in Africa. Their method of cultivation, their family relations and social practices, their drums, songs and music, such art as they practiced, and above all their religion which became famous, *Vodun*—all this was Africa in the West Indies.[2]

Actually, *vodun* was Africa *reblended.* The encounter of the classical religions of Kongo, Dahomey, and Yorubaland gave rise to a creole religion. This religion has two parts: one called *Rada*, after the slaving designation for persons abducted from Arada, on the coast of Dahomey, itself derived from the name of the holy city of the Dahomeans, Allada; and the other called *Petro-Lemba*, or simply *Petro*, after a messianic figure, Don Pedro, from the south peninsula of what is now Haiti, and the northern Kongo trading and healing society, Lemba.

Chiefly from Dahomey and western Yorubaland derived the *vodun* worship of a pantheon of gods and goddesses under one supreme Creator—deities who manifested themselves by possessing ("mounting") the bodies of their devotees. This aspect of *vodun* was reinforced by contact with French services for Roman Catholic saints who were said to work miracles. Chiefly from Kongo and Angola derived *vodun* beliefs in the transcendental moral powers of the dead and in the effectiveness of figurated charms for healing and righteous intimidation.[3]

Both *Rada* and *Petro* partake of these sources of African influence; neither is traceable to just one source. Both are at once African-inspired and indigenously created. *Rada*, predominantly Dahomean and Yoruba, is the "cool" side of *vodun*, being associated with the achievement of peace and reconciliation. *Petro*, predominantly Kongo, is the hot side, being associated with the spiritual fire of charms for healing and for attacking evil forces. The great Haitian

painter André Pierre, himself a *vodun* priest, has called *Rada* "civilian," *Petro* "military."[4]

It is important to stress, however, that the two fundamental *vodun* sections fused similar religious aspects of different African cultures. Thus, the "hot" sorcerous potentiality of an otherwise cool Yoruba riverain goddess was reassigned to the *Petro* side of deities. Correspondingly, the cool, creative Kongo *simbi* spirits were lifted from the realm of Kongo-inspired "attack" charms and reassigned to *Rada*, where their positive powers were akin to those of the gods and goddesses of Dahomey and Yorubaland.

Dahomey: A Distant Paradigm

The Dahomean kingdom once flourished in what is now the Benin Republic between Togo and Nigeria on the west coast of Africa. It lacked vast rivers and mountain ranges and therefore was accessible to Yoruba migrations from the east. From Tado, west of modern Abomey, the Adja branch of the ancient Yoruba migration from present-day Nigeria moved south. Around the fifteenth century, according to tradition, Aligbonon, the King of Tado's daughter, while seeking water in a forest, met and was made love to by a leopard spirit; the mystic union resulted in the birth of Prince Agasu, legendary ancestor of all the Fon of Dahomey, whose name is remembered in Haiti.[5]

Agasu's descendants founded the holy Dahomean city of Allada. About 1600 three of his sons contested the throne of the sacred town. The eldest won; the middle son took the throne of Ajase-Ipo (modern Porto Novo); and the youngest, Do-Aklin, trekked north and founded Abomey, capital of Dahomey.[6]

By 1700 the French had established a permanent slaving base on the Dahomean coast at Ouidah. The link connecting Dahomey and the West Indies, especially western Hispaniola, had been forged. The slave trade intensified the Dahomean warrior way of life. Quickly Abomey emerged from relative obscurity to become a major power in West Africa, with an efficient army, a stable cowrie-shell currency, a strong balance of trade, and firm control of political and social affairs.[7] Defense and economic welfare provided a rationale for military expansion. Abomey struck south, conquered Allada in 1724, and three years later reached the Atlantic Ocean, seizing the

trade in European firearms that flourished on the coast. Already Abomey had captured or was raiding Mahi, Savalu, Ketu, and the Anago Yoruba.

Paul Mercier underscores an important aspect of Dahomean cultural history—the transformation of the deities of immigrants and of conquered peoples into Dahomean spirits.[8] The cultures of the conquered—Mahi to the north, Ketu and Anago Yoruba to the east —were fairly close to the Dahomean way of life. Thus their gods and goddesses were assimilated by the Dahomeans.

However, the deities of the Yoruba had already made their presence felt in Dahomey over hundreds of years. Yoruba deities were served under different manifestations in Allada before 1659. Therefore, the Abomey conquests brought together Yoruba deities already transformed into Ewe and Fon local spirits, in addition to deities from Ketu and Anago Yoruba. The encounter of Ewe-Dahomean spirits with pure Yoruba *orisha* in Haiti produced still another synthesis of Yoruba-descended religious practices that, in the course of Dahomean history, had become separated from one another. Fusion and refusion of Yoruba spirits, first in Dahomey and then all over again in Haiti, go a long way toward explaining the phenomenon of multiple avatars of the same Dahomean-Yoruba god. It also helps explain the persistence of the concept of the *orisha* in the black New World.

The very Afro-Haitian term for spirit, *loa*, encapsulates the subtle nature of the syncretions that took place. In Abomey, deities are called *vodun* (mysteries); in Yoruba, diviner-herbalists are called *babalawo* (father-of-mysteries), a term creolized by Haitians into *papaloi* (the name for a *vodun* priest) through ingenious Afro-Gallic punning. The Haitian words for deity, *loa* or *mystère*, therefore appear to derive from the Yoruba *l'awo* for "mystery."[9] The interrelationships binding the gods of Dahomey to the Yoruba pantheon and both to the *loa* of Haiti are fascinating to behold:[10]

ENGLISH GLOSS	YORUBA NAME	FON NAME	HAITIAN NAME
God Almighty	Olorun	Mawu	Bondieu
Creativity God	Orishanla	Lisa	Lissa
Trickster	Eshu-Elegba	Legba	Papa Legba
Iron God	Ogún	Gū	Papa Ogún
Hunter God	Oshoosi	Age	—

Flash of the Spirit

ENGLISH GLOSS	YORUBA NAME	FON NAME	HAITIAN NAME
Smallpox God	Shapannan	Sakpata	Sabata
Thunder God	Shàngó	Hebiosso	Chango; Heviosso; so
River Goddess	Oshun	Aziri	Erzulie
Sea Goddess	Yemoja-Oboto	Oboto	—
Whirlwind	Oya	Avesan	—
Rainbow-Snake	Oshumare	Da Ayido Hwedo	Dambala-Ayida
Sacred Tree	Iroko	Loko	Papa Loko
Twins	Ibeji	Hohovi	Marassa
Herbalism	Osanyin	Aroni(?)	Ossange
Allada Founder	—	Agasu	Agasu
Ewe Sea God	—	Agbe (Hu)	Agoué
Ewe Market Goddess	—	Aizan	—
Ewe Sea Goddess	—	Avrekete	Aizan-Velekete
Ewe Sea Deity	—	Gede	Gede
Yoruba Farm God	Orisha Oko	Zaka	Zaka

Note that two Ewe-Fon deities merge into a single Haitian spirit, Aizan Velekete. Continuity by combination is a process that throws light on the apparent disappearance of Yemoja, Oya, and Oshoosi in Haiti. Their attributes may have been absorbed in iconographically similar cults.

With the coming of deities shared by Ewe, Fon, and Yoruba to Haiti, the stage was set for their involvement with the religions of Kongo and Roman Catholicism.

Dahomean Influences on Haitian Sacred Art

The Dahomean war deity Gū was destined to live momentously· in an alien land peopled primarily by persons brought from Kongo and Angola. On the Kongo-influenced side of *vodun* in Haiti, he became the *Petro* spirit Ogún-Bonfire, or Ogun-of-the-Blazing-Torch. Dahomeans know Gū as the personification of iron's cutting edge, which exists in the blade of a razor, in the slicing force of machetes, in the piercing jab of an iron-tipped spear.[11] Gū's own sword is represented by one of the monuments of Dahomean iron, the ceremonial blade called *gubasa* (Plate 106).[12] The image of the openwork disk of the sun relates this weapon to the sky. The master smith who fashioned

Plate 106

it in Abomey, probably in the late nineteenth century, attached to its side more than forty miniature iron implements—tiny swords, cutlasses, guns, arrows, hoes, hooks, lances. Arrows thrust out from the cutting edge, like myriad spitting vipers, intensifying the killing aura of the instrument.

A masterpiece of Dahomean brass-smithing (Plate 107) enlarges our comprehension of this dread power: an image of Gū, the iron god himself. This striking figure has been tentatively attributed by Abomey elders to a court brass-smith of Kings Ghezo and Glele, Azidji.[13] When this image arrived in Paris, near the end of the nineteenth century, it was still dressed in its complement of ritual garments (Plate 108), a brass hat for Age (the Dahomean god of the hunt), a cloak in Dahomean-made raffia cloth, a brass pendant and silver charm, and a loincloth of the kind Dahomeans and their Yoruba neighbors associate with forest cultivators, hence suggestive of brute forest energies.[14] The image brandishes with both hands the *gubasa*.

The bite of iron is matched by the snapping of a lion's jaws in another striking form of Dahomean visual praise (Plate 109). In this example, a lion rampant carved in wood, attributed to the great nineteenth-century court carver, Sosandande Likohin Kankanhau, monumentalizes Glele's famous praise name: "When the lion shows his pointed teeth, he terrifies the world."[15] Fragments of this visual lore of war were brought to Haiti by captives from the Dahomean region and fused in a new cult of the god of war. United with Ogún, the Yoruba god of iron, from whom Gū himself originally derived, Gū became Papa Ogún. Papa Ogún was, in turn, associated with the warrior saints of the Roman Catholic Church.

In Haiti, visual representations of the saints of the Roman Catholic Church were viewed with informed sympathy by the blacks. In such imagery they perceived—unbeknownst to the whites—ties to truths they already knew. They noted striking parallels in the lives and attributes of the saints, the *vodun* of Dahomey, and the *orisha* of Yorubaland.

The Church distributed among the slaves, who were forcibly baptized by law, inexpensive woodcuts and lithographs of the saints, demonstrating, didactically, their individual attributes. These were potent images indeed for minds informed by the visual cultures of Dahomean *vodun*, West Yoruba *orisha*, and Kongo *minkisi*. In the course of supposed Westernization, Haitians actually transformed

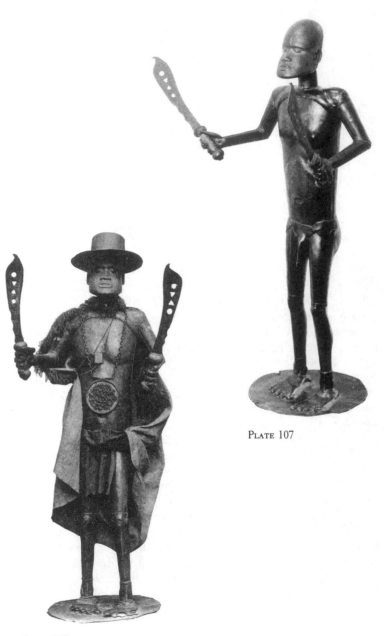

PLATE 107

PLATE 108

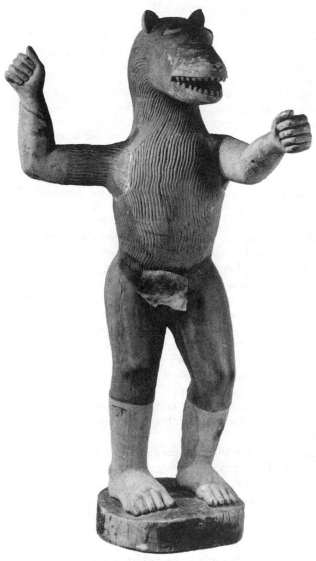

Plate 109

the meaning of the Catholic icons by observing their similarities to African spirits. Haitians restructured the identity of the saints of the Catholic Church in terms of their own religious language. Consider Saint James. Michel Leiris remarks:

> Because of a secondary figure, the picture of Saint James the Great [Plate 110] . . . will receive a double interpretation. The picture shows Saint James on horseback with sword and shield, fighting the Infidels, and escorted by a knight in armor, bearing a red standard with a white cross. All my informants agreed that the principal figure is the blacksmith and warrior god, *Ogun Ferraille* . . . (the essential attribute of which is a saber and, together with the other Ogun, the color red) but according to some, the figure in the background is *Ogun Badagri*, the brother of *Ogun Ferraille*, while others identify him rather as a *guede*, or graveyard spirit; this is because of the lowered visor of the helmet of the figure in question, which seems to recall the chin-cloth and other attributes of a corpse.[16]

The vision of *killing by iron* observed within the lithograph distinctly fits the martial paradigm of Dahomean Gū. And just as the *gubasa* is the central sign of war and smithing in Dahomey, so the *saber* became the chief icon of Ogún Ferraille in Haiti, in a new and wondrous context, often flanked by honorific banners, symmetrically displayed and inclined, as if nodding in honor of Lord Gū.

The shape of the shafts of the important flags that traditionally flank the sword of the saint in ground-paintings (and the sword of the master-of-ceremonies in *vodun* dancing) extend a little-noted accent of militaristic assertion. The flags' shafts reverse the S-curved saber's handguard; they are cryptic swords of cloth, following and flanking the lord of the cutting edge, even as a white cross on a field of red in the chromolithograph accompanied the warrior saint.[17]

In many instances, then, swords and flags are compared and the enlargement of the original meaning of *gubasa* has been effected by new visual influences of the iconography of Catholicism on the Afro-Haitian aesthetic.

When a person becomes possessed by the spirit of Papa Ogún Ferraille, an iron bar, standing in the earth near the altar dedicated to his name, is heated in a fire. The possessed person will then take this staff or some other equally heated bar and dance with it in his

PLATE 110

or her bare hands to prove that the possession is genuine. Deep
mastery of self is the point of the play with fire and heat.[18]

An artistic monument of Dahomey also involved with resistance
and self-restraint is the circular pendant (Plate 111) symbolizing
steadfastness, which the great brass figure of the iron god, now in

The Rara of the Universe 173

Plate 111

the Charles Ratton collection in Paris, once wore against his abdomen. It is a disk of brass to which a snarl of brass wire has been attached. Behanzin himself is supposed to have worn this pendant about his person to invoke the spirit of his father, King Glele. The pendant is a praise name of Glele materially rendered: *Togodo*, The-Circle-of-the-Earth (literally, "round thing") a word that connotes a deeper meaning, namely, that Glele, the king (the earth), resists, without moving, the hot, dry, northern winds.[19] The sphere is the earth, and the tangled skein of wire the winds—all of which glosses one of the strongest names for King Glele, "one knows not how to raise the earth aloft," i.e., the king is a force that can never be dislodged.[20] The resistance of earth to wind cosmologizes the king's collectedness of mind and steadfast sense of mission. Glele's intimidating presence promised peace and order. In the realm of

PLATE 112

PLATE 113

PLATE 114

zoology the same concept is conveyed by the image of a frog (Plate 112), whose presence correlates with water's coolness, hence with peace imposed by statecraft that is strong and just.[21] These were ancient ideas in Dahomey, long predating their particular association with nineteenth-century kings.

Another animal present in Dahomean art—Dā or Dan, the good serpent of the skies—appears not only in Haiti but also in Cuba (Plate 113), and, in mixture with the Yoruba rainbow deity, Oshumare, in Brazil (Plate 114), that is, wherever the Fon and their neighbors arrived as captives.

The highest deity of the Fon, Mawu-Lisa, combines female (Mawu) and male (Lisa) valences. Mawu is cool and gentle—she is the moon. Lisa is strong, tough, fiery—he is the sun. Their union represents a Fon ideal.

The good serpent of the sky, Dā, is a metaphor for this primary, combinatory sign of order. Like Mawu-Lisa, Dā combines male and female aspects, and is sometimes represented as a pair of twins. Many are his avatars, but principal among them is Da Ayido Hwedo, the rainbow-serpent. Coiling a resplendent bichromatic body about the earth, Dā shaped its globelike form and sustained its balance and existence. Color symbolism in the lore of this rainbow-serpent is potent and direct: "The male is in the red portion, the female in the blue."[22] Aggression and compassion are thus writ large across the skies.

In one Dahomean myth recorded by Mercier, Da Ayido Hwedo set up four pillars cast in iron at the four cardinal corners of the earth. He did this to hold aloft the sky. And then he twisted around these columns in brilliant spirals of crimson, black, and white to keep the pillars upright in their places.[23] These were colors of night (black), day (white), dawn and twilight (red). Clearly the iridescence of the sacred serpent signified to Dahomeans more than danger. It becomes a perfect metaphor for mind's own ordering motion.

Needless to say, Dahomean-influenced folk in Haiti, steeped in such lore, were impressed by the chromolithograph of Saint Patrick (Plate 115), dressed in full regalia, and shown at a critical juncture, driving the snakes from Ireland. They saw an elder, white of beard (things white are African attributes of Dā), making a gesture of power with his right hand. Instead of a saint treading vermin, banishing all evil—exorcism—they saw multiple embodiments of the serpent of the sky. The proof of this assertion, as will be seen, is how

Flash of the Spirit

PLATE 115

they rephrased this chromolithograph to fit their own religious language (Plate 116).

In addition, it can be imagined what an elder from Kongo thought when confronted with such a picture: here was an obvious ritual expert, with a staff of mediatory power, communing with forces incarnate in amphibian reptiles at the watery and grand boundary between the worlds of the living and the dead. Fon titles for this spirit are Dā, Dan, and Dan Bada, but the creole name in Haiti is Damballah. This overlaps, in form and meaning, the Ki-Kongo word for flatheaded rainbow-serpent, *ndamba*. MacGaffey elaborates:

The Rara of the Universe 177

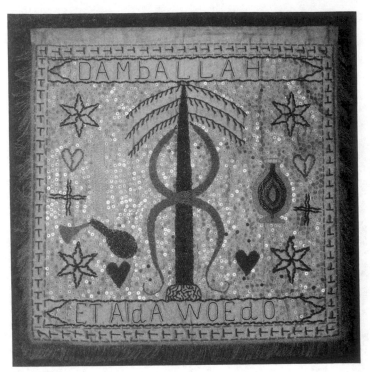

PLATE 116

Ndamba puns on the Ki-Kongo word for "to sleep" in the sense of the ecstatic love-making of two serpents, one male, the other female, who wrap themselves around a palm tree to carnally unite.[24]

This is remarkably similar to the image summoned by calling the names of Dan and his wife, Ayida Hwedo, in Afro-Haitian *vodun* and identical with the image used in *vodun* blazonry to call and designate these spirits.

Vèvè ground-painting for Damballah and Ayida Hwedo, Port-au-Prince, twentieth century.

Flash of the Spirit

Thus, in a commonsensical way, the iconographies of two classical African religions came together: the center post, a ritual site around which *vodun* devotees dance, is often painted with rainbow stripes or embellished with relief representations of serpents intertwined.

Kongo Influences on Haitian Sacred Art

Moreau de Saint-Méry wrote in the eighteenth century regarding a certain *danse à Dom Pèdre:*

> In 1768 a black man of Le Petit-Goave [a village on the north shore of the southern peninsula] . . . taking advantage of the credulity of the blacks with superstitious practices, gave them the idea of a dance analogous to that of the *vaudoux,* but in which the movements were more sharp and sudden. To give the dance even more of an effect, the blacks mixed well-crushed gunpowder in the cheap rum they drank while dancing . . . this dance, called *Danse à Dom Pèdre* or simply *Dom Pèdre* has caused the death of certain blacks. . . .[25]

In this account, "superstition" is mixed with substance. Saint-Méry believed that the Dom Pèdre "dance" began in 1768, and literally endangered those who danced it. Contesting this image, Melville Herskovits, the American anthropologist, wondered whether *Petro* spirits derived in fact from a species of African-derived ancestorism, for a Haitian black had told him that he believed *Petro* was an intimidating *vodun* priest who had died with the spirit of a god not properly released from his head. Evil and positive divinity therefore lived on within the spirit of this person, perpetually commingled.

Actually, lost here was not paradise but understanding. A ritual expert in Kongo today would have little difficulty in explaining plausibly the significance of these hazily remembered legends: Dom Pèdre was a messianic figure or an ancestor come back from the grave to renew his usefulness to the living in the body of a priest or healing charm.[26] In fact, there are figurated healing bundles, or *pacquet congo,* in Haiti today that bear Dom Pèdre's name. The great ethnologist, Alfred Métraux, writing in that vein of scientific skepticism tempered with artistic charm that was his alone, could sense—without identifying them—sub-Saharan origins in the legend of Dom Pèdre:

In the word *petro* we recognize the Pedro discussed above. Only a very naive person could believe that the complicated (petro) liturgy, which is inseparable from the worship of the petro divinities, could have been introduced by one man, however inspired . . . In contemporary Voodoo, Dompèdre is a powerful god who is normally greeted by the detonation of gunpowder. And so it seems certain there must have once been a *hungan* whose impact was so profound that his name took the place of African "nations" who today worship gods bearing his name, *petro,* and not theirs.[27]

Today additional evidence suggests that those "African nations" lie within Ki-Kongo-speaking Central Africa.

In some parts in the north of Haiti, people sometimes call *Petro* Lemba, the name of an old and most important Kongo trading society. The doyen of Afro-Haitian studies, Jean Price-Mars, stressed the Lemba-*Petro* equivalence thirty years ago.[28] If the same cycle of rites is called by a Kongo name—a creole term in the south—in northern Haiti, then *Petro* must be a rite, not a person; a concept, not a name.

The fiery militance of the *vodun* realm was fully evident in 1768 when first contrasted with the idealized coolness of many of the deities of Dahomey. *Petro* ritualized aggression would seem logically to derive from the spiritualized militancy pervading the world of "attack medicines" of Bas-Zäire and neighboring territories. The earliest mention of *Petro* associates the rite with sharp, staccato motions and the tasting of gunpowder—practices sharpened and confirmed by time. Today *Petro* dancing is defined as "distinctively intense, almost nervous. . . . Dancers, instead of riding the beat, as in Rada and Ibo, seem to be running in front of it, as if the beat were whipping them forward."[29]

The gestures of a *Petro* spirit, filling momentarily the body of a possession priest or priestess, are characteristically stern, hard, fierce:

Whereas Erzulie, the Rada Goddess of Love . . . is concerned with love, beauty, flowers, jewelry . . . liking to dance and be dressed in fine clothes . . . the figure of Erzulie-Red-Eyes, on the Petro side, is awesome in her poignancy. When she possesses a person, every muscle is tense, the knees are drawn up, the fists are clenched.[30]

Here is a spectacle that recalls possession by *bisimbi nganzi* in northern Kongo, spirits of those who died violently. The Haitian

Flash of the Spirit

propensity for re-creating and marshaling these incandescent forces is based on a belief in the spirits of *Petro*'s power to make things burn in a positive healing sense; their flames, their whips, their exploding charges of scattered gunpowder are summoned when cooler *Rada* cures have failed. *Petro* altars, in the context of the *houmforts* (the religious centers of *vodun*), powerfully reflect this notion of salvation through extremity and intimidation.

Houmforts betray more than a hint of the spatial arrangement of many compounds in Central and West Africa: the construction of a series of rooms about an open courtyard. The focus of the *houmfort* is the peristyle, a roofed-over dancing court with sometimes brilliantly embellished posts. The center post *(poteau mitan)*, at the center of the dancing area, is a mediating object par excellence, through which the deities are believed to ascend from the watery regions of the dead or come down from the skies. It is the still point of the spinning world of *vodun* dance: ground-paintings and the dances in honor of the deities symbolized by these paintings are centered on its axis.[31]

The influences of several African visual traditions are readily discernible in this single column. Firstly, as we have seen, according to a Dahomean belief, the Creator, Dan, "set up four iron pillars at the four cardinal points to support the sky, and twisted round them in spirals threads of the three primary colours, black, white, and red, to keep the pillars upright in their places."[32] There are *poteausmitan* in Haiti showing spiral decoration in the colors of Dan's own rainbow, or serpents entwined around its shaft.[33] Secondly, a cardinal tenet of Kongo culture is that "a tree stands up tall on the earth, like a chief witness to boundaries." Haitians talk about the central column in their songs as a "planted post" *(poteau planté)*, as if it were a tree. Thirdly, among the eastern Igbo and the Ejagham who inspired them, there has existed since at least the eighteenth century the tradition of a special central column in the Ngbe (leopard society) house, a column erected with an important stone set before it.[34] The column is planted in a raised, cylindrical dais of shaped clay—details again matched by those of the *poteau-mitan*.

Adjoining the dance court with its all-important center post is usually a building sheltering several shrines that open directly upon the peristyle. Each is a room containing one or more concrete or stonework altars *(pe)*. Each altar, dedicated to particular spirits, displays multiple niches, recessed within its base, in which offering

bowls and other objects are placed by the servitors. In *Rada* shrines, in the area between Port-au-Prince and Léogane, one often sees one single, large, dramatic opening for offerings of food to the spirits in the center of the altar's bottom tier. In shape and location this opening resembles the niches or alcoves recessed in Haitian tombs for food offerings on special occasions.

Many *vodun* altars are built in rising tiers upon which myriad objects, crowded and stained by actual use, impress the beholder with a sense of spiritual aliveness and activity. The power of these altars lies in their representation of complex ideas by specially selected objects:

> A vodun altar is a veritable bric-a-brac display of ritual objects: jars and jugs for the deities and for the dead, plates consecrated to twin-spirits, vessels for inititiated priestesses, thunder-stones, swimming in oil, playing-cards, ritual rattles and emblems of the gods, as well as bottles of wine and liquor offered to the deities. . . . chromolithographs are pinned to the walls. Near the sword for Ogun, driven into the earth, one still finds, in some shrines, *assein,* those curious supports in iron which are still to be bought in the market of Abomey in Africa.[35]

It would be appropriate to compare such altars to the store of an apothecary, for herein are also gathered all kinds of bottles and vessels, in different shapes and colors, many meant to lend spiritual confidence, or a healing sense of security, for troubled suppliants brought before the altar. The close gathering of numerous bottles and containers, on various tiers, is a strong organizing principle in the world of *vodun* altars.

That unifying concept, binding Haitian *Rada* altars to Dahomean altars in West Africa, precisely entails a constant elevation of a profusion of pottery upon a dais, an emphasis on simultaneous assuagement (the liquid in vessels) and exaltation (the ascending structure of the tiers). The intermingling statuary and containers on altars in Dahomey and graves in Kongo become the Haitian mingling of chromolithographs of Catholic saints on the wall and offertory and other vessels on the several tiers below.

In the Port-au-Prince area the *Petro* room is often one of several chambers adjoining the peristyle. Such rooms are striking for the touches, sometimes of deliberate horror, meant to suggest the moral terror of this fiery side of *vodun.* Thus a shrine to the *Petro* spirit Criminel at the sanctuary of Madame Romnus in Bizonton in 1970

Plate 117

included a human skull embedded in a kind of dado near the bottom of the altar dais. The head of a cat, glassy eyes staring eerily ahead, was suspended on a thread above the altar. Elsewhere, in the region between Gressier and Léogane, I have seen *Petro* altars built apart, in a small habitation separated from the main cluster of altars about the peristyle, emphasizing distance and great danger.[36] And there we sometimes find a table, laid for "work," healing, or acts of mystic aggression, instead of a dais with tiers for display of ritual objects.

I was allowed to photograph a *Petro* table on the south peninsula of Haiti in the spring of 1975. Deriving from Kongo on this table is the feathered image (Plate 117) of Simbi Macaya, to the right of a skull and in front of a bottle—a promise of the power of *Petro* to render urgent healing. A cluster of three transparent bottles each with a miniature crucifix within, dramatically displays points of

The Rara of the Universe 183

spiritual contact—crossroads in miniature, ensconced in spirit-attracting glass—and deepens the allusion to the dread powers of the *Petro* spirits. Playing cards have been laid on this table. They are for divination. Renamed in *Petro* terms, the Queen of Diamonds, for example, has become Erzulie-Red-Eyes, whose poignant possession style we have observed. There is even a human skull, as in Madame Romnus's shrine, here associated, so it was alleged, with the mystic killing of cruel or evil persons through the propitiation of the deity shown seated at this table.

No sooner do I come into this room than a servitor is instantly possessed with the spirit of Danger-Malheur, Danger-And-Ill-Fortune, a *Petro* avatar. Face frozen, he wears his traditional crimson hat. Sequinned bottles for assuagement refer in their glitter to the flash of the spirit that has descended here and add beauty to undertones of terror and moral vengeance. To the left of the table the top of an actual cemetery cross in wood rises from a mock grave and in another portion of this room a great black flag guards a carefully deposited piece of meteoritic stone and a long red coffin, lined with silk, has been set upon two chairs, like a presence in a mortuary.

The art history of the *Petro* table-altars of southern Haiti remains to be completed, but the presence of a strong Kongo element—fused with ingenious invention and an imaginative local sense of visual structure, pace, and timing—already seems quite clear.

Vodun flags

Vodun flags appear at the beginning of *vodun* ceremonies and herald the coming of a god or goddess, the possession of devotees. *Vodun* flags are profoundly liminal. Unfurled and paraded in *vodun* rites, they stand at the boundary between two worlds. The late *houngan* (*vodun* priest) Loudovique Elien of Gressier told me in April 1970 that *vodun* flags were used to "greet the deities" *(saluer mystères)*. Madame Romnus, the mambo of Bizonton mentioned earlier, also in 1970 told me that the meaning of the flags could be summed up in a single word: respect! *(respé!)*. When a Haitian approaches another Haitian's yard, making his presence known by shouting *Hono!* (Honor!), he does not, by the rural rules of etiquette, cross the threshold until he hears from within the corresponding cry of *Respé!* The resonance between this custom and the association

Flash of the Spirit

of the flags with *respé* underscores the power of these banners as mediating forces. These are creole variations on a fundamental Kongo theme—*nikusa minpa*—the ritual agitation or unfurling or "dancing" of squares of cloth to open the door to the other world.[37]

Métraux gives us a fine description of *vodun* flags in ceremonial context:

> They are brought out at the beginning of a ceremony or when a "great loa" possesses one of the faithful. Also, important visitors are entitled to the honor of walking beneath two crossed flags. When the moment comes to fetch these flags, the flag party, which consists of two women, goes into the sanctuary escorted by the *la place* waving his sword. They come out backwards and then literally charge into the peristyle behind their guide who is now twirling his weapon.[38]

This can inspire a song for Sogbo, lord of thunder and patron of flags, whose thunderous nature, like the sound of cannons on the battlefield, makes an appropriate accompaniment to the use of banners. Then:

> The trio maneuvers and from the four cardinal points salutes the *poteau-mitan*, the drums, the dignitaries of the society, and finally any distinguished guests, each according to his rank. The la-place and the standard bearers prostrate themselves in turn before them. These show their respect by kissing the guard of the sabre, the staff of the flag, and make the la-place and the standard bearers pirouette. The return of the standards is accomplished in a remarkable rite: the two priestesses, still preceded by the la-place, pointing his sabre before him, run around the *poteau-mitan*, often making quick changes of direction. This musical ride goes on till the la-place leads them off towards the sanctuary door through which, having first recoiled from it three times, they pass at the double.[39]

The balancing of a male-handled sword with two female-carried flags suggests a trace of Dahomean influence in the pairing of the sexes, and also perhaps reflects the sharing of power between male and female officiants in *vodun* in general.[40] Note that two women pair with a single male, as if their banners were co-wives to the spirit. And there is yet one more indication, in formal terms, that the flags themselves embody spirit—the fact that in some styles the silhouettes of deities honored by the banners are carefully described by shining beads on a field of gleaming spangles. In such cases the

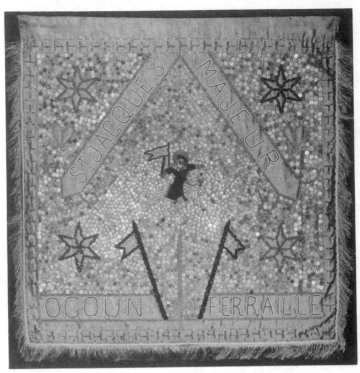

beads are often reserved for the direct visual rendering of the deity on the banner. In the spring of 1975 the locally famous healer-diviner Álvares told me in his sanctuary near Léogane why he draped shining beads about the tops of swords embedded upright in the earth before his *Petro* altar: "These are *kanzo* beads. They have to be here. We place them on the heads of sabers because there is a spirit in them."[41] And, similarly, the bead-embroidered silhouettes of the goddesses and the gods, on those *vodun* flags where such additional embellishment is found, suggest the presence of spirit within their gathered brilliance, foretelling that mediation is about to happen or confirming its completion.

Two masterpieces of the *vodun* flag tradition—works of the utmost clarity and precision—were fashioned by Adam Leontus, a former dock worker, later celebrated as "the master decorative artist of Haiti."[42] These flags, made c. 1945 in Port-au-Prince for Saint

Flash of the Spirit

James/Ogún Ferraille and for Saint Patrick/Damballah and Ayida Hwedo, incorporate the whole of their tradition (Plate 116).[43] They carry inscriptions identifying the powers for whom they were made. Like the Catholic chromolithographs, they sparkle with allusion to the attributes of the saints. Like the costumed "majors" of Haitian *Rara* street paraders, they achieve maximum glitter with sequin-covered surfaces. And like the head of the sword for Gū, the Fon deity of war and iron, observed in the *Petro* shrine of Álvares near Léogane and elsewhere, the portions of their composition indicating the silhouettes of sacred beings—or their attributes—are covered with bead embellishment.

The flag for Damballah and his wife, Ayida Hwedo, the serpents of the sky, is cut from a bolt of pale blue silk (Plate 116). It flashes with countless silver sequins. The serpents crushed under Saint Patrick's foot in his chromolithograph (Plate 115) disappear; they reemerge as twin-beaded serpents in the sky, joined in sacramental love about the swordlike palm tree, the sign of Aizan, the wife of the Dahomean trickster Legba. Aizan "marches" with the twin serpents. Leontus transformed the color of the snakes into gleaming silver, an affective suggestion of the richness of their powers and their purity. They stand, entwined, as rainbow-serpents, sources of creative coolness. The straightforward opposition of good and evil in the chromo has been transmuted into an extraordinary evocation of divinity and love. The intermingling of Damballah's body with that of Ayida is a sign of union and ecstasy, a sign that echoes throughout the composition, in the pairing of hearts, crosses, and rainbows meeting in a jar. Overmastering sensations of ecstatic union are stated and restated within a field whose starred corners suggest it is the universe itself.

Leontus's other flag bears equal witness to his power to shape a vision of two worlds. Gold sequins sewn on crimson silk outline the passage of the mounted warrior-saint across the composition, as if he were caught in a ray of sunlight (Plate 118). The dissolving of the scene of fallen warriors and abandoned shields of the chromolithograph (Plate 110) releases the saint from a single point in space and time and makes his action heroically continuous and iconic. He, too, is set within four stars, which suggests the translation of the action to the skies.

The parting of two flags about the standing sword at the bottom of the composition—precisely the act within the peristyle that her-

alds the coming of the spirit within the flesh of a dancing and initiated servitor—suggests that the hovering mounted figure above this motif is a spirit descending to this world. The miniature banners within the banner not only link this textile to its contexts but also create raking accents that mirror the shaftlike cartouches in which the spirit's Christian name is sited, above the mounted figure. These names descend, like arrows of God, pointing toward the corresponding Dahomean titles. Adam Leontus totally transcended his source of inspiration; he masterfully transformed a single battle against the Saracens into an endless arrest of supernatural power to inform the moral wisdom of this world.

Vèvè: Ritual Vodun Ground-Paintings

Vèvè, the celebrated blazons of the vodun goddesses and gods, are traced by priests or priestesses in powdered substances (normally cornmeal) on the earth about the central column of the vodun dancing court. Symmetrically disposed and symmetrically rendered, they praise, summon, and incarnate all at once the vodun deities of Haiti.

They take their name from an archaic Fon term for palm oil used in the making of simplified squares or rectangles on the ground for certain Dahomean deities. Essentially they take their structure from a reinforcing merger of Fon and Kongo traditions of ritual ground designs, with the cruciform cosmograms of Kongo and neighboring territory the dominating influence not only in terms of design but, critically, in point of context and process, too. Thus John Janzen:

> the tracing of ritual spaces in the Petro phase of the loa service offers some striking resemblances to . . . Kongo rituals. In the staking out of the cardinal points with candles, the [ritual expert] used a common, perhaps worldwide motif. However, in circling this space in a counter-clockwise direction, and then dividing it into two, one half representing the domestic realm (governed by "lord of the house" Mait' Habitation, the other half the realm of the wilds, the deep, of water (governed by "lord of the deep" Mait' Source) he was tracing a cosmogram the way it is done in many Kongo contexts.[44]

And there are analogous ground-signs, mediatory cruciforms, found among the Tu-Chokwe of northern Angola, the Ndembu of

northwestern Zambia, and the Pende of western Zaïre, doubtless fragments from a larger, yet to be discovered western Bantu field of visual expression. The Tu-Chokwe have especially developed ground-designs of intricacy and beauty, as illustrated by an ideograph that artfully fuses various motifs:[45]

The top of this design indicates the realm of God, whom the Tu-Chokwe, like the Bakongo, call Kalunga. There a human figure is shown standing. Twinned serpentlike forces mark the cosmic crisscross, framing the center of the design where nucleated lozenges indicate the sign of the *muyombo* tree. Myth says that God asked the stars, "On which side of the cosmos is man found?" And the stars replied, "On the side opposite yours." God observed: "Then man will die," thus identifying the bottom of the ideogram as representing the realm of the dead, and explaining why a the human figure therein represented lies in a recumbent pose of eternal sleep.

The symbolizing, with nucleated patterning, of a tree at the center of the cosmos compares closely with Kongo and Angola custom and also with the Haitian tradition of drawing *vèvè* around a treelike post in the center of the peristyle, as shown below. On the other hand, the contrast between the Tu-Chokwe and Haitian illustrated signs of cosmos not only clearly distinguish the creole blazons

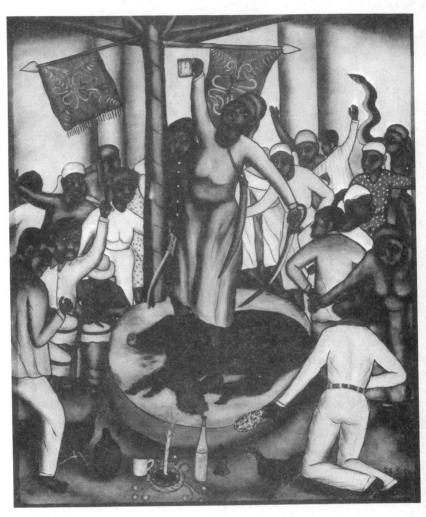

PLATE 119

from their Central African antecedents but also suggests why the
explosive variety of *vèvè* emerged. Both the Tu-Chokwe and Haitian
signs are centered on cosmic trees, but there the similarity ends. The
Central African cosmogram states the same pattern four times. The
Haitian illustration combines icons of various traditions and sources

Flash of the Spirit

—the upper right patterning is for Simbi, the Kongo-descended spirit, with an alphabetic *S,* and a sacrificial bullock bearing a Masonic emblem, in celebration of Masonic-like mysteries that surround the power of Simbi; at lower right appears a heart for the Dahomean-derived goddess of lovers, Erzulie, with the *M* of her Catholic counterpart, Mater Dolorosa; at lower left we find the star-nucleated diamonds of Ogún Badagri, framed with volutes relating, by one scholar's reckoning, to French grillwork; and finally, at upper left, the poised and balanced Dahomean serpents of the sky, Damballah and Ayida Hwedo.[46] In other words, this is more than a crisscross of the earth at point of contact with the sky. In effect, this *vèvè* complex provides geometric focus for a constellation of Dahomean, Kongo, and Roman Catholic forces constituting the very fabric of Haitian cultural history. The Kongo and Angola cruciforms invoked God and the collective dead, but the Haitian ground-painting invoked a host of deities and emblems inherited from many lands. In the reduction of historical multiplicity of experience to single New World forms, *vèvè* constitutes the quintessential form of Afro-Haitian art.

Everywhere in *vodun* art, one universe abuts another—the gathering of the "chromos" of the saints upon the altar walls; the standing of embottled souls upon the altar; the flash of the double *vodun* flags and swords (cf. Plate 119) about the peristyle; the coming of the deities, responding to this brilliance through the pillar at the center of the dancing court. Luminous force then radiates, so it is believed, from the bottom of this pillar in the form of the blazing chalk-white signatures of the goddesses and gods. These signs, these *vèvè*, are then erased by the dancing feet of devotees, circling around the pillar, even as, in spirit possession, the figures of these deities are redrawn in their flesh. And then the goddesses and gods themselves revolve about this tree, this rainbow, this standing serpent that helped God build the world, creating unities so splendid it is permissible to greet black Haiti as the *coumbite* of the western hemisphere, the *rara* of the universe, a school of being for us all.[47]

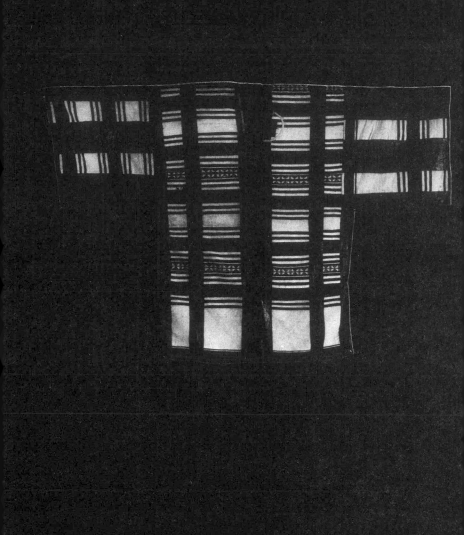

Four

ROUND HOUSES AND RHYTHMIZED TEXTILES

Mande-Related Art and Architecture in the Americas

Limned in one of the masterpieces of Mali oral literature as generous, strong, and brilliant, Sundiata established the Mali Empire in the thirteenth century.[1] He organized men of his age into an army and defeated his principal enemy, Sumaoro, by discovering and exploiting the latter's *tana*. *Tana* is a crucial Mande concept.[2] It is an inherited taboo, an animal-familiar that the inheritor should not kill or even touch, for he would thereby lose the concentration of the powers of his ancestors within himself. Sumaoro's *tana* was the spur of a rooster. He made the fatal error of bragging to Sundiata's sister about his source of power, unaware that she merely pretended to be in love with him in order to uncover precisely this intelligence. She swiftly relayed her finding to her brother. Sundiata is said to have shot an arrow, to which the spur of a rooster had been attached, at Sumaoro, sealing his doom.

After this victory, Sundiata went on to unite the twelve towns of Mande, "the twelve doors of Mali," pacifying them and bringing prosperity to the land. About 1240 he absorbed the remnants of the earlier empire of Ghana. After his death the armies of Mali conquered Timbuktu and the Niger town of Gao c. 1325. Mali was then supreme, from the waters of the Gambia and the Senegal to the inland delta of the Niger. Subsequent to these victories, and the establishment of Mali, Mande traders (Dyula) spread Mande civilization to the south, almost to the gates of what would be the emergent civilizations of the Akan in what is now the Ivory Coast

and Ghana. For example, the Dyula town of Kong, in what is now the northeast of the Ivory Coast, was founded at the beginning of the eighteenth century, not far from the northwestern marches of the Akan.

The Mande diaspora did not diminish their cultural identity. Such was the Mande strength of ethnicity that the cultural focus of the civilization was maintained, even among its widely dispersed members: "the merchants who established trading colonies in Kong and Bonduku in the Ivory Coast, and those who colonized the Gambia, sent their sons back to the Mande to learn the finer points of Mande culture and perhaps to return with a wife."[3]

Mande partly resolved the tension between tradition and innovation through their rich and extensive oral literature: animal stories; hunting songs; and, especially, the literature of the courts, sung by professional bards. The bards, "men of words," traveled widely, maintaining the integrity of their language, Mande-kan. Thus they themselves contributed to the amazing cohesiveness of Mande culture. Because they were sent to do their apprenticeship at training centers in such places as Kangaba and Keyla in the core area, and because they convened for important national ceremonies, the bards of the Mande—as Charles Bird points out—virtually constituted an academy.[4] They tempered cultural diversification with ancient norms. The Mande prize clarity, strength, and force of character, and they especially admire generosity and adherence to ancient custom.

The primary Mande aesthetic value is the search for simplicity, for the elegance of science. Thus the Mande-kan word *woron* "to get to the kernel" also means "to master speech, music, song, any aesthetic endeavor."[5] As Charles Bird observes, one masters something in the Mande world by stripping away the superficial covering, by discovering its inner and true nature, as in the poetic concept of *yere-wolo* (giving birth to yourself), in which a person finds his or her true self, his or her true essence.[6] And Patrick McNaughton has shown that the making of Mande figural sculpture and designs painted in earth on cloth (*bogolanfini*) is governed by *jayan*, "precision and clarity."[7] As the cadres of rigorously trained bards kept the language of ancient Mali from splitting into mutually unintelligible languages, so the Mande propensity for the essential apparently preempted the emergence of a tropical baroque in spite of centuries of complex urban life and leisure. The search for the *kolo*, the

kernel, the nucleus, the essential structure, militated against ostentatious display or mindless presentations of one's wealth, which is regarded as being in bad taste.

The expansion of the Mali Empire had profound cultural effects throughout West Africa that are still being felt today. Two of the most important Mande artistic traditions disseminated by Mande warriors and traders were cone-on-cylinder architecture and the making of multistrip textiles in vibrant colors—with the main accents of one strip staggered in relation to those of an immediately adjoining one but coordinated with those of another and so on. These aspects of Mande visual tradition survived—indeed still thrive—in certain regions of the Americas, where they were first introduced by slaves from Mande or Mande-influenced regions in West Africa. Moreover, they have been blended with local elements and improvised upon for so long that in most cases the practitioners of these traditions have no specific memory of Mande origins.

Black Space

In the Mande heartland, the basic architectural module is the clay round house (or wattle-and-daub round house) with a conical thatched roof—a mode that has remained unchanged in Mande country since the time of the Mali Empire. According to tradition, the most important cone-on-cylinder building in the land is the famous Mande Bolon, constructed by the workers of Mansa Soulemane as a repository for the sacred texts this leader brought back from Mecca about 1352. This splendid round structure (Plate 120), specially white-washed and written over with Mande ideographs, some of which are alleged to refer to "Mali" and to the "glory of Sundiata," is located in the culturally important settlement of Kangaba, where the bards of Mande assemble every seven years to chant the history of the land. And Portuguese explorers observed cone-on-cylinders buildings with straw roofs in the sixteenth century. These documents, material and literary, attest the existence of the cone-on-cylinder round-house tradition in Mande country at the time of the sixteenth-century exportation of Mande and Mande-area slaves to Mexico. For despite its inland position near the headwaters of the Niger and the Senegal, Mande was vulnerable to the reach of European slaving from its earliest period.

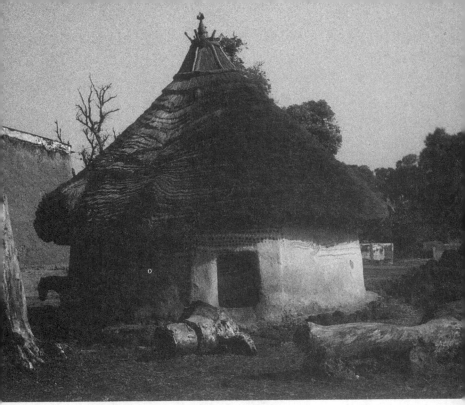

PLATE 120

In the sixteenth century Spain decimated the Native American population on a portion of the west coast of Mexico known locally as the Costa Chica (the little coast), territory 70-odd miles downcoast from the famous port of Acapulco, by bringing smallpox to the land: in 1552 there were 323,00 Native Americans; in 1582, 1,807. As her need for labor intensified, Spain began importing slaves from West Africa. And thus descendants of Sundiata appeared on the Costa Chica in southwest Mexico:

> The great Mande group were, without a doubt, the one who exercised the greatest influence in Mexico during the entire 16th century. . . . it is easy to prove in colonial archives the role they played in the integration of patterns of culture of the colony, and the persistence of their influx will surely be recognized when ethnographic investigations, motivated by the black groups which still live in Mexico, are undertaken.[8]

Slaves in western Mexico on the Costa Chica were often orga-
nized in groups of ten or twelve, and they lived in camps thirty miles
or less from one another.[9] In the rugged isolation of the Costa Chica
the blacks found themselves in a familiar, tropical environment with
unusual opportunites for autonomy: "What is important to realize
is that the Negroes of this coast were no longer slaves . . . they lived
alone with their families . . . away from the presence of the [absen-
tee] owners of the ranches, free to improvise responsibilities."[10] In
the process, the blacks intermarried with the surviving Native
Americans, as reflected by the physical type prevailing on the Costa
Chica. But there were black runaways whose African manner of
cultivation and architecture was noted as early as 1591:

> I have been informed that in a hilly place called Coyula, two
> leagues from said town . . . there are black runaway slaves. And
> to the present time they are there, *with their houses, maize
> cultivation, cotton-growing, and other things, as if they were in
> Guinea.*[11] [Emphasis added.]

PLATE 121

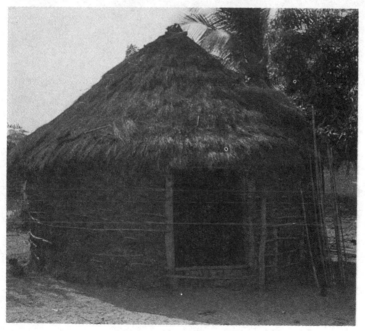

Round Houses and Rhythmized Textiles 199

PLATE 122

The priority of arrival of Wolof and Mande in Mexico and most likely the re-creation of "their houses" there by 1591 is a momentous event in the history of African-influenced architecture in the New World.

In western Mexico, *redondos,* or rondavels (round habitations with conical thatched roofs), appeared (Plate 121) and are still being built by Afro-Mexicans and their Native American neighbors. A consideration of the building techniques of the African round-house maker, as they have been studied, sharpens our appreciation of the Afro-Mexican rondavels.

Flash of the Spirit

There are four basic techniques of construction in Mande: 1) the superimposition of rows of sun-dried clay bricks sealed by wet clay; 2) the superimposition of string courses of puddled clay left to dry, one after the other; 3) the plastering over of woven wicker walls with a wet clay mix; 4) the arrangement of a ring of posts to support a conical thatched roof.[12] Of the four modes only the last two mentioned—technically the simplest—were mainly practiced in Mexico, evidently because of missing elaborate Mande crafts and because of the exigencies of the new environment.

The first two techniques enable the making of relatively massive and thick-walled habitations (Plate 122), as evidenced by a photograph of a compound in Kangaba, in the heart of ancient Mande territory, in 1975. But the builders of the black and maroon villages on the Costa Chica availed themselves of the thin-walled wattle-and-daub technique (Plates 121 and 123), and when they built kitchens, where ventilation was a critical issue, they simply drove a ring of posts into the ground, placing over them a conical thatched roof (Plate 124).[13]

The common housing unit of the central Mande area has four posts emerging from the very summit of the roof (Plate 125), whereas to the north of the core Mande region, the Soninke people complete their conical roofs without the four posts, using instead a woven ring of vegetal matter to hold the roof in place, as Afro-

PLATE 123

Round Houses and Rhythmized Textiles

Plate 124

Plate 125

PLATE 126

Mexicans do. Among the latter the securing-ring is called the *corona* (Plate 126).[14] Another hint of a possible Soninke influence on the architectural style of the west coast of Mexico is the fusing of a rectangular dwelling and a cone-on-cylinder kitchen by means of a veranda, a complex strikingly similar to certain constructions in Soninke country.[15]

Core Mande and perhaps the Soninke contributed builders during the formation of the Afro-Mexican round-house style, and Labelle Prussin, a leading authority in the study of African building traditions, after examining a series of recent photographs of Afro-Mexican *redondos* observed strong affinities with modes of southern Mandingo/Malinke construction. "I am reminded," she writes, "of innumerable 'palaver hosues' in the center of villages in the northern Ivory Coast and further west, i.e., the houses of the male elders of the villages."[16] What is more, the spatial arrangement of round houses in Afro-Mexican compounds, in circular plans, evinces further cultural ties to western Africa. Thus, among the Wolof of Senegambia round houses are "generally grouped in a circle, the house of the compound head being opposite the entrance."[17] The

Round Houses and Rhythmized Textiles 203

reconstellation of round houses in circular compounds was also the prevailing plan on the Costa Chica for which, evidently, there was no clear Iberian nor Native American precedent. The rationale for the grouping of the round houses in circular compounds was given Susan Yecies in the course of fieldwork conducted among a number of villages in the summer of 1970 and the spring of 1971:

> Critics constantly told me that my drawings were not complete because the other *redondos* (round-houses) that form a compound were missing. "This drawing does not represent a house; know why? Because the other round-houses are missing and without them, there's no balance, between man and man."[18]

The Mande word *lu* refers not only to a lineage but to the circular compound inhabited by that lineage. Similar usage prevails in Africa wherever Mande influence is strong, such as northern Ghana:

> There is an apparent absence of the concept of "house" or "dwelling" as a discrete entity among the traditional Western Sudanese cultures. Fortes, in his description of the way in which the Tale of Northern Ghana view their homesteads, notes that no linguistic distinction is made between the name for an extended family unit and the name for the physical architecturally circular compound which such a unit inhabits. Both are *yir*.[19]

To repeat, as Tod Eddy rightly points out, there is no concept of the solitary habitation among the Mande: "I refer to the cone-on-cylinder as a multi-habitational unit instead of a house. It is not merely an architectural structure but a representation of the individual within his or her social universe."[20] In like fashion descendants of Africans on the west coast of Mexico find the concept of the single round house meaningless or socially askew.

The strong links between the Mande round houses and circular compounds and the spatial planning and architecture among the blacks and their neighbors on the Costa Chica south of Acapulco indicate the latter's general provenance. But local ingenuity and adaptation to new conditions have considerably transformed the Mande tradition. Old Mande round houses were closely spaced together when villages had to be strongly fortified against attacks by enemy outsiders or slave-raiding parties. The round houses of the Costa Chica are in general spread more apart, because Afro-Mexicans were subject to, chiefly, absentee landlords and because relations with neighboring Native American groups generally were good.

Compounds such as those found in the hill-girt town of Amusgo (Plate 127) conspicuously lack the enclosing walls of Mande village compounds in Mali.

Native Americans on the west coast of Mexico have, over the centuries, adopted the Mande-influenced module as their own. Aguirre Beltrán, in his classic study of the black population and culture of the area, writes:

> The Amuzga, Mixtec, and Trique cultural groups also have, as their traditional form of architecture, the round-house form. In this case, we think it is a phenomenon of cultural borrowing, by the Native Americans, from the blacks.[21]

The adoption of these buildings by the Native Americans occasioned subtle changes in details of construction and plan that distinguish Afro-Amerindian structures from Afro-Mexican. For example, the Amuzga Native Americans use reinforcing crossbeams inside their round structures but this detail is missing from Afro-Mexican rondavels, as in Montecillos village on the Costa Chica.[22]

The presence of Mandeizing round houses among Native American buildings of the Amuzga, Mixtec, and other indigenous peoples of the Costa Chica in western Mexico raises the possibility that

Round Houses and Rhythmized Textiles

Plate 128

round houses with conical thatched roofs inhabited by Arawak Indians in northeastern Colombia, in South America, might also have reflected certain Mande influences. Colombia was surpassed only by Brazil and the United States in the massiveness of its black population during the Atlantic trade.[23] Colonial Colombia imported slaves from the Mande area as well as from Angola.[24] Among the Arawak of the Sierra Nevada de Santa Marta, in the extreme northeast of the republic, there is a distinct rondavel tradition: cylindrical walls, made of branches coated with clay and topped by a thatched conical roof (Plate 128).[25] These elements are proportioned and scaled in a manner that recalls the world of Mande architecture.

Already certain Western architects have experimented with the elegance, simplicity, and the power of social cohesiveness written into round-house forms from other parts of Africa. The Ndebele-inspired Jack Lenor Larsen house in East Hampton, New York,[26] and the Rice House of Christianburg, Virginia,[27] a romantic replication of rondavels from what is now Zimbabwe, are twentieth-century examples. Ideal black architects, availing themselves of increasing knowledge of Mande-influenced round houses in Africa and the Americas, will turn these historical presences into occasions for creative homage and elaboration. The round houses of Mali in the Atlantic world keep families together in socially binding spaces. They will be rediscovered—and maintained.

Flash of the Spirit

Rhythmized Textiles

A particular style of Mande and Mande-influenced narrow-strip textile, enlivened by rich and vivid suspensions of the expected placement of the weft-blocks (Plate 129)—thus characterized by designs virtually to be scanned metrically, in visual resonance with the famed off-beat phrasing of melodic accents[28] in African and Afro-American music—introduces to the history of art an extraordinary idiom, unique to the black world.

PLATE 129

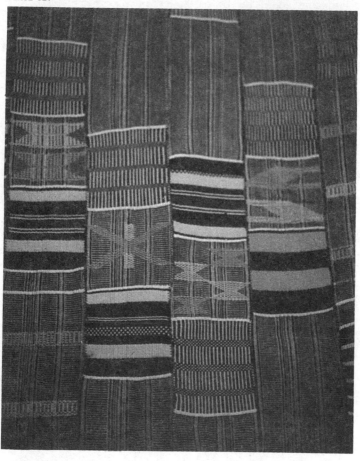

The Mande "country cloth" tradition spread west to Senegambia, east to the Djerma, among the Songhai of Niger, and—this is crucial —south by way of Mande Dyula traders to Kong and Bonduku (in what is now the Ivory Coast), then to Gyaman and Akan settlements proper in what is now Ghana, and again down, via the Songhai region, south into Dahomey and among the Ewe of Togo and eastern Ghana.[29] Thus on the west coast of Africa various enslaved peoples, bound for America, converged, sharing Mande-influenced or Mande-related ideas about the composition of textiles. These traditions were reinstated in diverse ways in the Americas—in Brazil, in Suriname, and in the United States, among other places.

But the creolized cloths of Bahia, the over-one-shoulder capes of the Djuka and Saamaka maroons in Suriname, and the string-quilts of the black South in the United States are not by any means "pure African textiles." Rather, they are works "carried out in terms of African tradition." Variables of Mande and Mande-related cloth-making remain indelibly intact in these Mande, West African– influenced regions of the New World. The recombination of these variables to form novel creole art—also embodying European influences—is an autonomous development in the history of Afro-American visual creativity, especially in Suriname. Nevertheless, the vibrant visual attack and timing of these cloths are unthinkable except in terms of partial descent from Mande cloth, a world of metrically sparkling textiles.

West African "country cloth" was made on the men's narrow horizontal loom in characteristic widths ranging from nine to fifteen centimeters.[30] Neither in Europe, nor in the Middle East, according to Venice Lamb, a ranking authority, do we find such emphasis on narrow-strip weaving, nor such dramatic fusion of such strips in the making of multistrip cloths and textiles.[31] Akan *asadua* cloth may be made up of as many as twenty-four strips of cloth. Some Nigerian garments call for as many as one hundred narrow strips, each one inch wide. Thus as multiple meter distinguishes the traditional music of black Africa, emphatic multistrip composition distinguishes the cloth of West Africa and culturally related Afro-American sites.

Narrow-strip weaving has been pervasive in West Africa since at least medieval times. Archaeologists, working at the site of the Tellem caves in modern Dogon country, central Mali, have discovered hundreds of old narrow-strip cloths.[32] Some hailed from Berber

weaving centers across the Sahara. Others were indigenous. The tradition of the West African multistrip cloth thus dates from the ninth to the twelfth century, a heritage more than seven centuries old. The weight of the tradition has resulted in a related predilection among West Africans for imported striped cloth. Narrow stripes were preferred as equivalent to narrow strips.[33] On this simple substitution, stripe for strip, was to turn a major aspect of the Africanness of certain forms of Afro-American dress.

The earliest cloths from Tellem (Plate 130) show a strong use of blue against white, a hint that African cloth has for centuries, as it is today, been distinguishable by deliberate clashing of "high-affect colors," dark blue against bone white, and so forth, in willful, percussively contrastive, bold arrangements.

Another variable in the making of a number of Mande or Mande-related "country cloths" is a vibrant propensity for off-beat phrasing in the unfolding of overall design. As multiple strips are sewn together by their edges, the major accents (weft-blocks) of one strip may be staggered in relation to those of an adjoining strip, with careful alignment of further elements in the same cloth preempting any assumption of accident and indeed confirming a love of aesthetic intensity through this form of special contrast.[34]

Round Houses and Rhythmized Textiles

One of the oldest examples of an African textile exhibiting this trait is a robe collected by one Christoph Weichmann "on the coast of Benin," probably in the early seventeenth century (Plate 131). The strips composing the right arm sleeve are staggered in relation to the siting of those of the left arm. Visual aliveness emerges in two related traits: one, a deliberate clash between patterned and unpatterned strips, some white with patterning, some pure dark indigo without a trace of pattern; and, two, the cutting of broadloom cotton (in this case dyed dark indigo) to narrow-loom strip size to complete a multistrip, multidecorative composition.[35] The latter technique, breaking the bulk of received foreign stuff, grants freedom to the maker of the costume: he can achieve a rippling effect by alternating narrow strips in union even without access to strips made from the West African narrow loom—he merely cuts imported cloth down to cultural size, to the frequency modulation, as it were, of the narrow-strip, multistrip style. This was of obvious importance as a precedent for Afro-Americans recapturing the flavor of the past in spite of the loss of the narrow loom.

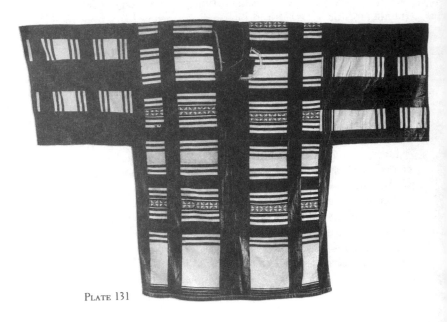

PLATE 131

Flash of the Spirit

PLATE 132

And thus emerged strategies for recovering in a special West African way spontaneity in design, without which there can be neither vividness nor strength in aesthetic structure. The prevalence and diffusion of this tendency toward metric play and staggering of accented elements can be demonstrated by a brief consideration of a Fulani *welmare*[36] cover from Mali and a cloth attributed to the Wolof from Senegal (Plate 132).[37] Both are surcharged with visual syncopation. A detail of the Wolof textile reveals two weft-blocks aligned in the top two rows, three aligned in the next two, the latter design staggered with yet another triple patterning below.

In the early nineteenth century similar subtleties were achieved in textiles from the Mande trading towns Kong and Bonduku, in what is now the Ivory Coast. Witness a cloth attributed to a weaver who migrated to Bonduku from the Mande settlement of Kong. His work displays multistrip phrasing. There is no symmetry in the top and penultimate strips, but there is in the second and fourth. Red center-striping is continuous, like scarlet drones. There is an equally sustained "checkerboard" rhythm (Plate 133).

Round Houses and Rhythmized Textiles 211

PLATE 133

The northeast of Brazil imported slaves from no fewer than three major civilizations with traditions of rhythmic cloths—Mande via the Cacheu slave trade in what is now Guinea-Bissau, Ewe from the slave coast, and Hausa from what is now northern Nigeria. In the pulsating African-inspired ceremonial life of the city of Salvador, multistrip textiles were used by blacks as garments. These textiles were called *pano da costa* ("cloths from the coast"). According to Nina Rodrigues, this originally meant cloths brought by slaves from Cacheu, where Mande influence was strong.

Surprisingly, the narrow-loom complex itself was also reinstated in Salvador. It is alleged that originally there were narrow looms in use among black folk in Cachoeira, across the bay from Salvador, and on the island of Itaparica, in the same harbor.[38] Today, however, only one narrow-strip weaver remains, the master black craftsman Abdias do Sacramento Nobre (Plate 134). About seventy years old

Flash of the Spirit

in 1980, when I interviewed him, Abdias do Sacramento Nobre inherited his loom from his godfather, Alexandre, who himself had inherited the technique of narrow-strip weaving from his West African forebears, possibly "Tapa" (Nupe) in what is now Nigeria.[39] The tradition is said to extend back to the nineteenth century in Bahia.

Nevertheless, Abdias's loom is a richly creolized thing. As Beth Jeffe has observed in a recent study, "The West African Narrow-Strip Weaving Tradition in the New World": "Abdias' loom suggests a Portuguese or Portuguese-influenced floor loom later adapted for use as a horizontal narrow-strip loom. . . . some of the components of his loom also indicate Mande influence, namely the shape and form of the tension bar disks and the nature of the foot pedals."[40] Marvelously, inventively, the carrying out of tradition in partially Mande terms is also evident in the composition of resplendent multistrip cloths Abdias has fashioned. There is a handsome collection of his works, evidently dating from the 1970's, in the Museu da Cidade in Salvador.[41]

Here is an example (Plate 135). Though the particular shaping and staggered siting of the narrow, red, rectangular weft-blocks

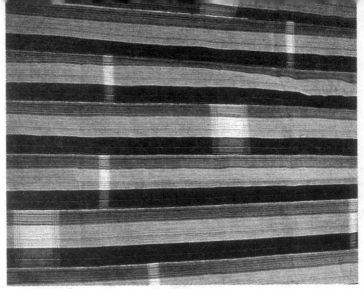

PLATE 135

seems Mande,[42] the interpolation of larger squares is an inventive touch by the artist; and he has elaborated his delicate parallel pin-stripes in turquoise and dark blue in a manner reminiscent of the dark blue and purple pinstripes of the Fon/Ewe/western Yoruba. Moreover, inasmuch as these ritual cloths were meant to be worn in *candomblé* ceremonies in Bahia, the colors have symbolic Yoruba-Dahomean meanings. This particular cloth is for Oshoosi, god of the hunt, whom we met in Chapter I; a similar multistrip cloth in red and white honors Shàngó; a rainbowlike gathering of strips in many delicate hues honors Oshumare, Yoruba serpent-rainbow of the sky, and so forth. In sum, Abdias's creole art fuses off-beat phrasing in the Mande manner with Yoruba-influenced niceties of expression. It could be said that to a heroically singular extent Abdias unfolds and improvises upon the richness of a multiple African heritage of art.

As the special history of Abdias and his Afro-Brazilian forebears indicates, slaves shipped from ports filled with captives from inland Mande-influenced areas certainly must have included weavers who would have remembered their craft in captivity. Indeed, there is another notice of a West African narrow loom having been set up in the Americas, in a black maroon village in French Guiana in 1748. The village was located in forested territory west of Cayenne near the so-called Lead Mountain, where:

. . . the women spin cotton when the weather is bad and work in the fields in good weather. . . . Couachy, Augustin, and Bayou weave cotton cloth, which serves to make skirts for the women and loincloths for the men . . . this cotton material is woven piece by piece and then assembled and decorated with Siamese cotton thread.[43]

There must have been similar memories of West African multi-strip cloth among black runaways of neighboring Suriname, for in 1823 Ferdinand Denis describes and illustrates (Plate 136) an article of dress, given as Carib: "Men cover what modesty demands with a *camiza*,[44] or loin-cloth made from a strip of cotton."[45] The illustration of this loincloth reveals a telltale multistrip style. Not only that, but two patterned narrow strips are separated by a single band of continuously unpatterned cloth in a manner that points back to early Asante cloths of the nineteenth century (Plate 137), when weavers were working under Mande influences radiating from Kong and from Bonduku, northwest of the Akan and north of Cap Lahou, whence sailed to Suriname 50 percent of a sample of Dutch slaving ships.[46]

PLATE 136

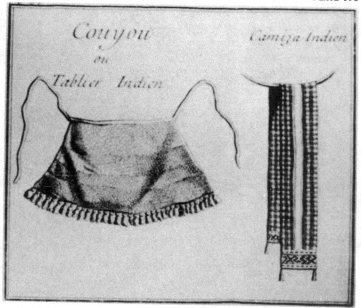

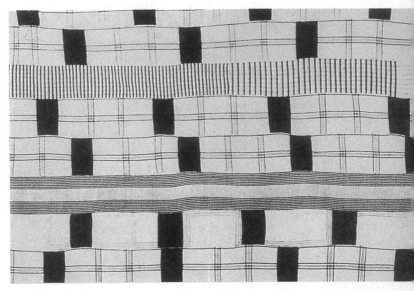

PLATE 137

PLATE 138

But then there is a mysterious gap, between the multistrip loin-cloth of 1823 and the splendid multistrip capes, variously called by runaways *aséesenti* or *aséesente*, that apparently did not emerge among the inland Saamaka maroons until the early decades of this century (Plate 138). Slightly earlier, multistrip cloths called *asée-senti*, made by the Djuka maroons of eastern Suriname, brought the tradition closer to its putative early-nineteenth-century roots in whatever area the Carib bought the multistrip loincloth Denis illustrates (for Native Americans of Suriname themselves in general make.and prefer solid red loincloths). In addition, the Djuka have elaborated a vernacular terminology for aesthetic assessment of mul-tistrip cloths that betrays full consciousness of its metric play. Thus some Djuka distinguish between *dobi sten* ("double voice") pat-terned strips and *stiipi* (literally, "single stripe") continuously unpat-terned strips in *aséesenti* elaboration.[47] "If one adds one *dobi-sten* in the middle of two unpatterned strips it's beautiful," said Ma Apina of Dii Tabiki, capital of the Djuka, in December 1981. She added:

> When Djuka paint something, the colors must clash [*kengi*, literally, "argue"], and where you stop, there must be another color not looking like the one you end with but far away from it [in color].[48]

This particular prizing of elements in contrastive alternation recalls the consciously clashed elements of the Weichmann robe of the early seventeenth century, as well as early, Mande-influenced Akan cotton multistrip cloths of the nineteenth century (Plate 137).

An art history of Suriname that considers the visual traditions of the plantation blacks of the coast and those of the inland maroons as an artistic continuum may well find links between Saamaka *asée-sente* of the twentieth century (Plate 138), Djuka *aséesenti* of the late nineteenth century, and coastal black patchwork textiles *(mamio)* of even earlier facture. *Mamio*,[49] "different pieces of cloth sewn together" (Plate 139), is likely to be a link between West Africa and the inland maroons. It crosscuts both sub-Saharan phras-ing and Western quilt-making patterns. The latter connection would explain why some examples of Saamaka multistrip cloth look like Afro-American quilt-tops and vice versa without invoking a mysterious collective black consciousness. Both in coastal patch-work, a coastal costume called *a meki sanni*, "she makes the moves"

PLATE 139

(Plate 140), and in maroon multistrip textiles, we find color-clashing, alternation of patterned and unpatterned strips, and staggered accents. These are abiding traits in the Mande textile world but were recombined differently in Suriname, resulting in the evolution of new styles that reached their culmination in Djuka and Saamaka multistrip expressions of the early twentieth century (Plate 141).

The traits that announce an African quotient in Suriname are also present in U.S. black quilt-top making. William Well Brown's *My Southern Home* documents a period immediately after 1865 at Huntsville, in northern Alabama, where a black-assembled "queer-looking garment made of pieces of old army blankets" was observed. Random elements of size, siting, and accent may well have accounted for the strangeness of this multipiece garment to Western eyes. What is certain is that an Africanizing (Mande-izing?) wool blanket was fashioned around 1890 by Luiza Combs of Hazard, Kentucky.[50] Her blanket provides a missing link between the rhythmized cloths of the western Sudan and the similarly vitalized quilt-

PLATE 140

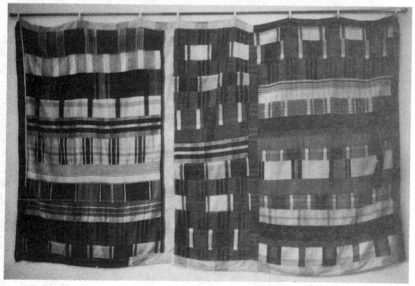

PLATE 141

tops of black North America. Kenneth Combs, the late quilt-maker's grandson, told me in 1980: "My uncle told me Luiza was born in Guinea . . . and that she made other such blankets but they are lost."[51] The stripes of this two-strip blanket are deliberately staggered in relation to one another (Plate 142). Luiza Combs would have been ten years old in 1863, when presumably she came as a child from "Guinea." There are two-strip cloths among the Tukulor and similarly deliberately skewed striping systems among the Bamana, suggesting the possibility of direct crossover from these western Mande-related areas to Kentucky, but only time and future research can confirm this.

Dominic Parisi in the summer of 1979 traveled to Hazard, Kentucky, the town where Luiza Combs worked, and interviewed Margaret Adams, a black quilt-maker. What she told him confirmed an abiding taste, in the assembling of cloth strips, for separation by color contrast, a rationale cognate with the Suriname maroon notion of seeking colors that "fall" (clash) well in combination, of seeking energy and vitality in juxtaposing *dobi sten* and *siteepi*, strips patterned and strips nonpatterned, in the making of Djuka *aséesenti:* You don't want no two reds together, no two blues together. Try to get those colors separated.[52]

Plate 142

Flash of the Spirit

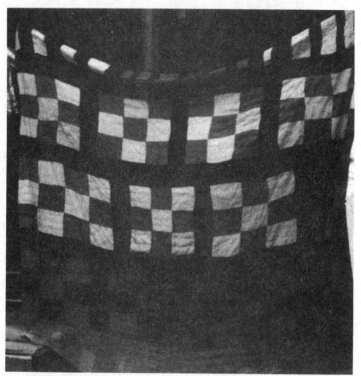

PLATE 143

Randomizing sitings of Western-design blocks ("nine-patch" and so forth) in the work of black quilt-makers like Lucinda Toomer of Dawson, Georgia, or Amanda Gordon of Vicksburg, Mississippi (Plate 143), suggest a trace of Mande visual influence. But only a trace. Aspects Anglo-Saxon and other African forces have complicated these splendid textiles. They gleam at the center of the traditional Afro-American home (Plate 144), as illustrated by a photograph by Maud Wahlman of the bedroom of Susie Ponds, a quilt-maker of Waverly, Alabama.

One final question demands an answer: Why the frequent, seemingly imperative suspension of expected patterning? In the British West Indies patchwork dress keeps the *jumbie*, a spirit, away from a resting place.[53] In Haiti a man procures from a ritual expert, when necessary, a special shirt made of strips of red, white, and blue to

break up the power of the evil eye.[54] Nelly Bragg, an old black woman of Warrensville Heights, Ohio, was asked "Why one red sock and one white sock worn deliberately mismatched?" to which she replied, "To keep spirits away."[55] For similar reasons, traditional Afro-American cabins once were wall-papered with deliberately jumbled bits of newsprint and crowded squares of magazine illustration.[56] In Senegambia it was important to randomize the flow of paths, since "evil travels in straight lines."[57] And the Mande themselves coded, in discretionary irregularities of design, visual analogues to danger, matters too serious to impart directly.[58] Not all textiles blazing with interrupted patterning communicate such symbolism across the Mande Atlantic world. Nevertheless, those pilgrims of the Mande concept of *fadenya* (individuality, with all its attendant dangers)—hunters and warriors, heroic wearers of off-beat textiles—continue to venture into disordered regions, mirroring them, deflecting them with their dress, and come back, as Mary Douglas has memorably phrased a parallel accomplishment, "with a power not available to those who have stayed in the control of . . . society."[59] The double play of Mande influences, *individuality and self-protection*—suggested by the rhythmized, pattern-breaking textile modes, and the *group affiliation* mediated by communal rounds of cone-on-cylinder houses—completes a history of resistance to the closures of the Western technocratic way.[60]

PLATE 144

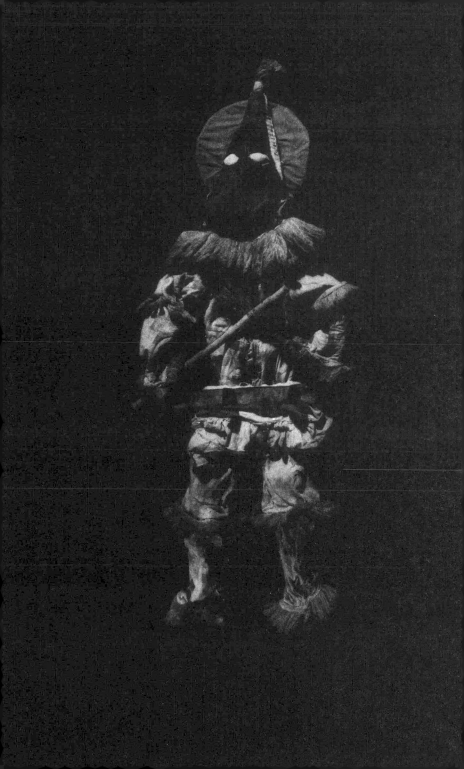

Five

EMBLEMS
OF PROWESS

Ejagham Art and
Writing in Two
Worlds

The ideographs of the Ejagham people of southwestern Cameroon and southeastern Nigeria explode the myth of Africa as a continent without a tradition of writing. The Ejagham developed a unique form of ideographic writing, signs representing ideas and called *nsibidi*, signs embodying many powers, including the essence of all that is valiant, just, and ordered.[1]

Numerous Ejagham women and men in traditional institutions—"the whole country is honeycombed with secret societies," an English explorer observed early in the twentieth century—wear ritual dress and make gestures strongly influenced by the patterns of *nsibidi*, extending the reach and complexity of Ejagham traditional writing.[2] Titled elders in major institutions (Nnimm, Eja, Ngbe) establish power or prestige by mastering arcane signs of sacred presence and recollection, luminous ciphers of the founding rulers and most important women. The force of *nsibidi* is a mystery. Some traditional Ejagham continue to regard this mystery as rationale governing their lives and labor.

Nsibidi, in the Ejagham language, means roughly "cruel letters." *Sibidi* means "cruel" in classical Ejagham, according to Peter Eno of Mamfe, Cameroon, an authority on the art and language of his people.[3] P. Amaury Talbot, an English author, discovered while traveling through Ejagham country that *sibi* meant "bloodthirsty." Consider *nsibidi* writing, then, as justifiable terror in the service of law and government. As might be expected, the traditional execu-

tioner society—men who killed convicted murderers or launched peremptory strikes against outside enemies—was called the Nsibidi Society.[4]

Few see the richest and most awesome of the signs of the *nsibidi* corpus, the intricate diagrams drawn upon the ground to control a crisis or honor the funeral of a very important person.[5] As Peter Eno remarks: "*Nsibidi* signs represent the heart, the very depth of our ancient Ejagham societies, showing the last stage, the final rites, and only the core of the members can come out to view such signs."[6] Ejagham ideographic writing both exalts the power of privileged persons and points to a universe of aesthetic and intellectual potentiality. Poetic play and stylized valor, artistic battles of mime and "action writing" enliven, with pleasure and improvisation, the dark dimensions of *nsibidi.*

Nsibidi do not derive from Western writing systems. There are no Arabic or Latin letters in the script. It is wholly African. The invocation of divine beginnings occasions the writing of certain of the most important signs, even as does the centering of power upon a seat of final justice. The moral and civilizing impact of *nsibidi* betrays the ethnocentrism of an ideology that would exclude ideographic forms from consideration in the history of literacy. Educated Western persons continue to assume that black traditional Africa was culturally impoverished because it lacked letters to record its central myths, ideals, and aspirations. Yet the Ejagham and Ejagham-influenced blacks who elaborated a creole offshoot of *nsibidi* in Cuba have proven otherwise.

Ejagham and Ejagham-influenced captives arrived in western Cuba primarily during the first four decades of the nineteenth century, as a result of the immense rise in sugar cultivation in that portion of the island.[7] The slaves included members of the all-important male "leopard society," called Ngbe in Ejagham. These men founded their own "society," promulgating Ngbe values of nobility and government and remembering the master metaphor of masculine accomplishment, the leopard, who moves with perfect elegance and strength. Ngbe in Cuba was known by the creole name, Abakuá, after Abakpa, a term by which the Ejagham of Calabar are designated.[8]

Nsibidi signs emerged in Cuba no later than 1839, when the archives of the police of Havana received confiscated papers from a black man's raided premises, papers emblazoned with Ejagham-

Flash of the Spirit

influenced ideographs, signatures of high-ranking Abakuá priests.[9] The sacred signs and signatures of Cuban Abakuá are chiefly called *anaforuana*, among other names.[10] More than five hundred signs have emerged among the blacks of the traditional barrios of six cities in western Cuba: Marianao, Havana, Guanabacoa, Regla, Cárdenas, and Matanzas.[11] Most of these ideographs are hypnotic variants of a leitmotif of mystic vision: four eyes, two worlds, God the Father —the fish, the king—and the Efut princess who in death became his bride. These signs are written and rewritten with mantraic power and pulsation. Mediatory forces, the sacred signs of the *anaforuana* corpus, indicate a realm beyond ordinary discourse. They are calligraphic gestures of erudition and black grandeur, spiritual presences traced in yellow or white chalk (yellow for life, white for death) on the ground of inner patios or on the floor of sacred rooms, bringing back the spirit of departed ancestors, describing the proprieties of initiation and funereal leave-taking.

Nnimm and Sikán

At the core of the Ejagham artistic phenomenon we find men and women involved in continuous, intensely spirited, brilliant play. The propelling force of the culture—hidden by some of the densest forests in West Africa—is a conscious choice to create objects and sequences of human motion through the playful application of vision and intelligence. In all the arts and rituals the Ejagham play for the sake of formal excellence, transcending, like the Greeks, their material existence through acts of aesthetic intensity and perfection. Their culture naturally made them the envy of neighboring civilizations—the people of Efut, Ibibio, Igbo, and Banyang territory, who eagerly borrowed the artistic fire of the Ejagham.[12]

Although traditionally engaged in the clearing of forests for cultivation and other hard work (e.g., digging yam heaps), many Ejagham men left most farm tasks to women or hired laborers. And even their minimal cultivating duties were performed by peer groups, whose members urged one another on with songs and rhythms. The Ejagham male was essentially an artist, a hunter, and a warrior.[13] The beauty of his life was that these roles were for the most part sportive. Wars were few and far between.[14] The Ejagham male could therefore concentrate on what were for him real, important

matters: the pursuit of excellence in the making of string-net costumes, body-painting, poetry, mime, and processioneering. He devised new dances or entire dramas and sold them with their appropriate emblems to less talented neighboring civilizations.

But it was the Ejagham female who was traditionally considered the original bearer of civilizing gifts. Ejagham women also engaged in plays and artistic matters. Their "fatting-houses" (nkim) were centers for the arts, where women were taught, by tutors of their own sex, body-painting, coiffure, singing, dancing, ordinary and ceremonial cooking, and, especially, the art of nsibidi writing in several media, including pyrogravure and appliqué.[15]

It could be argued that the more Ejagham women, like their men, devoted themselves to creative consciousness and élan, the more they liberated themselves from subservience and came into their own. Talbot, in his classic study of early-twentieth-century Ejagham, In the Shadow of the Bush, extolled Ejagham women's "mastery of outline . . . far beyond the average to be expected from Europeans." In fact, the high quality of Ejagham and Ejagham-influenced women's arts had caught the eye of European observers such as T. J. Hutchinson, who remarked that "the women of Old Calabar are not only the surgical operators, but are also artists in other matters. Carving hieroglyphs on large dish calabashes and on the seats of stools; painting figures of poeticized animals on the walls of the houses. . . ."[16]

Their ultimate triumph was the spreading of the Ejagham "fatting-house" tradition among the women of Ibibio and Efik country, where Ejagham arts of feminine elegance and power were taught to women of other Cross River cultures. Efik women, in particular, were fiercely proud of what they borrowed from the Ejagham. Thus Madame Grace Davis, an Efik woman of Calabar, has said:

> It used to be thought that the girls just went into the fatting-house to get fat and idle away their time. This is nonsense. Actually, during the time of their seclusion they were given serious instruction in dancing, comb-making, care of children, embroidery, and many other things, including how to make symbolic appliquéd cloths [mbufari.] That is how our Calabar appliqué cloths came into existence.[17]

The gift of an appliquéd mbufari cloth with nsibidi patterns reflected "cool" norms, knowing how to make presents judiciously and with style. Artistically underscored acts of generosity in Calabar

PLATE 145

included acts of honorific submission or service, as in the Efik phrasing "shows obedience to the person" *(suk ibuut no enye)*, which literally means "cool one's head in relation to a person."[18] The women of Calabar continue to give presents on multiple levels of ideographic meaning, for example, by carefully aligning bottles of gin and lager and other refreshments in a brass tray *(akpankpan)*, itself chased with floral patterning made by women, patterns that in the nineteenth century were richly intermixed with *nsibidi* signs. The bottles in the tray are covered over with the bannerlike *mbufari*

PLATE 146

cloth, bearing appliquéd symbols of benison and honor. This orchestrated act of stylized giving—tray, gin, appliquéd cloth covering—can be mounted on a traditional stool richly carved with symbolic figuration (Plate 145).

Mbufari nsibidi patterning reflects the status of the woman who devises it and the status of her husband. Her proper training and individual wit are both implied in the careful use of symbolic color —with white, for example, standing for "peace" or "stability of

relationship"; red equaling "success in bringing children into the world," a "sign of life"; green meaning "plants," "good harvest"; gold, "the light of the sun, the feeling of contentment"; and blue, "water . . . in case your husband hopes to be a fisherman."[19] A woman's depth of accomplishment is evidenced by a detail of an *mbufari* cloth attributed to the grandmother of Mma Eme Abasi Effiom of Calabar, a piece of textile provisionally dated c. 1938 (Plate 146). This cloth communicates a vision of water by means of a chain-motif border in blue. Repeated floral patterns, in red and gold, evoke simultaneous visions of children and contentment.

The brilliant honorific modes of symbolizing ideas with pieces of cloth (as adapted by Efik and Efut women in Calabar) inform Ejagham wall paintings among the remote forest villages of the Ekwe clan. The wife of Amaury Talbot sketched a mural on an important house at Nfunum, between Lake Ejagham and Ndebiji, just inside what is now western Cameroon:[20]

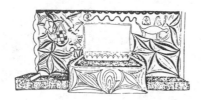

The painting is emblazoned with a scalloped border at the top, casting the composition in a watery mode, consonant with important Ejagham myths about the origins of the male and female societies, Ngbe and Nnimm, within the river. Petaled, leafy elements, pulsing like starfish under clear transparent water, add, like *mbufari* green, notes of power and abundance, thus enhancing and exalting the checked (signifying leopard pelt) and feline symbols of sovereignty and government.

Ejagham women with the prestige of membership in the Nnimm Society had even greater occasion to exercise their sharp aesthetic faculties. A woman entered Nnimm as a young girl, before marriage. Partaking of powers mystic and political, she became a leader among women.[21] Nnimm women, in full regalia, were virtual walking charms, laden with material allusions to forces in the skies and in the

depths of streams and rivers. Their ritual dress was rich and sumptuous; their body-painting sure and cursive, not unlike the calligraphy of the southern Sung of China.

The same petaled elegance of line that danced across the walls of the "treasure house" at Nfunum here achieves equipoise upon the initiate's brow and cheeks. Glints of forest power, signaled by a feline silhouette and a long-tailed leopard at Nfunum, are materially suggested by the myriad shells and calabash containers making up the bristling initiate's dress. A crown of feathers adorns the head of the Nnimm woman. Monkey bones project starkly and enigmatically from the sides of her impressive coiffure. Concentric necklaces, bound in leather, go about her neck and rest upon her shoulders. Finally a cowrie-fringed wrapper of palm fiber, dyed crimson, completes her costume (Plate 147).

Most important was the single descending bowlike feather emerging from the back of the initiate's head. This was the Nnimm feather. It specially identified the Nnimm woman, marking her as

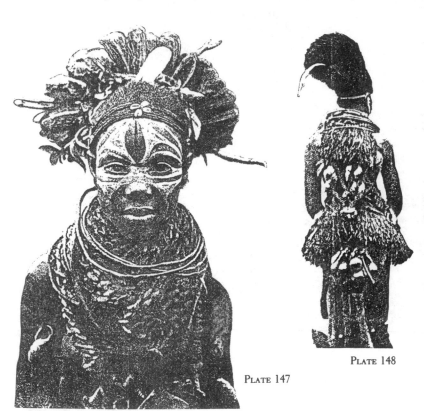

PLATE 148

PLATE 147

different from ordinary persons. The first Nnimm woman, so it is believed in Ejagham, came down from heaven with this special feather in her hair.[22] Nnimm women moved, as the forest moves, as the sea moves, in a swaying, chiming mass of fibers, bones, and shells. Beyond use, beyond disruption, the image of the Nnimm woman was a multitextured manifestation of potentialities, resisting the pigeonholing of women as purely instruments of labor. Fear of what these women had intuited and stored within their objects provided checks against injustices that might have been committed against them by men or other women.

In Ejagham country, women maskers wear an impressive plumed headdress called "calabash-head" *(echi okpere).*[23] The flashing twinned light of mirrors can be added to such structures, warding off all evil. Stately plumes, dyed blood-red, rise like feathered sentinels. The plumes can stand for titled women within the Nnimm Society (Plate 149).

Aban dancer with
"hoop-skirt" *(nkpin)*,
feathered headdress,
and beaded panoply. After
Kenneth C. Murray, 1939.

Like the bristling "medicines" that adorn the Nnimm initiate's body, the calabash-head headdress is characterized by a dazzling recombination of elements: blood-red standing plumes, red and white strands of cotton, diamond-form devices dyed forest- or harvest-green, and miniature versions of the Nnimm feather appearing at the summit of the plumes.

The structure of these plumes is special to the Ejagham, hence unmistakable when they reemerge in Cuba to attain full and lasting value. Nnimm as an institution did not survive the shock of the Middle Passage. But the whole point of Ngbe ceremonial was to honor, in part, the mother of the sounding leopard, Ebongó, who in Cuba was replaced by another female figure, Sikán. And wherever Ebongó or her Cuban counterpart appeared, we very often find Nnimm-like plumes and decorations. Afro-Cubans, in fact, assume that Sikán belonged to some powerful "matriarchal" society (i.e., Nnimm) and that women knew the secrets of Ngbe, its rites and writings, before men did.

Thus the theme of silence and femininity recurs in the iconographics of Ngbe and Abakuá. Feather symbolism, connoting silence for instance, informs Ngbe and Abakuá sacred musical instrumentation. Ngbe mourners display "drums of silence," short cylindrical, wedge-tuned drums to whose sides plumes are attached. The skin of such drums can be shaded half white, half black to form *nsibidi mboko*, sign of the messenger of death, or, quartered by two intersecting lines, forming *nsibidi nkanda*, sign of the "crown" of the seven or more Ngbe grades or branches:[24]

The "speech" of Ejagham drums of silence arises from the signs chalked upon their skin and from their special plumes, with the eloquence of prestige and spiritual presence. Such drums, with their

Flash of the Spirit

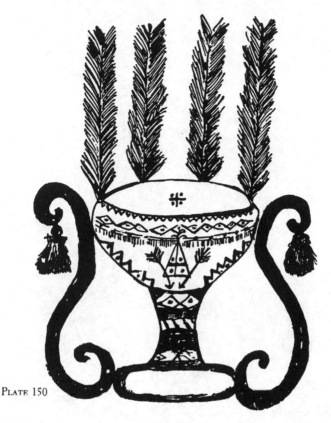

PLATE 150

plumes, came to Cuba. We meet them in Abakuá funerals and
initiations, as the *Sese* drum. "*Sese*," said a black Cuban priest of
Abakuá, "is not a drum as the whites understand such instru-
ments."[25] It is an instrument of display, not for use, an instrument
of significant silence, not reverberation. It is material writing, to be
read, not heard (Plate 150).

A feather seals a dancer's lips with a sign of silence in Calabar.
The addition of wooden shafts wrapped with feathers to Abakuá
drums similarly transforms them into silent, honorific presences.
Abakuá consider *Sese* an incarnation of Sikán, a powerful female
spirit at the heart of their society. And this belief deepens the
continuity of the meaning of the plumes, silence and nobility, and
their Nnimm-like bearing. Abakuá state explicitly that *Sese* repre-

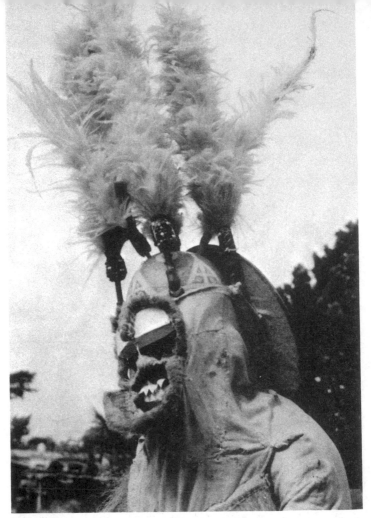

PLATE 151

sents the head of Sikán. The drum is an abstract mask, with plumes like *echi okpere*, representing important personages, and a triangular sign, the signature of the priest called Isué, who alone has the right to hold this silently sounding instrument. And thus the plumed and feathered glory of Nnimm-like presence comes alive in Cuba, as documented by a drawing of a *Sese* drum rendered by an Abakuá member and published in 1954 (Plate 150).[26] Tassels and volutes frame this Ejaghamizing vision; they cryptically allude to the first

letter of Sikán's name, thus complicating one form of writing with another.

The standing plumes of Nnimm/Sikán, ciphers of a circle of departed dignitaries, reemerge in a ritual mask representing Sikán, great princess of the Efut, a civilization just to the south of the Ejagham (Plate 151). Saibeke, titled priest of Abakuá, made this mask in the Havana area, according to Lydia Cabrera, between c. 1925 and 1954. It was inadvertently destroyed in 1961. The illustrated photograph, taken by Pierre Verger in 1957, therefore reflects a vanished monument of Afro-Cuban art. The mask is called *Akuaramina*, creolized Efik for "Great Spirit." The curve of the great tassel-covered calabash with bristling plumes for Nnimm in Ejagham (Plate 149) remains in place but, here, is "signed" with ideographs of the priest Isué, carefully painted at each cardinal point.[27] Instead of honorific tassels and colors symbolizing richness of achievement and initiation, the curve of the calabash leads directly to an ingeniously constructed Janus mask, one visage staring into the future, the other at the past, symbolizing clairvoyance and presence in two worlds. This mask, honoring a great woman and her power, brings the noble plumes of Nnimm, towering and magnificent, to the world of Afro-Cuban art.

Ejagham believe that Nnimm women were privy to ancient secrets first given by—or seized from—beings in the river or the sea. They say that Nnimm is at least as old as Eja, a venerable war society concerned with "subduing enemies and evil."[28] And Eja, we know from a European document, was in existence at Calabar on the coast west of the Efut, south of the heartland of the Ejagham, in 1668.[29] Some Ejagham aver that the Nnimm Society actually derived its powers from the waters of the Ndian River, flowing through northern Efut territory, a little-known Bantu civilization east of the Calabar and south of the Ejagham. The Efut adapted, disseminated and very richly rephrased Ejagham art and culture to the point where Efut lodges of the leopard society carried more prestige and were the costliest to join c. 1877–78.[30]

It was an Efut man from Usaha-Edet, an important cluster of three Efut villages along the creeks of northern Efut, who sold the secrets of the Ngbe Society to the Efik of Calabar c. 1750.[31] The Efik adopted the Ngbe Society and renamed it after their own word for leopard, *ekpe.* The Efik found in Ekpe (Ngbe) a source of secret vengeance and moral circumspection, an ultimate mysterious au-

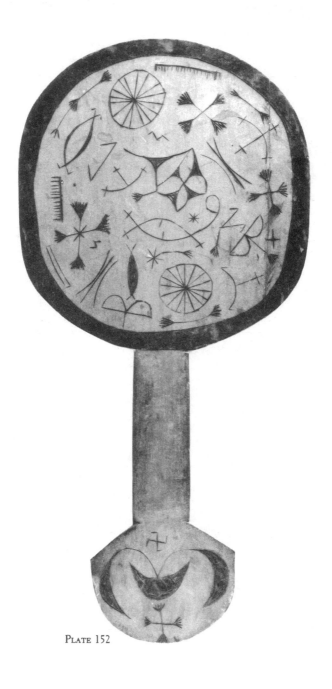

PLATE 152

thority, rumbling "like the belly of a guilty man" behind a curtain in the Ngbe hall. In the name of this Voice, laws were made or canceled, debtors forced to pay, and European arrogance defied.

A new source of authority and moral insight had entered the world of Calabar precisely when the area was heating up under the impact of the growing slave trade in the late eighteenth century. Ekpe (Ngbe) permeated the southern regions of the Cross River partly through the natural consequence of the influence and power and prestige of Calabar. And the Efut of Usaha-Edet, the link to all that was beautiful and morally impressive in Ngbe, was the tutor of Calabar. Usaha-Edet, one of whose citizens sold Ngbe to Calabar, has taken on among some Afro-Cubans the status of a holy city. Usagaré, as the latter call Usaha-Edet in creole Abakuá idiom, is sacred because there, so it is believed in Cuba, the first secrets of God were revealed by the banks of the Ndian creek (Abakuá: Odán, imaginatively further creolized by Christian Abakuá as the river Jordan).

According to Afro-Cuban informants, the origins of Ngbe are as follows:

Tanze was an ancient king of the Ejagham. A long, long time ago, when the king died, his spirit became a fish, which a woman captured, discovering thus in the river the fortune of the kings of Ejagham. And a man came and took this power away from her, killed this woman, and set up the religion [of the leopard society]. Lord Tanze was a departed king who entered the body of a fish and then became the body of female drum *(Tanze so mismo rey viejo Ekoi. Ne murí jaya tiempo, tiempo ante, y píritu di e bobé pecao que mué coge, ne contrá lo río la suete lo rei ekoi, y varón quitá neye, mata mué, pa poné un religión. Obon Tanze e rey mueto que entrá pecao y pasá bongó).* [32]

Here is a different version of the same myth:

Efut were the people chosen by God to receive the Secret, there, near Efut Ekondó, the right-hand side of the Efut monarch's territory, opposite the left-hand territory, Efut Abua, in northern Efut in the region of Usaha-Edet, south of Ibunda.

There lived a princess named Sikán, daughter of the lord of Northern Efut, Mokuire. Every day she went to fetch clear water from the Ndian from a large calabash left overnight within a hollow underneath a towering palm tree standing sentinel upon the riverbank.

On the fateful morning that she met her destiny, she took water from the river in this manner and placed the calabash-container on her head. She had not gone several paces when she felt something moving in the water in the vessel balanced on her head. A roar like thunder sounded in the water carried on her head. Sikán Sina Yantan did not suspect that at that very moment her head had already become sacred by contact with the presence of The Almighty, nor that she, a woman, was carrying salvation to the people of Efut.[33]

The spirit Sikán had captured for her people was a fish who had been king, who some say was God himself. Afro-Cubans know this fish by the name Tanze, which, provisionally at least, seems a creolizing combination of the Efut word for "lord" or "father," *Ta*, with the standard Ejagham for "fish" *(nsi)*. As a lord or king, Tanze by definition had his leopard spirit, his leopard double, who leaped when he was in danger, carrying him beyond, making him athletically and militárily invincible. The creolized praise names of Tanze that have come down to us from ancient Efut via western Cuba make these powers plain:

Fish of the river
Fish of the sea
Sacred sounding Voice
Excellent beyond all measure
Arriving grandeur,
Who melts into a leopard's body
Who melts into a leopard's body
Force for whom our old diviners yearned
Eyes in the water, yellow eyes of life.[34]

According to another Afro-Cuban informant:

The sacred fish lived for a while in its calabash container and then it died. A grand Efut priest, Nasakó, began the rites to recapture its spirit within a sacred object in which its mighty voice could sound again. Nasakó removed the skin from the body of the fish. Later, in his sanctuary, he traced the first symbol of the leopard society upon the skin of the fish . . . the symbol of renaissance and immortality.

Flash of the Spirit

Over the skin of Tanze, Nasakó initiated the seven sons of Ngbe, the founding persons. These represented the seven clans of Efut. These seven chiefs, born in the beginning, included titles which have come down to us in the Ngbe hierarchy, such as it was elaborated among Efut: Mokongo, Ekueñón, Isué, Mpegó, Iyamba, and Nrikamo. Their souls are present today in the seven plumes (of the Abakuá lodge).

... Nasakó then began to build a sacred object for the spirit of Tanze, a base in which his Voice could again resound. He covered, with Tanze's sacred skin, the mouth of the calabash in which the Fish had lived. ... But this skin-covered calabash gave back the Voice of Tanze weakly. It was but a shadow of his Voice. Nasakó's divining-instrument, *mañongo pabio*, then spoke, saying it was imperative to bring the instrument to stronger life with Sikán's blood. And Nasakó then ordered Sikán's sacrifice.[35]

By mere contact with the presence of the Voice, Sikán became in essence the bride of God. Hence the death of the fish predestined her demise, and she was sacrificed so that her blood, combined with his, might bring back his spirit to the secret sounding instrument. Nasakó summoned her spirit after sacrifice by attaching her skin to the instrument even as he summoned Tanze's spirit by these means. And it came to pass that through this orchestrated union, skin on skin on wood and other media, male and female valences fused within a single object and Tanze's mighty voice—"the fish that thunders like a bull"—returned. The accomplished miracle assured the moral continuity of the Ejagham and the Efut and, centuries later, the Abakuá.

Thenceforth the elders could devise laws and sanction them by referring to the living roar of the Voice, the Lord, the Leopard, the Mystic Fish, sounding behind a curtain in the Ngbe hall.[36] The site of the roar became a court of last appeal. The Voice was the moral terror that forced an erring person to mend his ways, that commanded hardened criminals or murderers to be killed, that announced a reported incidence of adultery or some other crime against the well-being of the town. Tanze, within the council hall, became the source of certainty.

But the crucial role of women in Cross River culture is emphasized by the fact that even today, among the Ejagham of Calabar, when a king dies, his leopard spirit is said to flee into the forest, and cannot be persuaded to return to proper government to start anew,

until mystic chains are cast to ensnare him and an elderly woman with a rooster held aloft stands before the leopard-society house and calls out the names of the great ancestors, one by one. Only a woman can call the leopard spirit back because, so it is believed, the leopard society was first a women's society.[37]

Nsibidi and *Anaforuana*

The late king of Oban in southern Ejagham told me in the summer of 1978 that *nsibidi* emerged in the dreams of certain men who thus received its secrets and later "presented it outside." That was version one. And then he told me version two: "How nsibidi started: *mermaids* showed us how to write nsibidi" *(nga nsibidi adohe—aku natóngena wud nsibidi)*. A vision of writing emerging from the places where bells and gongs echo beneath the water, when Ngbe is being played upon the land, prepares us for the resonances of this indigenously African form of script. For *nsibidi* is more to be aesthetically played and displayed, in valiant jousting contests of erudition, than to be written and understood in any strict or linear Western way.

The power to notate most important happenings with emblems and ideographs and the confidence that comes from contact with and descent from the secret noble source, the lord Tanze within the instrument, inspired the establishment and continuity of Ngbe in Efut and creolized Ngbe (Abakuá) in Cuba.

Nsibidi symbolize ideas on several levels of discourse. First, there were signs most people knew, regardless of initiation or of rank in the Ngbe Society, signs representing human relationships, communication, and household objects (which themselves were in some instances used as material-ideographs):[38]

love, unity, comparability:

hatred, disunity, divorce:

word, speech meeting, congress:

mirror, looking-glass:

table set for drink and meat:

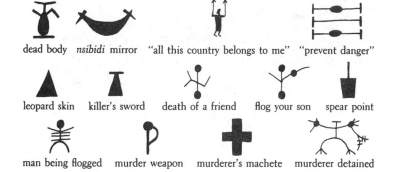

trek, journey, voyaging, tracks:

Afro-Cuban men, who were able to scale down ceremonial drums to equivalent objects only inches high when occasions for dissembling their religion through miniaturization arose, were indeed the spiritual descendants of men and women who could conjure love within enlacements, separate and drive a wedge between curves to indicate divorce or hate, and let a simple small cross, symbolizing the intersection of two points of view, multiply, in intensity of exposition, until it came to designate a congress or a full-scale meeting. As the signs proliferated in all their variations, they came to resemble a vast musical score.

Secondly, there were serious signs of danger and extremity, the "dark signs," and these were often literally shaded:[39]

dead body *nsibidi* mirror "all this country belongs to me" "prevent danger"

leopard skin killer's sword death of a friend flog your son spear point

man being flogged murder weapon murderer's machete murderer detained

Shaded signs designated danger, even as drums of silence announcing the death of an important Ngbe member were shaded half black and half white, both to speak of the pain caused by the departure of a family member and to prepare the path to assuagement: black stood for river mud or death, and the white stood for water or freshness and vitality, according to the proverb "Where there is mud, there must be water."[40] Thus the usage of *nsibidi* musically counterpoints visual and verbal arts.

The syntax of *nsibidi* signs also recalls some of the pleasures of music: repetition, call and response, and correspondence. Ritual fans bearing pyrograved *nsibidi* illustrate the point—fans called *effrigi*, used in traditional villages in contexts involving initiation. One example, acquired by the Industrial Museum of Scotland in 1859, bears a border filled with patterning said to represent inconstant love. These signs of separated curves, almost always diagnostic of some sort of deeper separation, surround an amazing buzz of different signs, neatly rendered with the heated end of a metal stylus. Another, later example, showing fewer signs, was collected by the Nigerian Museum in Lagos in 1950 (Plate 152).

PLATE 153

Flash of the Spirit

The concepts represented by this fan are not spelled out in treatise form but rendered through repetition, through "visual music." There are twinned signs of social disintegration, harlotry, leg irons or punishment, trouble or speech upon the crossroads; young men gossiping on the council log; high levels of convocation. Emblems of speech are thus countered by ciphers of parlousness and interspersed with signs of trouble and predicament, an implied warning to those who talk idly, to those unaware of the consequences of unprincipled discourse and disputation.

Thus far our examples have been purely Ejagham, but the men and women of Usaha-Edet among Efut, and Bende among Igbo, and Ekeya among Okobo Ibibio were renowned for excellence in the arts of Ngbe and the writing of *nsibidi*. Here we consider *nsibidi* as a women's art, a "fatting-house" accomplishment par excellence. The illustrated work is a calabash tray (Plate 153) from Ekeya, made in this century before 1938, on the right bank of the Cross above Oron. Here the *nsibidi*—stars of love, shaded triangles suggesting power and danger within the leopard society, spirals of motion, and checked patterns restating once again Ngbe grandeur—revolve around the core of the calabash in a playful, vital manner. Leaflike cartouches enclose each sign. These are connected to one another by means of stems or leafy points.

Finally, there were important *nsibidi* signs of rank and ritual among the higher branches of Ngbe, Nnimm, and other societies. Ngbe houses, for example, pridefully unfurled great cotton cloths with blue and white tie-dyed blazons in *nsibidi* script. These were the great *ukara ngbe* cloths, privileged textiles of prestigious houses having the coveted Nkanda branch. In recent years a full spectrum of color has been added to indicate the richness of mind and elaboration represented by the Nkanda branch. A sign circumscribing radial accents could similarly indicate complexity of initiation among the Ngbe members of the Bende Igbo, who call such signs *Nsíbiri*, meaning "you all around, you have all the secrets."

Women had their secrets too, knowledge of supernatural underwater transformations, lore about fish that were really leopards, leopards that were really kings, and many other forces. They slyly interposed some of these "heavy," awesome images in the decoration of outwardly secular objects—calabashes, stools, and trays—confident that only the deeply initiated would catch the glint of power veiled by decoration. For example, a chased brass tray *(ekpankpan)* from

Old Calabar now in the Glasgow Museums and Art Galleries (1894.58d) shows two checked "leopard" fish beside a "mermaid" with a chewing stick. (The "checkerboard" motif is an ancient Ejagham symbol of the leopard.)

In sum, the formal world of *nsibidi* writing was glorious and vast. It encompassed signs of love and domestic household objects and human communication, signs that the people knew and used. It encompassed shaded signs of moral terror and punishment, shaded signs of danger and extremity. And finally it encompassed complex signs and signatures of the most privileged ranks of the Ejagham societies, particularly Nnimm and Ngbe. To attain high rank was to view at last impressive calligraphs rendered on the floor of inner rooms or upon the earth in secret forest groves. Public signs, shaded emblems of terror and moral intimidation, and complex secret hierarchical signs of deepest initiation—all were *nsibidi.*

In 1839, nineteen years before the British explorer Hutchinson noted the presence of women's "hieroglyphics" in Old Calabar, and nearly a century before a brief flurry of European articles on Nigerian *nsibidi* appeared in print, a black dock worker named Margarito Blanco attempted to found an Abakuá lodge in Havana. Blanco doubtless had been inspired by the success of the first lodge in Regla across the harbor from the Cuban capital some three years earlier. He had planned to take the title of Mokongo, keeper of Abakuá justice, a title believed once held by the father of Sikán himself, but the police of Havana arrested him before he could set up his lodge and charged him with "conspiracy." They seized his papers. And thus the archives of the police of Havana came into possession of a precious scrap of paper on which Margarito Blanco had traced an early *nsibidi-* derived sign in Cuba, a circle reported as being identical with the modern Mokongo sign, i.e., quartered and showing two pairs of staring eyes:[41]

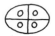

As the many branches of Ngbe were compacted into two in Cuba,[42] the glory and specifications of power that make up Nkanda-branch symbolism in Calabar seem to have infused Abakuá writing from its earliest documented instances. Margarito's sign of the Mokongo title strongly resembles the quartered-circle sign of Nkanda as well as the ancient Efut *nsipidi (nsibidi)* of "the child of

Flash of the Spirit

Ngbe," *obonekpe* and cognate Igbo expressions elsewhere in the *nsibidi*-using universe:

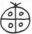

Afro-Cuban *anaforuana* sign,
the signature of the Mokongo
title in Abakuá, Havana, 1839

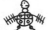

Afro-Cuban *anaforuana*, Mokongo
signature, Havana, 1954

Efut *nsipidi*, child-of-Expe sign,
Calabar area, 1951

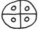

Efik *nsibidi*, "Nkanda calabash"
Calabar, c. 1925

Nsibidi Nkanda sign, drawn on
drum of silence, Oban Ejagham,
1978

Aro Igbo (?) brass bangle
with *nsibidi* pattern,
nineteenth century (?)

Nsibidi pattern on skin of a
drum collected at Akoa, Anyang
area, Cameroon, 1908

Analogies to the structure of the Mokongo emblem can be found far and wide, and most have to do with the prestige of Nkanda, which a person of the rank of the father of Princess Sikán, Mokongo, would certainly have belonged to, and with generalized Ngbe or Ngbe-related symbolism, such as signs collected among the Efut of Calabar and the Anyang of Akoa north of the upper Cross River facing the heartland of the ancient Ejagham.

The meanings that black Cubans attached to this sign show a richness of imagination and a celebration of the Ejagham sign-making tradition. They say the three plumes atop the circle stand for three settlements in Efut country, Usaha-Edet, Bekura, and Efut-nsun.[43] The circles within the quartered area symbolize the eyes of Tanze and the eyes of Sikán, and the fusion of their powers. Other informants in Cuba interpret this sign as symbolic of the primordial calabash in which the Voice was abstracted from the waters, echoing the plumed and quartered "nkanda calabash" *nsibidi* collected in an unpublished study by Jeffreys in 1923. In sum, Margarito Blanco had taken one of the primordial signs of the *nsibidi* corpus, a sign redolent with associations of prestige and celebration, and adapted it to symbolize a priestly title within the new creole Abakuá Society.

Early *nsibidi*-derived signs of Cuba had to do not only with priestly signatures but with the identification of entire towns. Thus, in 1882, *La Correspondencia de Cuba* published the Abakuá signature of the town of Regla, where the Abakuá rites were born:[44]

This illustrates the mirror-play of special quartered circles and intersecting arrows with shaded feathers. By this time in Afro-Cuban history, men of Calabar descent not only had devised heraldic devices in their own calligraphic script to signify the sugar towns of western Cuba but had also renamed them, in creolized Efut. Havana became Nunkwe Amanisón Yorama. Matanzas was renamed Itiá Fondaga. Cárdenas was called Itiá Kanima Usere.[45] There was also in existence in Cuba at this time the usage of the shaded *nsibidi* of extremity and terror. There was a fabled nineteenth-century sign of "war and blood" *(guerra y sangre)* which Abakuá used when one lodge broke off relations with another and was about to fight. This war sign consisted of a quartered triangle with two heavily shaded feathered elements, very likely abstract shafts of war. The triangle also enclosed cross-patterns with small circles at their ends, plus an emphatically overdrawn or shaded cross in the lower right compartment.[46]

There was another, very expressive, complex sign of "war and blood" that has come down to us from the "days of the Spanish colony," i.e., the nineteenth century.[47] The latter sign displays, again, a cross with small circles at each end. This special cross is superimposed on a small circle within a larger circle, the latter figure being shot through with arrows of war. Plumes at the top of the emblem suggest that the circles stand for a drum of honor, resting upon a four-sided stand, with the latter element itself sectioned into areas, many bearing additional signs:

Abakuá "war and blood" sign,
Havana area, 1882.

Flash of the Spirit

Nsibidi of argument and poison overlapping Cuban sign	Abakuá "war and blood" sign, northwestern Cuba, attributed to the nineteenth century

 "two men have an argument every time they meet"

 "wound"

"poisoned bow and arrow"

Shaded feathers recall the "dark" signs of war in the *nsibidi* corpus (adding a note of belligerence and toughness to the nineteenth-century signature of the town of Regla, as well). The cross with circular termini would appear cognate with African *nsibidi* of poison and danger—shaded black circles.

Signs of initiation were also emergent in Cuba. Talbot described Nkanda initiatory signs chalked upon the back and chest of Nigerian Ngbe postulants, "five rings made on front and back." In 1882 one of the first descriptions of Ngbe-derived Abakuá initiation was published, together with three initiatory signs (Plate 154):

PLATE 154

mativamente, se les hace la señal de la cruz en la frente con yeso amarillo y la forma que se estampa es así +; otra cruz se les hace en el pecho cuya forma es esta $\frac{+}{\circ}\Big|\frac{\circ}{+}$ y la cual sirve de firma ó sello que se le imprime antes desde fuera de la habitación, para que cuando entren al juramento vean los que lo reciben que ya éste se halla listo para profesar. La tercera cruz se hace en la espalda desde el cuello hasta la cintura y es de esta forma $\frac{\circ}{\circ}\Big|\frac{\circ}{\circ}$ la cual significa que ya ha profesado, por cuya razón se le pone después del juramento.

The sign of the cross is made on his forehead in yellow chalk [yellow is a sign of life] and the design so drawn on him takes the following shape: ＋ Another cross is made on the chest, the form of which is as follows: ☩ This serves as a signature to be marked before the adept leaves the room, so that when he enters into the formal swearing-in those who receive him will see that he is ready to profess the faith of Abakuá. The third cross is made on his back from the neck to the waist and it takes this form: ⊹ This means he had now taken his vows.[48]

Margarito Blanco and the men who came after him concentrated their calligraphic energies on the reformulation of Ngbe signs of initiation, discipline, and funereal leave-taking. In the process, the term *nsibidi* apparently was lost, and in its place emerged three creole terms: "signs" *(anaforuana)*, "signatures" *(gandó)* and "revelations" *(ereniyo).* [49] The first-mentioned word is becoming the standard name for Ejagham-Cuban graphic writing. The last term, referring to that which is seen, puts the fundamental concern of *anaforuana* with mystic vision in perspective.

For most of the *anaforuana* signs of Cuba, written like *nsibidi* in lines of uniform thickness tracing essentially geometric shapes, have to do with mystic vision—the theme of four eyes—just as in Cameroon membership in Ngbe is synonymous with "seeing Ngbe,"[50] i.e., demonstrating formal knowledge of its secrets and its constitution. Frequent *anaforuana* patterns elaborated in western Cuba include quartered circles ⊕, multiple crossed arrows ✖, quartered diamond-forms with mirrored plumes ◈. A strong preoccupation with crossroads imagery and the mediation of power across worlds, as in Kongo art and writing, is apparent here: ＋ ⧻ ⧺ ♕ Moreover, a strong liking for the image of the arrow, sign of war, token of aggression and manful self-assertion, reflects more than a trace of the Ejagham male commitment to formalized combats of aesthetic virtuosity and initiatory depth. *Anaforuana*, a creole concentration upon certain ancient themes, hypnotically repeats and subrepeats a theme of mystic surveillance and completion. *Anaforuana* writers impart grace and force to sign after sign through the repetition of the theme of the paired eyes of Tanze and Sikán at the boundary between worlds. It makes no difference whether a particular sign or emblem is circular, diamond-form, open and curving, a calabash or horn design—the eyes of Tanze and Sikán ceaselessly appear:

It cannot be overemphasized that even as Westerners in the
Middle Ages wrote down and memorized what was most precious,
most holy to them, the founding priests of Abakuá rendered in
ideographic writing the basic images and tenets of the society. Thus,
at some point after the 1830's, when Canary Islanders began to be
brought to Cuba as cheap labor on a plantation where "there was
nothing but Africans and Canary Islanders," every Sunday afternoon
the Carabalí (men and women from Calabar slaving areas) came
together to relive their culture:

> They used to tell stories, very beautiful stories, and, above all,
> they remembered their homeland. Whenever it was the saint's
> day of one or another of them, they would set up an ironing-board
> and draw with chalk upon this board something like a calabash
> with seven plumes—

> My uncle used to tell me: "That be *ereniyo*—writing—stand for
> woman they killed, be Sikán and the Fish."[51]

Indicating the primordial calabash in which Sikán captured the
sounding fish of God within the waters of the Ndian, this nine-
teenth-century Abakuá design strongly recalls Nkanda plumed cala-
bash themes as well as feathered signs of festivities in Ejagham
symbolism:

In the image of the feathered calabash the creative intelligence
of the Ejagham was returned to Cuba. By the time of the present
century this particular emblem had been elaborated into a superbly
rendered calligraphic work of art: a central, descending arrow, mark-
ing the center of the design, led the eye from one position within
the founding myth (the finding of the Fish within the calabash) to
another (the circle of the instrument wherein the spirits of Sikán and
Tanze forever were combined). The central arrow, the seriousness
and grandeur of which is suggested by its shaded plumes, is flanked

by simpler arrows. This image unifies revelations of great power and mystery. And within the curving outline of the calabash of Sikán four double pairs of staring eyes challenge us with the persistent vision of the ancients of Ejagham.

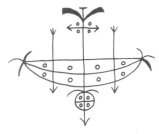

The common aim of *anaforuana* signs is the unfolding and elucidation of the richness of Abakuá art and ritual. As an Abakuá informant himself defined them, they are "reaffirmations of what happened in Africa at the founding of the ancient lodges . . . evocations, sacred authorization emblems, imparting force to what is done here [in Cuba]."[52] In addition to the recapture of elements of the past in certain signs such as the one we have just observed above, and the awarding of power to titled priests in the granting to each one his own particular signature, plus the ritual mapping of initiation ceremonies, and ceremonies of leave-taking of this world, *anaforuana* declare war, maintain discipline, authorize new lodges and brotherhoods, and announce the special Abakuá fiestas called *plantes*.

"Authorization signs" are drawn to symbolize the swearing-in of a person to a vacant position in the Abakuá hierarchy.[53] The sign validates the candidate and indicates he has the permission of the brothers to assume his post. Structurally, such signs combine a representation of the calabash of origin, plus the latter's honorific plume, with a horizontal arrow bearing the emblem of the particular title being filled. In the gesture conjured by this kind of *anaforuana* sign, one kind of beginning is significantly crisscrossed with another.

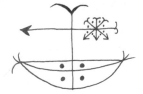

Flash of the Spirit

Each priest or highly titled member of Abakuá also has the privilege of a special blazon, a signature called *gandó*. In the authorization sign just examined, the crossed-arrows blazon of the Iyamba title is held aloft over the calabash or origin symbol. Iyamba is "first priest of the leopard-lord," and he takes as his signature four crossed arrows, two marking the cardinal points and two marking the points sited in between. The informants of Lydia Cabrera, from whose monumental study of *anaforuana* (some 512 examples) the following evidence is culled, state that the arrow marking the sign of Iyamba stands for his personal arrow while the perpendicular one indicates his nobility (evidence consistent with the indication of rank along the horizontal axis in authorization signs). The same informants allege that the raking arrow slashing to the left in the Iyamba signature stands for his prowess in sorcery, whereas the corresponding, right-hand raking arrow indicates his prowess in the war.[54] The interpretation here is clearly linked to left-right nuancing of objects and ideas, with the "left" being the covert side, where mystic war is waged by secret means, whereas open warfare belongs to the more positive right-hand side.

The crisscrossed signature of the Iyamba title, shorn of creole flourishes, points, and feathers, very much recalls *nsibidi* variously interpreted to mean "speech," "the paw print of a forest feline," the sign of leopard society, and even wealth in accumulated copper bars. The latter meanings appropriately modify the image of the feline lord within the sounding instrument, which Iyamba has the honor of guarding. As a matter of fact, Iyamba is the priest in Abakuá who actually makes the sacred sounding instrument speak.[55] In the crisscrossing of these arrows, richness of speech and the ferocity of spiritual attack seemingly become visible.

Each of the signature-*anaforuana* of the Abakuá recasts, rediscovers, and exalts, in different ways, essential images of the myth of Tanze and Sikán. Sikán's executioner, *Ekueñón*, takes as his sign an arrow across the line between two worlds whose feather has been half ruined, symbolizing loss, death, execution (Plate 155). The point is

PLATE 155 PLATE 156

well illustrated by one further example of a sign that identifies the possessions and the presence of a high-ranking priest. The signature of Isunekue (Plate 156), guardian of the Voice of the lord within his instrument, combines a diamond with four staring eyes over a slashing arrow with four eyes over a triangle with yet another pair of staring eyes. The masklike, diamonded device at the summit of the sign recalls the signature of the most feared of the messengers of Abakuá, Nkóboro. The slashing horizontal arrow represents the martial prowess of this priestly figure and the triangular structure underneath is interpreted, by some Abakuá members, to represent the hill at Ibon Nda, in ancient Efut, where the spirit of the lord leopard-fish, Tanze, was first invoked.[56] And, of course, in the eyes within the Voice, the eyes of Tanze and Sikán, the power of surveillance and vision, the deepest force of Abakuá, discloses itself.

The quartered diamond, shared by Isunekue and Nkóboro as symbolic emblem for stern and fearsome priests, especially Nkóboro, overlaps the image of dangerous or evil men in *nsibidi* patterning collected among the Afikpo Igbo of the Cross River.

Anaforuana: the blazon of Isunekue *Nsibidi:* "bad palaver man"

Anaforuana: the blazon of Nkóboro *Nsibidi:* "a bad man"

If the *gandó* or signatures of the ranking priests of Abakuá appre-
hend in compact form both their individual powers and their em-
bodiments of the essential vision and history of the Abakuá, their
complex funereal signs map and indicate passage to the other world.
They are structured according to the creolizing genius of the Aba-
kuá. In other words, such signs represent an assimilation and trans-
formation of *nsibidi* of death and mediation. *Nsibidi* emblems of
death among Ejagham and the clans of their neighbors often appear
in material media of stark and dramatic force. Near the settlement
of Nko-Obubra in August 1978 I photographed a shrine to the
memory of a dead person—a white enamel basin suspended, upside
down, pierced and nailed to the summit of a staff whitened with
kaolin, the color of death, and attached to the staff were scraps of
cloth fluttering in the breeze. Talbot discovered near Ekuri Eying,
between Ikom and Calabar, that the death of a chief inspired the
making of a striking material sign: the survivors affixed to the summit
of a tall palm staff the dead man's umbrella and his coat, with the
garment disposed so that the arms spectrally pointed outwards. In
addition, Keith Nicklin found, in Mbubeland, Ogoja, that when a
warrior or a hunter dies, the fronds of surrounding palm trees are
shot so that the fronds droop earthwards thereafter. This custom is
similar to the Ekwe Ejagham tradition whereby members of the
Nsibidi Society mourn the passing of a brother by cutting down
plantain stalks behind his house.[57]

Viewed as a structural whole, these customs represent death's
power both to invert all things, hence the reversal of the basin and
the bending of the palm fronds, and to set in motion an upward
journey to the sky, hence the elevation of the coat and the parasol
and the motifs of mourning high among the ruined palm fronds.

Among the Abakuá, death was comprehended in similar visual
idioms. In Cuba, when the brothers perambulate in a formal proces-
sion called *beromo* (Plate 157), they sometimes hoist on high the
goatskin of Sikán as a flaglike evocation of her spirit, and this recalls
the elevation of the tunic and umbrella of the vanished chiefs of
Ekuri Eying. Death's powers of reversal similarly come to the fore

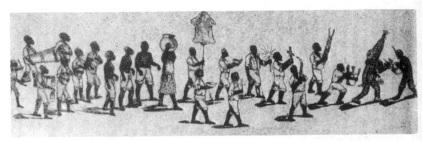

PLATE 157

in Abakuá funereal symbolism. When a brother is sworn into the Abakuá, arrows are drawn in the yellow chalk of life upon his body, all pointing down to indicate the descent of life and grace into his body from above. When he dies, the direction of such arrows, now written in death's color, white, is reversed.[58] Pointing toward his head, they indicate upward passage to the other world.

Upward-pointing arrow signs of death are sometimes abstracted from the context of funereal body-painting and drawn upon the earth at funeral ceremonies. In this case they are called *erikuá*, the "arrow of farewell." *Erikuá* arrows are sometimes rendered in strict verticality and crossed with multiple arrows of Anamanguí, messenger of death among the Abakuá, and sometimes they are wavy and cursive in design but always they point up, indicating the return to heaven. Moreover, they indicate the way to the other world at the end of lines of deliberate elongation, recalling the elevation of dress or shattered leaves at the top of shafts or trees in Nigeria. All of these signs suggest the transformation of a person into a spirit, a spirit that has vanished upward, from ruin toward higher worlds.

Afro-Cuban *anaforuana*:
processioneer with goatskin of
Sikán, hoist on high as
evocation of her spirit, 1950's

Nigerian material *nsibidi*:
"the chief is dead,"
Ekuri eying, c. 1910

Flash of the Spirit

Afro-Cuban *anaforuana:*
erikuá, "arrows of farewell."
Left arrow is crossed with
multiple arrows of the messenger
of death, Anamanguí, 1959

Nigerian material *nsibidi,*
funereal motifs, shrine to
dead member of a family,
Nko-Obubra, 1978

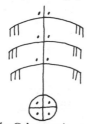

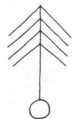

Afro-Cuban *anaforuana:*
emblem of death's messenger,
Anamanguí, 1959.
"Three crescent-form branches with
fallen leaves symbolizing grief"

Nigerian *nsibidi:*
a bamboo stick with
the leaves turned backwards,
mourning emblem for a chief,
early twentieth century

An *nsibidi* sign announcing the death of a distant chief, which is drawn to represent a bamboo stick with the leaves turned backwards, compacts the ritual of the palm tree fired at by the survivors of a hunter or a warrior within a few calligraphic strokes. The design and meaning of this *nsibidi* almost certainly inspired the rise of a corresponding emblem among the Abakuá, a signature-*anaforuana* *(gandó)* of the society's masker of death, Anamanguí. This particular emblem of the death-messenger—he has a variety of emblems—displays a vertical stroke rising from a quartered circle, not unlike the Nkanda calabash sign in Calabar, with the crucial addition of "three branches with fallen leaves symbolizing the death of the brother."

The signatures of Anamanguí are various, as if death were too all-encompassing to be concentrated within a single emblem. They form variations on a theme, a feather arrow ruined or rendered incomplete by death:[59]

Emblems of Prowess

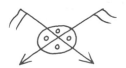

Images of the masker of death, branches shedding leaves, a skull and crossbones, four parallel arrows, form a vital part of Abakuá funerary art. At the death of an important member, the brothers render in white chalk on thick black paper (about 25 by 35 inches) complicated funerary ensigns. These ensigns are mounted on the walls of the inner shrine *(fo-ekue)* of an Abakuá lodge and are called "altars." There is a mihrablike sense of concentration and sacred directionality to their design.[60]

Funereal ensign, or Abakuá "altar" c. 1959. Note arrows of the masked messenger of death

Nsibidi: seven spears of a murderous father, seven spears used by his son in self-defense, 1911

The illustrated "altar" is set within a pointed frame surmounted by the cross sign of Tanze and Sikán. Two "arms" bear the multiple parallel arrows of Anamanguí, phrased in a manner reminiscent of an *nsibidi* of patricidal strife. Anamanguí's three branches with drooping leaves again recall the *nsibidi* of the death of a ruler or a warrior.

Thus, Cuban Abakuá brought to the New World aspects of the language[61] and ritual costuming traditions[62] of the Ejagham. Together with initiatory and funereal blazons came a tradition of masked messengers of the spirit rumbling in the leopard-drum unseen but fearfully appreciated. Costumes for the messengers of Ngbe/Tanze form, according to one Cuban folklorist, the "maximum incarnation of Abakuá spirit."[63] But that incarnation was brought into being, shaped, and kept in cultural focus by the power of *anaforuana* to affirm the past. In fact, the whole panoply of Ngbe/Abakuá messengers, with their costumes, characteristically

Flash of the Spirit

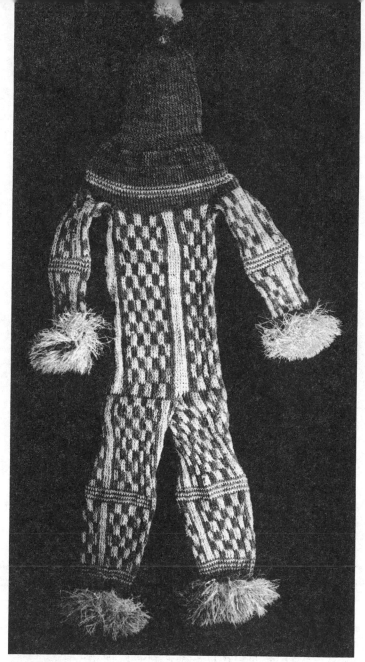

PLATE 158

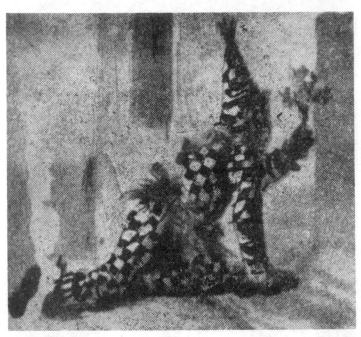

PLATE 159

trimmed with fiber at the wrists and ankles, could be accurately characterized as *nsibidi* or *anaforuana* in material form. The checked leopard pattern of a Nigerian Ibibio leopard-masker (Plate 158), which tells us where the power of the dancer is coming from, reappears, as it were, on the dress of an Abakuá masker of the 1870's (Plate 159). The Cuban masker even crawls, symbolically, to render the feline animality, which is both the glory and means of moral intimidation of his society. Again, the quartered circle with four eyes —spiritual communication and enlightenment, the core emblem among the signs of the *anaforuana* corpus—becomes, in Abakuá masking, a Janus with two eyes seen in front and two implied (or rendered) on a disk at the back of the head (Plate 160). And just as the intersection of two lines in *nsibidi* communicates the intersection of words of one person with words of another, with the same sign the nineteenth-century Abakuá masker visually voices the idea of speech. He crosses broom and wand before his body to indicate a desire to speak of things positive and lasting. The richness of media-

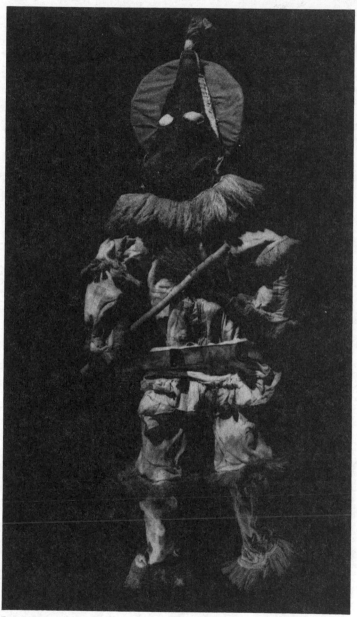

PLATE 160

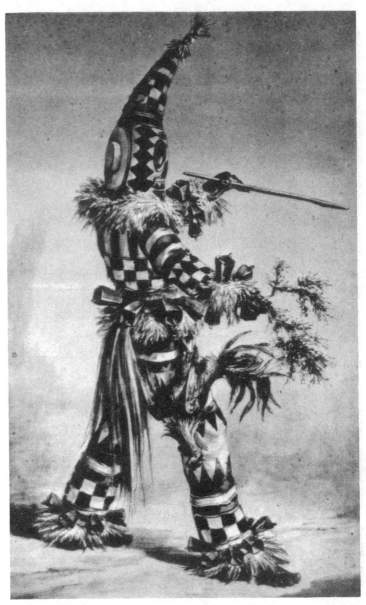

PLATE 161

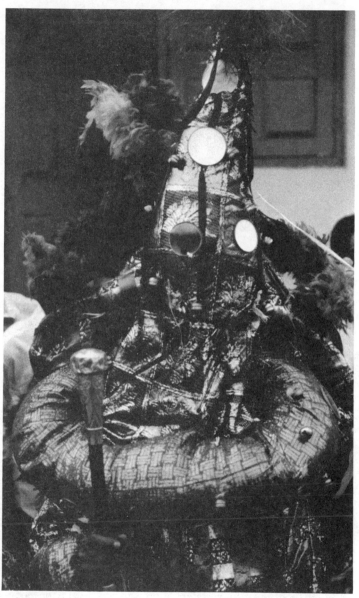

PLATE 162

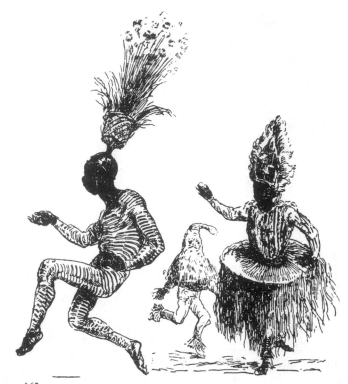

PLATE 163

tion and spiritual embodiment communicated by a nineteenth-century Abakuá masker (Janus of mystic vision, checkerboard of feline strength, soft conical headdress characteristic of Ebongó, in Calabar given as the female dimension to Ngbe, the mother of all leopards) is a marvel of cultural reinstatement, a fusion of sartorial and ideographic means (Plate 161). It provides a measure to assess strong changes occurring now in Calabar (Plate 162), where Ebongó is allowed metallic cloth and many mirrors for the glory of her prestige and powers of mystic vision. If Ebongó seems purer in Havana, in some senses, than in Calabar, the old Cuban reflection of the special hoopskirted Calabar *Aban* dancer, a reflection once vibrant and once strong in the 1870's (Plate 163), has disappeared, and only Calabar (Plate 164) continues this visual tradition. We may be sure the hoop-skirt was a sign, a piece of ancient writing worn as dress.

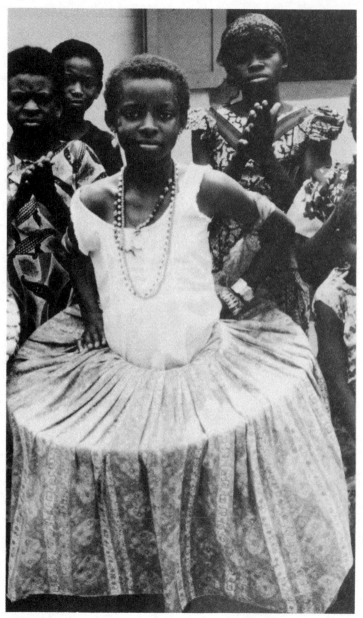

PLATE 164

We turn, at the ending of this chapter, to a climax in the Abakuá calligraphy of the dead—the sign of the lifting of the plate *(levantamiento de plato)*, referring to the custom of taking up the plate of a dead person from his table, "for no longer will he use it in this world."[64] It is a complicated ideograph, which mourns the entire dead of a lodge that has to restore its positions. It is a mapping of a mass keening, a calligraphic machine for honoring myriad ancestors simultaneously. It has a long axis complicated by a cluster of four priestly signatures of high rank about a circular device centered upon two intersecting arrows, often given as the sign of the four winds. The line continues. It traverses a skull and crossbones of Anamanguí and two extraordinary winglike branches, bending back to form the ancient *nsibidi* of death, as if pulled down by the weight of phantom priests whose spectral signatures constellate underneath the "wings" in sympathy with their curves. The line continues, collides with, and pierces, in an unceasing journey upward, more crossed arrows, a quartered circle of supernatural vision, a calabash of origin, itself crossed with arrows and gleaming with many eyes of Tanze and Sikán, a fusillade of arrows from the deadly quiver of Anamanguí, a final crisscross of two worlds, and then, departure, into the great beyond, on the tip of the arrow of farewell.

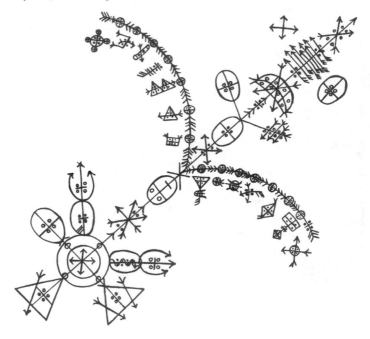

NOTES

One

1. Rev. R. H. Stone, *In Afric's Forest and Jungle: Or Six Years Among the Yorubans* (New York: Fleming H. Revell, 1899), pp. 20–21, 23.
2. See summary comments on Yoruba art and culture in R. F. Thompson, *African Art in Motion* (Los Angeles: University of California Press, 1974). For Yoruba urbanism, see G. J. Afolabi Ojo, *Yoruba Culture: A Geographical Analysis* (London: University of London Press, 1966), pp. 104–30. A classic article is William Bascom, "Some Aspects of Yoruba Urbanism," *American Anthropologist* LXIV, 4 (August 1962), 699–709.
3. Oladipo Yemitan, *Ijala: Are Ode* (Ibadan: Oxford University Press, 1963), p. 67. Translation from the Yoruba is mine.
4. Miss Tucker, *Abbeokuta; Or, Sunrise Within the Tropics* (London: James Nisbet & Co, 1853), p. 165.
5. T. J. Bowen, *Grammar and Dictionary of the Yoruba Language* (Washington D.C.: Smithsonian Contributions to Knowledge, 1858). See entries *amẹwa* and *mẹwa*, and also R. F. Thompson, "Yoruba Artistic Criticism," in Warren d'Azevedo (ed.), *The Traditional Artist in African Societies* (Bloomington and London: Indiana University Press, 1973), pp. 26, 60, note 10.
6. Babatunde Lawal, "Some Aspects of Yoruba Aesthetics," *British Journal of Aesthetics*, Vol. III (1974), p. 239.
7. Araba Ekó, conversations with the author, Lagos, Nigeria, 1972–73. The Araba, one of the leading priests of divination in Yorubaland, has

been enormously kind over the years in sharing his rich knowledge of the literature of divination in relation to the nature of the *orisha*.

8. Interview with Araba Ekó, 13 January 1972, Lagos.

9. Informant: A. O. Williams Onáyemin, Ilesha, 5 August 1965.

10. *Iroko* shrines seen in the field, Ketu, Republic of Benin, summer 1972. For a spectacular document of the Afro-Brazilian continuity of this custom, blended with the cognate Dahomean Loko cult, see Carybé, *Iconografia dos Deuses Africanos no Candomble da Bahia* (São Paulo: Raizes, 1980), p. 110.

11. The definition of red "as the supreme presence of color" stems from Claude Lévi-Strauss, *The Savage Mind (La Pensée sauvage).*(London: Weidenfeld & Nicolson, 1966), p. 65.

12. Araba Ekó, Lagos, 13 January 1972.

13. Informant: the late J. K. Adejumo, Ipokia, capital of the Anago Yoruba, 5 January 1968.

14. Cf. Denrele Obasa, *Awọn Akewi,* cited in A. Fajana, "Some Aspects of Yoruba Traditional Education," *Odu* (July 1966), p. 25.

15. Babatunde Lawal, *op. cit.,* p. 241.

16. "Giving with *both* hands," Henry Drewall (personal communication, 4 December 1979) points out, "signifies as well the union of social and spiritual worlds, for the left is used in greetings by *orisa* (i.e., possessed worshippers) to mortals. Thus it is a *sanctified* gesture of giving."

17. Araba Ekó, 12 January 1972.

18. *Ibid.*

19. Babatunde Lawal, "The Significance of Yoruba Sculpture" (mimeographed paper read at the Conference on Yoruba Civilization, University of Ife, Ile-Ife, 26–31 July 1976), p. 9.

20. The late J. K. Adejumo, Ipokia, 5 January 1968. In addition, in the communication cited in Note 13, Henry Drewall further glosses this testimony: "Opening his cap may also connote peaceful intentions; for, in contrast, the caps of hunters hold medicines for cursing. The gesture of removing one's cap to take out the medicine is an act of war, but 'opening' the cap shows friendship."

21. Araba Ekó, interview, 17 January 1972.

22. R. C. Abraham, *Dictionary of Modern Yoruba* (London: University of London Press, 1958), p. 658.

23. Araba Ekó, 12 January 1972.

24. E. A. Ajosafe Moore, *The Laws and Customs of the Yoruba People* (Abeokuta: Fola Bookshops, n.d.), p. 7.

25. For details, see Robert S. Smith, *Kingdoms of the Yoruba* (London:

Methuen, 1969), pp. 133–55. See also Rev. Samuel Johnson, *The History of the Yorubas* (Lagos: C.M.S. Bookshops, 1921).

26. S. A. Akintoye, *Revolution and Power Politics in Yorubaland 1840–1893* (New York: Humanities Press, 1971), p. 44.

27. Juana Elbein dos Santos, *Os Nago E A Morte: Pàdé, Àsèsè e o culto Égun na Bahia* (Petrópolis: Editora Vozes, 1976), p. 13.

28. William Bascom, *Shango in the New World* (Austin: African and Afro-American Research Institute, 1972), p. 13.

29. Focused on the African-influenced life of Port-au-Prince in Haiti, a thoughtful and important study of the punning process in linking attributes of the saints to those of the *vodun* (Dahomean spirits) and the Yoruba *orisha* is Michel Leiris's: "Note sur l'usage de chromolithographies par les vodouisants d'Haiti," in *Les Afro-Américains* (Dakar: Mémoires de l'Institut Français d'Afrique Noire, 1953), pp. 201–7.

30. Bascom, *Shango in the New World*, pp. 16–17: such syncretisms are not consistent, varying from place to place, even from shrine to shrine. Bascom illustrates this point with an excellent table of Shàngó/Catholic saint correspondences across the western hemisphere (pp. 16–17).

31. Dos Santos *op. cit.*, pp. 171–81.

32. *Ibid.*, p. 179.

33. See Carybé, *op. cit.*, p. 46, for a watercolor of an Eshu-Elegbara priest in Bahia wearing a headdress that is red on one side, black on the other.

34. Hence the pitchforks of Satan, horns of the Devil, and other infernal images that cloud his true role as messenger of the deities and principle of individuality, particularly in the Yoruba-influenced religious life of Rio, where a kind of meta-literature has arisen in his name, incredibly creolized and inventive in its references, freely mixing Kongo, Yoruba-Dahomean, Roman Catholic, spiritualist, and other concepts, as illustrated, for example, by N. A. Molina, *Na Gira dos Exu* (Rio de Janeiro: Editora Espiritualista, n.d.); Antonio de Alva, *O livro dos exus: Kimbas e Eguns* (Rio de Janeiro: Editora Eco, 1967); and José Maria Bittencourt, *No reino dos exus* (Rio de Janeiro: Editora Eco, 1970).

35. From a conversation with the Araba Ekó, Lagos, 18 January 1972.

36. Juana Elbein dos Santos and Deoscoredes M. dos Santos, *Eṣu Bara Laroye: A Comparative Study* (mimeographed), Institute of African Studies, University of Ibadan, Nigeria (April 1971), p. 28: "Esu is the Lord of Power, Elegbara, its controller at the same time as its representation." See also their "Esu Bara, Principle of Individual Life in the Nago System," a paper delivered at the conference on *The Notion of the Person in Black Africa* (Paris: Centre National de la Recherche Scientifique, Colloque Internationaux, No. 544, 1971).

37. Interview with Lydia Cabrera, Coral Gables, Florida, September 1981.

38. Lydia Cabrera, *El Monte: Igbo Fina Ewe Orisha, Vititinfinda* (Havana: Ediciones C.R., 1954), p. 80: *"Propicio, modifica el peor de los destinos; hostil, ensombrece el más brillante."*

39. Witnessed in Rio, spring 1968.

40. Cabrera, *op. cit*, p. 95: "Eshu is an Elegba ready to do nothing but evil."

41. Dos Santos and Dos Santos, *op. cit.*, p. 29.

42. It may well be, as Henry Drewall suggests (personal communication, 4 December 1979), that "the iron blade/tuft/penis projecting from the top of the head of Esu/Elegba seems more Fon or more precisely Ewe than Yoruba. I documented a large cement sculpture of a seated Legba figure with iron bursting from his head at the entrance to a compound in an Ewe town north of Lome." It is fairly certain that Fon, Ewe, and other Yoruba-influenced groups living to the west of Yorubaland "came before" the Yoruba to Brazil, as Drewall adds, "not with them." The complex problem of the merging of Yoruba-influenced Legba imagery, from Ewe/Fon sources, with Yoruba impulses in Brazil and Cuba will be discussed in a future publication, *The Face of the Gods.* Here it suffices to note the probable reinforcement of Yoruba imagery by already existing Fon/Ewe customs in the Western Hemisphere.

43. Argeliers León, "Elebwa: una divinidad de la santería Cubana," *Abhandlungen und Berichte des Staatlichen Museums für Volkerkunde Dresden,* 21 (1962), pp. 57–61.

44. Letter written by Julius Oyetunde of Ibadan, dated 22 July 1919, and now in the archives of the Museum of Ethnic Art, UCLA, Los Angeles. The letter came with a shrine image carved in wood for Eshu-Elegba, attributed to Agesingbena of Ibadan (Museum of Ethnic Art: X67-600), now at UCLA. I thank George Ellis for a copy of this letter.

45. Dos Santos and Dos Santos, *Eṣu Bara Laroye*, p. 29.

46. Joan Wescott, "The Sculpture and Myths of Eshu-Elegba," *Africa* XXXII, 4 (October 1962), 338.

47. Dos Santos, *op. cit.*, pp. 135–37.

48. *Ibid.*, p. 162.

49. Cabrera, *El Monte.* The photographs at the back of this important volume are unnumbered; what would be the tenth and eleventh pages of the plates focus on art for Elegba in the late forties and early fifties in western Cuba.

50. *Arará* (Afro-Cuban for Dahomean/Ewe worship) is cognate with the Afro-Haitian term *Rada.* Both words stem from the name of an an-

cient town, Allada, in Dahomey. For a rewarding survey of Ewe art, see Dzagbe Cudjoe, *Tribus* (August 1969), pp. 49–60.

51. Attribution by Lydia Cabrera, conversation with the author, summer 1979.

52. I heartily thank Sidney Mintz, of the Anthropology Department, Johns Hopkins University, Baltimore, for bringing this fine piece to my attention, and for details about its collection.

53. For a broader interpretation of projections from the head throughout Yoruba art, see Margaret Drewall's "Projections from the Top in Yoruba Art," *African Arts* XI, 1 (Fall 1977), 43–49.

54. Lydia Cabrera, conversation, winter 1979.

55. Roger Bastide, *Imagens do Nordeste Místico* (Rio de Janeiro: Empresa Gráfica o Cruzeiro, 1945), p. 129.

56. *Ibid.*, pp. 129–30.

57. *Ibid.*, photograph between pp. 160–61, caption reads in Portuguese: "Exu-bara (Photo Recife Department of Police)."

58. See Mario Barata, "Arte negra," *Revista da Semana* (17 May 1941), pp. 16–17, 34, where he speaks of "macumba idols from Rio recently collected by the town police." "Collected" is a euphemism for police confiscation of objects including an interesting image for Eshu-Elegbara roughly similar to the piece under discussion. Both are now in the Police Museum of Rio. But the pre-1941 dating of the object under discussion is still no more than an informed guess, for other than this article no records of accession could be found during several visits to the Police Museum in March and August 1968. See also Mario Barata, "The Negro in the Plastic Arts of Brazil," in *The African Contribution To Brazil* (Rio de Janeiro: Edigraf, 1966), p. 38, note 21.

59. M. A. S. Barber, *Oshielle: or Village Life in the Yoruba Country* (London: James Nisbet, 1857). Illustration faces p. 187.

60. Susan M. Pearce, *Yoruba Archaeology and Art* (Exeter: Royal Albert Memorial Museum, 1970) catalog object no. 27 (RAMM no. 1385/1868).

61. Pierre Verger, *Notes sur le culture des orisa et vodun* (Dakar: IFAN, 1957), p. 134: *Ó fi erí ejo fun fere* (with the head of a snake he blows a whistle). Verger collected this praise-verse in Ketu, an ancient town over which, according to tradition, Eshu once ruled.

62. Informant: Araba Ekó, interviews, Lagos, July 1965.

63. Verger, *op. cit.*, pp. 136, 138.

64. For Bahia, Verger, *ibid.*, pp. 138–39; for Cuba, Lydia Cabrera, *Música de los cultos Africanos en Cuba*, Disco 4, Lado 2; for Miami, *Eru Ana: Afro-Cuban Folklore* (Onix LP: ORLPS-004, Cara A, "Eleguá").

Notes 275

65. Valdelice Carneiro Girão, "A Coleçao Arthur Ramos," *Revista Ciencias Sociais* II, 1 (1971), 105:" (1.60.122) *Exu,* 33 cm. high, wooden statuette, restored . . . [from the] Candomblé da Bahia."

66. As well as in Hispanic New York City. I am indebted to Eshumiwa, a New York priest of Eshu-Elegbara, for the privilege of studying a hook for Eshu, painted red and black, Eshu's colors, made in Harlem in 1965.

67. Cabrera, *El Monte,* ninth page of unnumbered photographs.

68. Wande Abimbola, *Ifá Divination Poetry* (New York: Nok Publishers Ltd, 1977), p. v.

69. Cf. William Bascom, *Ifá Divination: Communication Between Gods and Men in West Africa* (Bloomington and London: Indiana University Press, 1969), p. 11.

70. Abraham, *op. cit.,* p. 274, *Ifá: aigbofa la n woke: Ifá kon kò si ni para* ("owing to being unskilled in divination, we are looking up at the thatch, but it is not a likely place to find him!").

71. Wande Abimbola, *Ifa Divination Poetry,* pp. 2–4. For another myth of Ifá, see Fela Sowande, *Ifá* (Yaba: Forward Press, n.d., c. 1964). See both Abimbola and Bascom, *op. cit.,* for excellent descriptions of the divination process and its instruments.

72. Fela Sowande, *Ifa. Odu Mimo* (Lagos: Ancient Religious Societies of African Descendants Association, 1965), p. 28.

73. *Ibid.*

74. For a discussion of visual art pertaining to Ifá and its Dahomean equivalent, Fa, see Bernard Maupoil, *La Geomancie a l'ancienne Cote des Esclaves* (Paris: Institut d'Ethnologie, 1961), reprint of the 1922 edition. There is an excellent survey of Ifá art in relation to the oral literature of Yoruba divination by Rowland Abiodun, "Ifa Art Objects: An Interpretation Based on Oral Tradition," in Wande Abimbola (ed.), *Yoruba Oral Tradition: Poetry in Music, Dance, and Drama* (Ife: Department of African Languages and Literatures, University of Ife, 1975), pp. 421–69.

75. Abimbola, *Ifa Divination Poetry,* pp. 150–51. I have slightly retranslated the Ifa verse herein cited.

76. William Bascom, "Two Forms of Afro-Cuban Divination," in Sol Tax (ed.), *Acculturation in the Americas* (Chicago: University of Chicago Press, 1952), pp. 169–79.

77. Cf. Fernando Ortiz, *Los Instrumentos de la música Afrocubana,* Vol. I (Havana: Ministerio de Educación, 1952), p. 193, Fig. 9 (illustration of an Afro-Cuban *irofa* and *opon ifa*). Bascom, "Two Forms," reports (p. 172) that "in Cuba few diviners know the use of the sixteen nuts,

most of them relying on the divining chain. Similarly among the Yoruba the chain is more frequently employed."

78. Abiodun, *op. cit.*, makes the important observation (p. 12) that "Ifa acknowledges the power of Èṣù symbolically, placates him and solicits his cooperation through the carved face(s) of Eṣu in the border decoration of *opon.*" Drewall has examined an *atefa* in the Deoscoredes dos Santos collection in Bahia which belonged to a servitor of the Yoruba gods who divined. This tray even had a circular indentation on the bottom which in Nigeria, according to my informants, means that the *opon* is a secret drum with two membranes, one on each side. Peter Morton-Williams (with J. R. O. Ojo), *Museum of the Institute of African Studies, University of Ife: A Short Illustrated Guide* (Ife: University of Ife Press, 1969), says, on p. 8: "The back of the tray is hollowed so that it sounds when tapped by the diviner with his ivory rattle to invoke Orumnila." Drewall (personal communication, 1979) says it has to do with a covert function of cursing. All three versions dovetail within, and support, the notion of the *opon* as a most important instrument of communication with the gods.

79. See Morton-Williams and Ojo, *op. cit.* For a brief discussion ot form and meaning in the study of *agere ifa*, see Abiodun, *op. cit.*, pp. 447–50.

80. Roger Bastide, *Le Candomblé de Bahia* (Paris: Mouton, 1958), p. 51, note 77. In Brazil the *agere* was redesignated "box for Yemanya," goddess of the sea, possibly by analogy with its discovery by the sea.

81. It is important to note that while the use of the *opele* in Cuba and Cuban-influenced North America remains strong, our early visual source published in (Fernando Ortiz, *Hampa Afro-Cubana: Los Negros Brujos* (Madrid: Editorial America, 1906), p. 178, illustrated (Plate 20b) in this book, is actually a drawing, taken from another drawing, published in a late-nineteenth-century Havana newspaper. In translation, "divining-chain" became confused with "necklace," and what we have are enough seeds on a chain to make *two opele* (cf. Plate 20a) with one left over! Nevertheless, the spacing of chain to seed is identical with the Nigerian antecedent, and the same reference gives us an early document of the use of green and yellow beads for Ifá in the western hemisphere (p. 177).

82. Cabrera, *El Monte*, p. 15. The citation is a composite of two sentences in which I translate *derecho*, lit., "right," as protocol.

83. See R. F. Thompson, "Icons of the Mind: Yoruba Herbalism Arts in Atlantic Perspective," *African Arts* VIII, 3: 52–59, 89–90.

84. *Ibid.*

85. Cabrera, *El Monte*, pp. 70–71.

86. For details, see my "Icons of the Mind," noted above.

87. Cabrera, *El Monte*, p. 101.

88. Araba Ekó, interview, 12 January 1972.

89. Quoted in my *Black Gods and Kings* (Los Angeles: Museum of Ethnic Arts, 1971, p. 11/3.

90. Informant: Julito Collazo, interviews, Hamden, Connecticut, winter 1970. The melody of an ancient Osanyin song appears in Cuba (*Cult Music of Cuba*, Ethnic Folkways LP FE 4410) and also in Brazil (*Folk Music of Brazil*, Library of Congress LP AFS L13). Harold Courlander, in the notes to the LP of Cuban black ritual music, was apparently the first to notice the implications of antiquity in the geographic distribution of this song. A full version, mentioning the immovable stone under water, was recorded in the 1950's by Lydia Cabrera, *Música de los Cultos Africanos en Cuba*, Record 3, Side 1 (c. 1958).

91. Teodoro Díaz Fabelo, *Olorun* (Havana: Ediciones del Departamento de Folklore del Teatro Nacional de Cuba, 1960) p. 67. The original text interweaves Lucumí (Cuban creolized Yoruba) and Castilian phrases which I elide together.

92. *Ibid.*, p. 68.

93. Geraldine Torres Guerra, "Un elemento ritual: El Osun," *Etnología y Folklore*, Vol. III (1967), pp. 65–81.

94. Cabrera, *El Monte*, ninth unnumbered page of photographs, "Altar of a priest, for the Niño de Atocha, Elegba."

95. I am grateful to Owoeye of Efon-Alaiye for an introduction to a corpus of works of art in iron by members of the atelier of Odeleogun and his son, Ajanakú, in the winter of 1964.

96. See, for example, Bastide, *op. cit.*, pp. 72 ("tree of life"), 111 (a bird at summit, surrounded by small branches), which Ramos took to be "Eshu of the seven roads." Cf. Deoscoredes dos Santos, *West African Sacred Art and Rituals in Brazil* (Ibadan: Institute of African Studies, 1967), p. 80: "A central bar with six smaller bars and an iron bird on top symbolizes a tree with seven branches and the bird at the top."

97. From oral evidence collected at Igogo-Ekiti, summer 1965, Nigeria.

98. For an earlier version of this paragraph, see Lewis M. Dabney, *The Indians of Yoknapatawpha* (Baton Rouge: Louisiana State University Press, 1974), p. 146. Finally, no reference to Osanyin is complete with mention of Pierre Verger's important booklet, *Àwon Ewé Òsanyìn: Yoruba Medicinal Leaves* (Ife: Institute of African Studies, University of Ife, 1967).

99. *Black Gods and Kings* p. 7/1. Robert Smith, *Journal of African History* VIII, 1 (1967), 93, makes an observation that is relevant here: "Among the Yoruba the sword was regarded essentially as a cutting weapon." Finally, for a superb study, see Sandra T. Barnes, *Ogún: An Old God for a New Age* (Philadelphia: ISHI, 1980).

100. Told me by the Chief of Ipole, near Ilesha, winter 1963.

101. A composite of praise-verses *(àwon oríki)* published by Verger, *op. cit.*, pp. 178–79, verses 1, 3, 9; 8, 9 (in the last verse I expand the idiophonic *rororo*, the sound that fire makes, into: "leaves the forest screaming . . .", pp. 175–77, 180–81, 183–85, 188.

102. Informant: Onayemi of Ilesha, July 1965.

103. *Ibid.*

104. *Ibid.*

105. Verger, *Notes sur le culture*, p. 182: "Seven Ogun in the house of Ire."

106. Quoted in Ortiz, *op. cit.*, p. 65. The object was in this text misattributed to the cult of Orisha Oko.

107. There may be a trace of Kongo influence here, blended in with Yoruba practice, for some Afro-Cuban informants have told me that one works with an *nfumbi* (creole Ki-Kongo for "dead man") locked in the Ogún cauldron. The cauldron itself resembles a famous pot on a tripod of three stones in which the founder of Kongo primordially "cooked up" the first medicines of the land. Cf. the morphology of the famous Afro-Cuban Kongo charm "Graveyard-Midnight" (Plate 66), *supra*.

108. Informant: Larry Harlow, New York City, fall 1979. Moreover, a few Afro-Cuban *botánicas* (herbal stores) in New England sometimes sell protective chains of Ogún to hang at the bottom of front doors, on the inside, for protection.

109. Verger, *Notes sur le culture*, p. 206.

110. *Ibid.*, pp. 208–9.

111. The cited verses are a composite, from praise literature for Oshoosi and closely related hunter-deities, in Verger, "Notes." The page numbers, and, in parentheses, the numbers of the verses follow: 221 (4, 5), 225 (65), 215 (village of Save, 1), 216 (4); 222 (13).

112. M. A. S. Barber, *op. cit.*, 1857.

113. R. S. Smith, "Yoruba Warfare and Weapons," in S. O. Biobaku (ed.), *Sources of Yoruba History* (Oxford: Clarendon Press, 1973), pp. 232–33.

114. Dos Santos, "West African Sacred Art," Plates 80 and 81.

115. Cf. Babatunde Lawal, *op. cit.*, p. 246: "The person who wears an all-red garment is likely to be mistaken for a priest."

116. Abraham, *op. cit.*, p. 623.

117. Informant: Adisa Fagbemi, *Imaṣai*, northern Egbado, winter 1963–64.

118. Verger, *Notes sur le culture* p. 244. So closely does Obaluaiye relate to his Dahomean derivative, Sakpata, that I follow Verger in combining songs for both deities to illustrate the nature of the redoubtable earth deities. This particular selection is excerpted from *nukoroma-han*, bright, satiric songs of moral allusion that "invite people to mend their ways or else incur the wrath of Sakpata."

119. *Ibid.*, p. 244.

120. *Ibid.*, pp. 256 (2); 257 (4); 259 (acclamations); 260 (4), an ancient image of nobility and regal poise in Yoruba poetry; 264 (10); 264 (5,6); 265 (7).

121. Dos Santos, "West African Sacred Art," p. 67, Plate 57.

122. Source: Araba Ekó, 18 January 1972.

123. Juana Elbein Dos Santos, in conversation with the author, January 1980, Bahia.

124. There is a good description of this shrine, which I myself visited on 16 May 1963, in Geoffrey Parrinder, *West African Religion* (London: Epworth Press, 1961) pp. 28–29.

125. The priest of Nana at Dassa-Zoumé told me (16 May 1963) that the clay pillar within the crown and sheath of straw was called *ata bukuu* and added: "Bukúu lives in there and comes out during spirit possession." This spirit can force market prices to drop if the poor are suffering.

126. For notes on the Ejiwa cult in Lagos, see unpublished notes of Kenneth Murray, Nigerian Museum, Lagos. The myth of Ejiwa was explained to me by Ajanaku Araba Ekó (13 January 1972): "Elegba while fishing is known as Ejiwa." Obaluaiye gave Ejiwa (Eshu) the gown of raffia because the latter had once been kind to him.

127. Dos Santos, "West African Sacred Art," pp. 50–66.

128. Informant: Momuri Orilegbolodo, servitor of Bukúu, Ketu, 8 September 1972.

129. Dramatically pantomimed by Momuri Orilegbolodo in the process of her explanation of the staff's powers. She called it *ileesin gogo*.

130. And her concern with instilling a social conscience in her followers (cf. Dassa-Zoumé legends about Nana forcing market prices to fall to favor the poor) matches that of her fiery son.

131. Informant: Babalawo Alawode Ifayemi, apparently recorded in Ketu country. Dos Santos, "West African Sacred Art," pp. 58–65. I have retranslated portions of the original Yoruba version of the myth.

132. Interview, Araba Ekó, 8 December 1975.

133. *Ibid.*

134. Yemitan, *op. cit.*, pp. 4–6.

135. For example, the altar to Yewa, an important riverain goddess, at Ipokia, capital of the Anago Yoruba, is circular, made of clay, and dyed a splendid indigo blue.

136. Johnson, *op. cit.*, p. 243: "Burying the king in the bed of the river was regarded as an expiation made for his murder." The inner power of the riverain goddesses is likewise measured by the immense shield of flowing water that separates them from the world of the living.

137. Judith Hoch-Smith, "Radical Yoruba Female Sexuality," in Judith Hoch-Smith and Anita Spring (eds.), *Women in Ritual and Symbolic Roles* (New York: Plenum Press, 1978), p. 265. As to the negative dimensions in the mystic use of fans, cf. Araba Ekó (17 January 1972): "There are fans, which the 'mothers' use, concealing poison; while fanning a 'mother' can use it as a means of throwing death or injury or madness upon a person."

138. From a myth described to me by a migrant from the ancient city of Owo in southern Ijebu country, winter 1963–64.

139. Source: Henry Drewall, who has conducted excellent researches among Ketu, Egbado, and, recently, Ijebu Yoruba.

140. Verger, *Notes sur le culture, p.* 297.

141. Or, cf. Fernando Ortiz, *Los instrumentos de la música Afrocubana,* Vol. II (Havana: Ministerio de Educación, 1952), pp. 299–301: "There are serious cases when one must 'cool' a saint, or rather his stone, with five or seven fans in action all at once, according to what Ifá (the oracle) indicates."

142. Verger, *Notes sur le culture*, p. 298, Abeokuta prayer 2.

143. *Ibid.*, p. 426, Ilesha verse 9.

144. José Ribeiro de Souza, *400 Pontos Riscados e Cantados na Umbanda e Candomblé* (Rio de Janeiro: Editora Eco, 1966), pp. 40–41.

145. Informants have also mentioned that a starfish image might be intended here, for which there is good authority in Bahia. Cf. Edison Carneiro, *Candomblés da Bahia* (Rio de Janeiro: Tecnoprint Grafica, 1967), p. 45: "A large starfish . . . in homage to Yemanya."

146. Dr. Lawrence Longo of Los Angeles has made a film of the Oshun festival at Oshogbo, which was kindly screened for me in the summer

of 1970 by George Ellis, then of the Museum of Ethnic Arts, UCLA. The film documents the flower-hurling portion of the Oshun festival.

147. Verger, *Notes sur le culture*, p. 422 (2,5,8), 423 (10,12,14,15,17), 424 (23,24,29), 425 (1,6) 426 (3,9) 427 (3), 428 (16).

148. *Ibid.*, pp. 429 (6, 10,12,13,14), 430 (16;4), 431 (8,9), 433 (5).

149. Lydia Cabrera, *Yemayá y Ochún: Kariocha, Iyalorichas y Olorichas* (Madrid: C y R, 1974), pp. 271–72.

150. I am extraordinarily grateful to the son of the late Oginnin for taking several days in July 1965 to explain in detail the meanings attached to this fan as his father had explained them.

151. Cf. Abraham, *op. cit.*, p. 622.

152. I am grateful to the Alaafin of Oyo for the privilege of witnessing the annual perambulations of Alakoro in January 1964.

153. For an excellent summary of the lore of Shàngó, see Babatunde Lawal, *Yoruba Sango Sculpture in Historical Retrospect* (Ann Arbor: University Microfilms, 1970).

154. Verger, *Notes sur le culture*, pp. 342 (21); 351 (121); 359 (13, 14,19;3); 361 (26,30); 362 (31); 362 (48); 363 (49,56); 366 (1); 374 (30); 378 (77,88); 380 (104,112); 381 (12); 390 (12); 392 (4), lit., "beads, rich, on king of Oyo"; 393 (11); 395 (4).

155. Morton-Williams and Ojo, *op. cit.*, p. 9.

156. Vivaldo da Costa Lima, *Una festa de Xango no Opo Afonja* (Salvador: IV Coloquio Internacional de Estudos Luso-Brasileiros, Universidade de Bahia, 1959) p. 19.

157. Eva L. R. Meyerowitz, "A Bronze Armlet from Old Oyo, Nigeria," *Man* XLI, 15–37 (March–April 1941), 26.

158. Fernando Ortiz, *Los Bailes y el Teatro de los Negros en el Folklore de Cuba* (Havana: Ediciones Cárdenas y Cia, 1951), p. 235.

159. It is possible the modification of the gesture in this Brazilian instance was influenced by the strong presence of the Kongo left-hand-on-hip gesture *(telama lwimbanganga)* with right hand forward.

160. From a MS. in progress by Robert Farris Thompson, *The Face of the Gods: Art and Altars of the Black Atlantic World*.

161. See Carl M. Hunt, *Oyotunji Village: The Yoruba Movement in America* (Wahington, D.C.: University Press of America, 1979), p. 63: "Villagers are skilled in leather crafts, pottery making and cloth dyeing . . . some of the men are also very good artists and skilled wood carvers."

Two

1. Philip Curtin, *The Atlantic Slave Trade: A Census* (Madison: University of Wisconsin Press, 1969), p. 188.

2. *Ibid.*, p. 105.

3. Interview with Fu-Kiau Bunseki, winter 1979.

4. *Ibid.*

5. For further Kongo and other Bantu sources in black American speech, see Winifred Kellersberger Vass, *The Bantu-Speaking Heritage of the United States* (Los Angeles: Center for Afro-American Studies, UCLA, 1979). See also J. L. Dillard, *Lexicon of Black English* (New York: Seabury Press, 1977). This fine text is full of useful observations, such as (p. 61) "Popular music has established a countertrend in which Black terminology has virtually taken over the domain for American English," and (p. 111) "The terminology of [rootwork and conjure] differs more from mainstream language than does that of any other activity." The formula for the original *tobe* charms is cited in K. E. Laman's *Dictionnaire Ki-Kongo-Français*, Vol. II (Farnborough: Gregg reprint, 1964).

6. Robert Farris Thompson and Joseph Cornet, *The Four Moments of the Sun: Kongo Art in Two Worlds* (Washington D.C.: National Gallery of Art, 1981), p. 149.

7. Vicente Rossi, *Cosas de negros: Los Orígenes del Tango y Otros Aportes al Folklore Rioplatense* (Córdoba: Imprenta Argentina, 1926), pp. 34–35. The source of Rossi's observation would appear to be the French naturalist Alcides d'Orbigny, who witnessed a *candombé* in Montevideo in 1827 which made him recognize that in dance Africans "regain for a moment their nationality." See George Reid Andrews, *The Afro-Argentines of Buenos Aires: 1800–1900* (Madison: University of Wisconsin Press, 1980), pp. 162–63.

8. Georges Balandier, *Sociologie actuelle de l'Afrique noire* (Paris: Presses Universitaires de France, 1955), p. 39.

9. Wyatt MacGaffey, *Custom and Government in the Lower Congo* (Los Angeles: University of California Press 1970), p. 306.

10. John M. Janzen and Wyatt MacGaffey, *An Anthology of Kongo Religion: Primary Texts from Lower Zaire* (Lawrence: University of Kansas Press, 1974), p. 34.

11. A. Fu-Kiau Kia Bunseki-Lumanisa, *N'Kongo Ye Nza Yakun'zungidila: Nza Kongo* (Kinshasa: Office National de la Recherche et de Développement, 1969), p. 14.

12. *Ibid.*

13. As poetically instanced by the following citation from Karl E. Laman, *The Kongo, III* (Uppsala: Studia Ethnographica Upsaliensia, 1962), p. 42: "A chief inheriting the kingdom of Vunda must see the mountain Ludi . . . before his investiture, to enable him to judge *(ludika)* with impartiality."

14. For details on Kongo medicine and government, see Thompson and Cornet, *op. cit.*, pp. 37–42.

15. A point not lost on W. E. B. Du Bois, who wrote: "The chief remaining institution was the priest . . . healer of the sick, the interpreter of the unknown, the comforter of the sorrowing, the supernatural avenger of wrong." Cited in John W. Blassingame, *The Slave Community: Plantation Life in the Antebellum South* (New York: Oxford University Press, 1979), pp. 40–41.

16. From a work in progress kindly shared by Professor MacGaffey with the author.

17. Janzen and MacGaffey, *op. cit.*, p. 34.

18. *Ibid.*

19. For further details on the sign of the four moments of the sun, see Thompson and Cornet, *op. cit.*, pp. 43–52. See also Fu-Kiau Bunseki, *The African Book Without Title*, privately published MS., 1980.

20. Fu-Kiau, Bunseki, *The African Book Without Title*, p. 3

21. Fu-Kiau Bunseki, *N'Kongo Ye Nza Yakun'zungidila*, p. 30.

22. Interview, Fu-Kiau Bunseki, winter 1978.

23. MacGaffey, *op. cit.*, p. 25.

24. Lydia Cabrera, *El Monte: Igbo Fina Ewe Orisha, Vititinfinda* (Havana: Edicones C.R., 1954), p. 136.

25. *Ibid.*

26. *Ibid.*, p. 127.

27. *Ibid.* Wyatt MacGaffey translated this fragment of Ki-Kongo.

28. "Como se prepara una nganga," in Cabrera, *op. cit.*, pp. 118–48.

29. George Eaton Simpson, " 'Baptismal,' 'Mourning' and 'Building' Ceremonies of the Shouters in Trinidad," *Journal of American Folklore*, 79 (1966), pp. 537–50. Jeannette Hillman Henney, *Spirit Possession Belief and Trance Behavior in a Religious Group in St. Vincent, British West Indies* (Ann Arbor: University Microfilms, 1968), pp. 202–4.

30. Simpson, *op. cit.*, p. 547, Diagram 4. Chalked circles around the eyes of initiates enable them to "see" when they travel spiritually, which mirrors closely Kongo belief and custom.

31. Henney, *op.cit.*, p. 203. In modern Kongo, Janzen and MacGaffey report (*op. cit.*, p. 23, Fig. 3), that this is the "membership card of the

Universal Church of the Twelve Apostles. The central device is an example of *glossalalia in print* [emphasis added]. It was originally seen 'like a billboard in the sky' by the founder of the Church. . . ."

32. Roger Bastide, *The African Religions of Brazil* (Baltimore: Johns Hopkins University Press, 1978), p. 206.

33. Napoleão Figueiredo, "Os caminhos de Exu," *Sete Brasileiros e seu universo* (Brasilia: Departamento de Documentação e Divulgação, 1974), pp. 89, 96.

34. José Ribeiro de Souza, *400 pontos riscados e cantados na umbanda e candomblé* (Rio de Janeiro; Editora Eco, 1966), p. 60.

35. *3000 pontos riscados e cantados na umbanda e candomblé* (Rio de Janeiro: Editora Eco, 1975). According to Rainer Flasche, in his *Geschichte und Typologie Afrikanischer Religiositate, Marburger Studien zür Afrika–und Asienkunde, Seria A* (p. 199): "In the area of Umbanda [as opposed, apparently, to macumba] which is taken to be specially scientific, the *pontos riscados* are today valued no longer as sacred signs that bring down the spirits but rather only as symbols that elucidate teachings [about such spirits]."

36. I wish to thank Senhor Oresto Mannarino, director in 1968 of the Police Museum, for many courtesies involved in the study of these pieces. Both the cup and the sash are probably twentieth-century works, dating perhaps from before 1941.

37. De Souza, *op. cit.*, p. 91. The text of the song combines scraps of Ki-Kongo *(zungi, Nzambi)* and Yoruba *(Oduduwa)* with Portuguese.

38. John H. Weeks, *Among the Primitive Bakongo* (London: Seeley, Service & Co., 1914), p. 281: "Shooting stars *(nienie)* are believed to be spirits . . . travelling . . . about in the sky."

39. For a brief discussion of the Eshu/Ogún liaison in Afro-Brazilian thinking, see Roger Bastide, *Le Candomblé de Bahia,* (Paris: Mouton, 1958), p. 226, 43n. There are also clay images for Elegba in Cuba brandishing iron rods, "roads of Ogún."

40. Janzen and MacGaffey, *op. cit.*, p. 35, 2.4.

41. *Ibid.*, 1.1, 1.3, 1.6.

42. *Ibid.*, 4.2, 4.5.

43. For details, see Thompson and Cornet, *op. cit.*, pp. 37–39.

44. Karl E. Laman, *The Kongo, II* (Uppsala: Studia Ethnographica Upsaliensia, 1957), Figs. 35A, 38.

45. Karl E. Laman, *The Kongo, III* (Uppsala: Studia Ethnographica Upsaliensia, 1962), p. 132.

46. Interview, Fu-Kiau Bunseki, July 1975.

Notes 285

47. Interview, Wyatt MacGaffey, winter 1978.

48. Interview, Fu-Kiau Bunseki, November 1978.

49. Cabrera, *op. cit.*, p. 123. This particular *prenda* also included holy water from a Roman Catholic church, "to make the medicine Christian," the head of a bat, the head of a chameleon, and many other things.

50. *Ibid.*, p. 131.

51. Information given me by Lydia Cabrera, telephone interview, winter 1979.

52. Cabrera, *op. cit.*, p. 121.

53. Lydia Cabrera, *Porqué: Cuentos Negros de Cuba* (Havana: Ediciones C y R, 1948), pp. 248–49. Cabrera mentions the names of Afro-Cuban carvers of *minkisi*—Tata Ñunga, Sabá Caraballo, and Ta Rafael—and a sugar plantation, Las Canas, where intensive carving of *minkisi*-figurines was said to have occurred in Cuba in the last century.

54. *La Ilustración Española,* Ano XIX, No. XXX (15 August 1875), p. 1.

55. The *matiabo* image was picked up from a rebel soldier in Zumarquacam, Cuba, and was said to have been filled with the ashes of Spanish soldiers. On the other hand, Fu-Kiau Bunseki (personal communication, November 1978) says the horn could have been used by an expert in peace-making as well as in war.

56. Louis Maximilien, *Le Vodou Haitien: Rite Radas-Canzo* (Port-au-Prince: Imprimerie de l'Etat, 1945), pp. 185–91. Cf. also Maya Deren, *Divine Horsemen* (New York: Chelsea House Publishers, 1970), p. 275: "Pacquets Congo are bound as magical safe-guards. [their] efficacy depends on the technique of careful wrapping."

57. *Ibid.*, photograph facing p. 188.

58. Informant: André Phanord, March 1975, Port-au-Prince.

59. Source: Lydia Cabrera, November 1978.

60. Fu-Kiau Bunseki, interview, December 1978.

61. For example, as early as the eighteenth century in Jamaica there were, among the blacks, notices about charms enclosing cemetery earth.

62. Newbell Niles Puckett, *Folk Beliefs of the Southern Negro* (New York: Dover, 1969), p. 273.

63. Fu-Kiau Bunseki, October 1978.

64. Puckett, *op. cit.*, p. 233.

65. Fu-Kiau Bunseki, interview, October 1978.

66. *Ibid.*

67. Robert Tallant, *Voodoo in New Orleans* (New York: Collier, 1962), p. 229.

68. *Ibid.*, p. 228.

69. *Ibid.*, p. 229.

70. Eric Sackheim, *The Blues Line: A Collection of Blues Lyrics* (New York: Schirmer Books, 1975), p. 432.

71. Cf. Thompson and Cornet, *op. cit.*, p. 200, excerpted from a long interview with Fu-Kiau Bunseki, 30 September 1980. For a brief but brilliant analysis of symbolic usages of tombs in Kongo, see Kimpianga Mahaniah, *La Mort dans la pensée kongo* (Kinsantu: Centre de Vulgarisation Agricole, 1980).

72. Sarah Hodgson Torian, "Notes and Documents: Antebellum and War Memories of Mrs. Telfair Hodgson" (*Georgia Historical Quarterly*, 27, 4 (December, 1943), p. 352.

73. Georgia Writers' Project, *Drums and Shadows* (Athens: University of Georgia Press, 1940); for further examples of tying the spirit of the dead person to the tomb by means of the last things she or he used, see John Vlach, *The Afro-American Tradition in Decorative Arts* (Cleveland: Cleveland Museum of Art, 1978), p. 40. Cf. Peter A. Brannon, "Central Alabama Negro Superstitions," *Birmingham News* (January 18, 1925): "A Gullah negro on the Santee river explained to me that it was their custom to place the last plate, the last glass and spoon used before death on the grave."

74. R. E. Dennett, *Seven Years among the Fjort* (London: Sampson Low, Marston, Searle & Rivington, 1887), p. 104. The burial carriage is decorated with other items sometimes appearing on nineteenth-century Kongo tombs—crockery, flags, statuary, vessels, and a wild-cat skin.

75. Alexander Barclay, *A Practical View of the Present State of Slavery* (London: 1828), pp. 131–33.

76. *Georgia Writers' Project, op. cit.*, p. 167.

77. Thompson and Cornet, *op. cit.*, p. 201.

78. Laman, *The Kongo, III*, p. 37.

79. Telephone interview, fall 1975, also cited in Thompson and Cornet, *op. cit.*, p. 198.

80. Gilbert de Chambertrand, "La Fête des morts en Guadeloupe," *Tropiques*, Vol. LII (December 1954), pp. 35–41. Ramona Austin brought this reference to my attention.

81. Fu-Kiau Bunseki, interview, 9 October 1977.

82. André Pierre, interview, Port-au-Prince, 22 March 1981.

83. Ruth Bass, "The Little Man," in Alan Dundes (ed.), *Mother Wit from the Laughing Barrel* (Englewood Cliffs: Prentice-Hall, 1973), p. 395.

84. Thompson and Cornet, *op. cit.*, pp. 193–210.

Notes

85. Fu-Kiau Bunseki, interview, fall 1977.

86. L'Abbé Proyart, *Histoire de Loango, Kakongo, et autres royaumes d'Afrique* (Paris: Berton and Crapart, 1776), p. 192–93.

87. Thomas Atwood, *The History of the Island of Dominica* (London: J. Johnson, 1791), p. 265.

88. Informant: Edward Kamau Brathwaite, Kingston, Jamaica, September 1981.

89. I am grateful to Sa. Janina Rubinowitz, who pointed out a *kandu* tree at Godo Olo, on the Tapanahoni River in Suriname among the Djuka in December 1981.

90. Samuel Selvon, *Ways of Sunlight* (London: Longman Group Ltd., 1979), pp. 99, 101.

91. Eudora Welty, *The Wide Net and Other Stories* (New York: Harcourt Brace Jovanovich, 1971), p. 156. See also the section on bottle trees in Thompson and Cornet, *op. cit.*, pp. 178–81.

92. Thompson and Cornet, *op. cit.*, pp. 208, 137n.

93. *Ibid.*, pp. 197, 209, note 167. This section is but a preliminary assessment of the bottle-tree phenomenon in the Kongo New World. John Mack, assistant keeper of the Ethnography Department of the Museum of Mankind, has kindly pointed out (personal communication, 21 December 1981) the Bongo and Moru versions of the bottle tree among East African civilizations. With further evidence we may plot the distribution of intervening Bantu traditions, between East Africa and Kongo, thus revealing myriad possibilities of massive reinforcement of the tradition in the Black New World. Cf. W. and A. Kronenberg, *Die Bongo* (Wiesbaden: Franz Steiner Verlag, 1981), Figures 54, 55, 73.

94. Lynda Roscoe Hartigan, *The Throne of the Third Heaven of the Nations Millennium General Assembly* (Washington, D.C.: National Collection of Fine Arts, 1976); *The Throne of the Third Heaven of the Nations Millennium General Assembly* (Montgomery, Ala.: Montgomery Museum of Fine Arts, 1977), pp. 1–20.

95. The work might be characterized as monumental visual glossolalia. Hampton devised a secret script in association with his sacred furniture, itself a kind of writing in three dimensions. Study of this work in comparison with "spiritual writing" in Rio, Trinidad, and Cuba might unlock unsuspected resonances and intentions, particularly as regards the geometrically enclosed mystic ciphers of the ground-drawings of the holy "pointers" of the island of St. Vincent.

96. Literature on the work of Henry Dorsey includes John Fewtterman, "Tinkerer Dreams Up a Forest of Things," Louisville *Times*, Septem-

ber 13, 1960; John Christensen, "Henry Dorsey's House as Art," *Scene* (Louisville *Times* Sunday magazine), November 18, 1972; Guy Mendes, "Found People: Some Figures on My Urn" *Place/Rogues Gallery* II, 2 (1973), 44–46; Ellsworth Taylor, *Folk Art of Kentucky* (Kentucky Arts Commission, 1976); Jan Wampler, *All Their Own: People and the Places They Build* (New York: Oxford University Press, 1977), pp. 150–55; Charles McCombs, "Modern Art in Brownsboro," in *Charles McCombs Almanac* (Brownsboro: Charles McCombs, 1974).

97. Charles Duvelle, *Musique Kongo: Ba-Bembe, ba-Congo, ba-Kongo-Nseke, ba-Lari* (Ocora LP OCR 35), accompanying essay, illustration 12: "friction-drum, a *mukwiti*. This is an open, cylindrical drum to which one skin is nailed; a wooden stick hidden inside the body is firmly attached to one to the center of the membrane. . . . various metal objects of Western origin (switches, electric-light bulbs, electric cables, etc.) are attached to the body of the instrument and are supposedly connected to an earphone situated inside the drum. . . . While he plays the drummer operates the switches or turns a small handle. . . ."

98. I thank Eva Dorsey Williams, surviving sister of Henry Dorsey, who in an interview in the summer of 1974 let me copy pertinent facts from her family scrapbook, especially as regards the life and times of Maria Prewitt.

99. *Ibid.*

100. Interview with Guy Dorsey, brother of Henry, February 1974. In a letter dated 21 October 1974 Guy Dorsey added a phrase that in many ways summed up the work of his departed sibling: "My brother Henry . . . spent many hours of happy moments getting all his trinkets together and enjoyed showing people that stopped by to see everything in working order."

101. Interview, Eva Dorsey Williams, fall 1974.

102. James Joyce, *Ulysses* (New York: Vintage Books, 1961), p. 49. Joyce apparently refers to a song, which itself refers to a prodigal wanderer, one of the themes of the Dorsey house. But this interesting coincidence cannot detain us here.

103. Interview, Guy Dorsey, March 1974.

104. Interview, Eva Dorsey Williams, July 1974.

105. David C. Driskell, *Two Centuries of Black American Art* (New York: Alfred A. Knopf, 1976), illustration, p. 89.

106. Guy Mendes, *op. cit.*, p. 46.

107. Visible in Jan Wampler, *op. cit.*, p. 151.

Three

1. Melville J. Herskovits, *Life in a Haitian Valley* (Garden City, N.Y.: Anchor Books, 1971), p. 31.

2. C. L. R. James, *The Black Jacobins* (New York: Vintage Books, 1963), p. 394. See also Philip Curtin, *The Atlantic Slave Trade: A Census* (Madison: University of Wisconsin Press, 1969), pp. 75–77, 144 (graph), 181–83, 191–97, 200. Curtin points out (p. 181) that Haiti's population stemmed from slaves who had accounted for more than three-quarters of the entire eighteenth-century French Atlantic slave trade.

3. See Chapter III, sections on *minkisi* and *nzó a nkisi*.

4. Interview with Ralph Isham, spring 1976, kindly granted by Mr. Isham.

5. Alfred Métraux, *Le Vaudou Haitien* (Paris: Gallimard, 1958), p. 24.

6. See Robert Cornevin, *Histoire du Dahomey* (Paris: Éditions Berger-Levrault, 1962), pp. 74–82.

7. For details, Karl Polanyi's *Dahomey and the Slave Trade* (Seattle: University of Washington Press, 1966) provides an excellent analysis.

8. Paul Mercier, "The Fon Of Dahomey," in *African Worlds: Studies in the Cosmological Ideas and Social Values of African Peoples* (London: Oxford University Press, 1954), pp. 212–14.

9. This etymology, my own, fits the fact of the intense and creative creolizing pressure brought to bear on many elements of culture from Africa on Haitian soil. The Yoruba term *l'awo*, "mystery," expands into a broader semantic range when it dovetails with the Dahomean sense of mystery, meaning "deity."

10. This chart draws on many sources, including Herskovits, *Life in a Haitian Valley*, pp. 314–17; Harold Courlander, *Haiti Singing* (Chapel Hill: University of North Carolina, 1939); Harold Courlander, *The Drum and the Hoe* (Berkeley: University of California, 1960); and Maya Deren, liner notes to *Voices of Haiti*, LP (New York: Elektra Records, c. 1953).

11. Mercier, *op. cit.*, p. 223: "Gū is specially linked with *Lisa*, strength and the sun. . . . *Lisa* comes down to earth holding *Gu* in his hand in the form of a *gubasa.*"

12. I heartily thank Vincent Kinhoué Ahokpe of the Musée d'Abomey and his assistant for the privilege of photographing and studying the famous monumental *gubasa* of Abomey, 10 January 1968. It was given as an "altar of the spirit of victory."

13. Informants: Sagbaju, son of King Glele and brother of King Gbehanzin, and Akpalosi, son of Sagbaju, Abomey, 10 January 1968.

14. *Ibid.*

15. *Ibid.*

16. Michel Leiris, "Note sur l'usage de chromolithographies catholiques par les voduisants d'Haiti," in *Les Afro-Americains* (Dakar: Ifan-Dakar, 1953), p. 204.

17. Alfred Métraux, *Voodoo in Haiti* (New York: Oxford University Press, 1959), Plate XV, print of St. James the Elder. For further argument on possible symbolism inherent in the shape of the staffs of the flags of *vodun*, see my section of *The Four Moments of the Sun*, pp. 172ff.

18. Seen on a field trip to Haiti, late August 1961, at Bizonton, in the company of Emmanuel Paul, who kindly led me to a rite for Papa Ogún.

19. Explication of the iconography by Sagbaju and Akpalosi, Abomey, 10 January 1968. Their testimony jibes with Cornevin, *op.cit.*, p. 127: "*Gle gle ma yon ze* fields cannot be lifted up [by the wind]," which he, too, gives as a "strong name" of Glele. See also entry for *togodo* in Julien Alapini, *Le Petit Dahoméen: Grammaire—vocabulaire* (Cotonou: Éditions du Benin, 1969), p. 257.

20. Informant: Vincent Kinhoué Ahokpe, Abomey, 10 January 1968.

21. Cf. Maximilien Quénum, *Au Pays des Fons: Us et coutumes du Dahomey* (Paris: Larose Éditeurs, 1938), p. 149.

22. Mercier, *op. cit.*, p. 221.

23. *Ibid.*

24. I thank Wyatt MacGaffey for bringing this pun to my attention.

25. Moreau de Saint-Méry, *Description topographique . . . de la partie française de l'île de Saint-Domingue*, Vol. I (Philadelphia: 1797), pp. 210–11. Quoted in Métraux, *Voodoo in Haiti*, p. 39. I have reworked the translation.

26. Métraux, *ibid.*

27. Jean Price-Mars, "Lemba-Petro: Un Culte secret," in *Revue de la société d'histoire et de geographie d'Haiti* IX, 28 (1938). John Janzen, an anthropologist who has worked for several years in Kongo, has had occasion to analyze this text and finds many strong influences stemming from Kongo in general and the Lemba Society in particular. He discusses these parallels in a recent volume, *Lemba, 1650–1930: A Drum of Affliction in Africa and the New World* (New York: Garland, 1982), pp. 273–92.

28. Jean Price-Mars, "Lemba-Petro, un culte secret," in *Revue de la société d'histoire et de géographie d'Haiti*, Port-au-Prince, 9, 28 (1938), 12–31.

29. Maya Deren, *Voices of Haiti* LP.

30. Maya Deren, *Divine Horseman: Voodoo Gods of Haiti* (New York: Chelsea House Publishers, 1970).

31. For discussion, see Métraux, *Le Vaudou Haitien*, pp. 66–67.

32. Mercier, *op. cit.*, p. 221.

33. Seen between Bizonton and Port-au-Prince during a survey of peristyles in the area of the capital in March 1975.

34. P. Amaury Talbot, *In the Shadow of the Bush* (London: William Heinemann, 1912), p. 25, illustration.

35. Métraux, *Le Vaudou Haitien* p. 68. Translation mine.

36. These structural observations are inspired by Karen McCarthy Brown's *The Veve of Haitian Vodu: A Structural Analysis of Visual Imagery* (Ann Arbor, Mich.: University Microfilms, 1975), a landmark study.

37. Thompson and Cornet, *op. cit.*, p. 203, suggesting links between this custom and the rhythmic unfurling and dancing with umbrellas at the traditional jazz funeral in New Orleans.

38. Métraux, *Voodoo in Haiti*, p. 161.

39. *Ibid.*

40. And recalling the fact, as Polanyi, *op. cit.*, p. 54, points out, that in old Dahomey "everything went by pairs and even multiple pairs. . . . every official in the kingdom had his female counterpart. . . . throughout the army . . . every male, from the highest ranking officer down to the last soldier, had his female counterpart in the palace."

41. Interview with Álvares, near Léogane, 21 March 1975.

42. Eleanor Ingalls Christensen, *The Art of Haiti* (New York: A. S. Barnes and Company, 1975), p. 69.

43. I am grateful to Pierre Monosiet, curator of the Museum of Haitian Art, for bringing these flags to my attention in the summer of 1961. They have since been stolen from a private collection in New England and their whereabouts are still unknown. Monosiet himself suggested the tentative dating of 1945 for these flags.

44. John Janzen, Lemba, 1650–1930, pp. 284–85.

45. For the Tu-Chokwe design, see Eduardo dos Santos, *Sobre a religião dos quiocos* (Lisbon: Junta de Investigações do Ultramar, 1962) Fig. 1; for the Ndembu ground-sign, Victor Turner, *Chihamba the White Spirit: A Ritual Drama of the Ndembu* (Manchester: Manchester University Press edition, 1969), Plate 8b; Pende drawings of cosmograms, from an unpublished MS. by R. P. de Sousberghe, were kindly shared with me, in a personal communication (18 August 1977), by Marie-Louise Bastin.

46. Cover illustration, Milo Rigaud, *La Tradition voudoo et le voudoo haitien* (Paris: Éditions Niclaus, 1953).

47. R. F. Thompson, "The Flash of the Spirit: Haiti's Africanizing Vodun Art," in Ute Stebich, *Haitian Art* (New York: Abrams, 1978), pp. 34–35. *Rara* refers to Kongo-influenced pre-Lenten street orchestras, *coumbite* to African-influenced communal work parties fueled by percussion.

Four

1. D. T. Niane, *Sundiata: An Epic of Old Mali* (London: Longman, 1965).
2. *Ibid.*, pp. 58, 93–94, note 62: "A 'tana' is an hereditary taboo, can also mean a totem . . . in this case Soumaoro was forbidden to touch ergot, of which a cock's spur is composed, and as long as he observed this he could concentrate in himself the power of his ancestors." The presence of a similar belief, in the power of the animal-*tono* (cf. *tana*), among Afro-Mexicans of the Costa Chica south of Acapulco would appear to constitute an important New World Mandeism.
3. Charles S. Bird, "The Development of Mandekan (Manding): A Study of the Role of Extra-linguistic Factors in Linguistic Change," in David Dalby, ed., *Language and History in Africa* (New York: Africana Publishing Corp., 1970), pp. 154–55.
4. *Ibid.*, p. 156.
5. Charles S. Bird, personal communication, winter 1976.
6. *Ibid.*
7. Personal communication, spring 1980.
8. Gonzalo Aguirre Beltrán, "Tribal Origins of Slaves in Mexico," *Journal of Negro History*, Vol. XXXI (1945), p. 280.
9. For details, see Gonzalo Aguirre Beltrán, *Cuijla: Esbozo etnográfico de un pueblo negro* (Mexico City: Fondo de Cultura Económica, 1958), pp. 52–64. As late as 1801, authorities were complaining of the independence of the blacks of the region, "that they didn't have a fixed residence, that they lived in the fields in scattered huts" (p. 62).
10. Lic. Francisco Vázquez, *Ometepec: Leyenda de un pueblo* (Puebla: Editorial Cajica, 1964), p. 74.
11. Aguirre Beltrán, *Cuijla*, p. 60, from a letter by the mayor of Guatulco to the viceroy of New Spain, 1591.
12. Gerard Brasseur, in his *Établissements humans au Mali* (Dakar: Mémoires de l'Institut Fondamental d'Afrique Noire, 1968), p. 247, reports that the primary characteristic of nuclear Mande architecture is the nearly exclusive position held by the cone-on-cylinder type in traditional villages. In this matrix emerged the four variants of the Mande cone-on-cylinder style. For details, see Tod Eddy, "Manding

Architecture from Africa to the New World: A Study in the History of African and Afro-Mexican Art" (unpublished paper, spring 1974), pp. 3–40. Eddy's paper has the advantage of field study, not only on the Costa Chica but in terms of long residence in Kangaba, the heart of the nuclear Mande. It is an excellent study and I have relied heavily upon it. My own field trips to Kangaba (1975) and to the Costa Chica in Mexico (spring 1977) confirm his findings.

13. I am grateful to Señora Julia Venedado, of the village of Montecillos, and her colleagues, for the privilege of making a close study of their family kitchen-roundhouses in March 1977.

14. Eddy, *op. cit.*, p. 42, was the first to note this trace of possible (northern Mande) Soninke influuence on the roof types of Costa Chica black architecture. For details on Afro-Mexican roofing, see Beltrán, *Cuijla*, pp. 94–95.

15. Eddy, *op. cit.*, p. 52.

16. Personal communication, 29 July 1977.

17. David P. Gamble, *The Wolof of Senegambia* (London: International African Institute, 1967), p. 41.

18. Susan M. Yecies, "African Influence in Domestic Mexican Architecture: San Nicolás, Costa Chica," May 1971, New Haven.

19. Labelle Prussin, "Sudanese Architecture and the Manding," African Arts III, 4 (1970), 15. Cf. George W. McDaniel, *Hearth and Home: Preserving a People's Culture* (Philadelphia: Temple University Press, 1982), p. 33: "Many traditional African societies did not think of a house as a single building; instead, homes consisted of clusters of buildings, the 'rooms' for sleeping, eating, entertaining. . . ."

20. Eddy, *op. cit.*, p. 27.

21. Beltrán, *Cuijla*, p. 93.

22. Eddy, p. 56, was apparently the first to suggest this nuance: "Two cross beams reinforce the roof from the inside instead of the lower internal ring of [thin and flexible rings of wood]."

23. Aquiles Escalante, *El Negro en Colombia* (Bogotá: Universidad Nacional de Colombia, Facultad de Sociología, Monografías Sociológicas, 18, 1964), p. 5.

24. *Ibid.*, p. 76.

25. Marquis de Wavrin, *Chez les Indiens de Colombie* (Paris: Librairie Plon, 1953), p. 218. In Julian H. Steward's *Handbook of South American Indians* (Washington, D.C.: Smithsonian Institution, 1949), Vol. 5, p. 8, it is stated that "such houses [with a circular plan and conical roof] are reported for the Arawak of the West Indies, and for the Choco of Colombia." These are areas inhabited by blacks as well. The

problem of mutual reinforcement of similar ideas in Colombia cannot, in the absence of fieldwork, be resolved. But it is imperative to compare the two traditions in the future on the assumption that outward Amerindian form might conceal a number of traits absorbed from runaway slave architects. Certainly to judge from a published photograph of Colombia Arawak dwellings, Mande influence seems likely.

26. Cf. *House and Gardens* 129, 3 (March 1966).

27. *Virginia Historic Landmarks Commission Survey Form*, no. 154-10 (June 29, 1973).

28. The phrase and explication of "off-beat phrasing of melodic accents" are to be found in Richard Waterman's classic article, "African Influence on the Music of the Americas," in Sol Tax (ed.), *Acculturation in the Americas* (Chicago: University of Chicago Press, 1952), pp. 207–18.

29. Venice Lamb, *West African Weaving* (London: Gerald Duckworth, 1975), pp. 90–100, 180, 190, 198. "These Ewe blankets resemble strongly the weaving generally found in regions north of the Volta Region" (p. 212).

30. *Ibid.*, p. 20.

31. *Ibid.*

32. *Ibid.*, p. 75. See also R. Vedaux, *Tellem* (Berg en Dal: Afrika Museum, 1977), p. 76.

33. *Ibid.*, pp. 86–87.

34. Cf. Roy Sieber's observation in his *African Textiles and Decorative Arts* (New York: Museum of Modern Art, 1972), p. 190, apropos of a rhythmized *welmare* [Fulani men's cover] "a superb example of seemingly random placement of pattern. . . . the careful matching of the ends of the cloth dispels the impression of an uncalculated overall design."

35. Lamb, *op. cit.*, p. 86.

36. Pascal James Imperato, "Blankets and Covers from the Niger Bend," *African Arts* XII, 4 (August 1979), 41. Owen Barfield's *Poetic Diction* (Middleton: Wesleyan University Press, 1928) is a perfect school of learning for the appreciation of rhythmized textiles like *welmare*. Cf. p. 179: "Imagination . . . lights up only when the normal continuum . . . is interrupted in such a manner that a kind of gap is created, and an earlier impinges directly upon a later—a more living upon a more conscious."

37. Renée Boser-Sarivaxevanis, *Les tissus de l'Afrique occidentale* (Basel: Pharos-Verlag, 1972), p. 83, Fig. 7.

38. Beth Ann Jeffe, "The West African Narrow-Strip Weaving Tradition

in the New World" (senior thesis, Yale University, May 1977), p. 13.

39. *Ibid.* See also Vania Bezerra de Carvalho, *Mestre Abdias: O Ultimo Artesão do pano da Costa* (Salvador: Studio Domingos, 1982), p.12

40. Jeffe, *op. cit.*, p. 17.

41. I am grateful to Juana Elbein dos Santos and to Beth Ann Jeffe for copies of photographs of multistrip cloths by Abdias.

42. When on 10 January 1980 I asked Abdias, at his atelier in Salvador, why he used offbeat phrasing in his cloths, he replied: "The design is more beautiful with elements thus separated out" *(Fica mais linda ainda como separado o disenho),* and he added that offbeat phrasing distinguishes his work, as well as his inspiration, from machine-made cloths, "which cannot make my zigzags." He repeated these points in August 1982.

43. Richard Price (ed.), *Maroon Societies: Rebel Slave Communities in the Americas* (Baltimore: Johns Hopkins University Press, 1979), p. 317.

44. M. Ferdinand Denis, *La Guyane: ou histoire, moeurs, usages et costumes des habitants de cette partie de l'Amerique* (Paris: Nepveu, 1823), p. 130, plus illustration facing p. 131. The word *camiza* is not Amerindian but maroon black, referring to cotton loincloth. C. Healey brought this reference to my attention.

45. *Ibid.*

46. Richard Price, *The Guiana Maroons: A Historical and Bibliographic Introduction* (Baltimore: Johns Hopkins University Press, 1976), pp. 14–15.

47. From a conversation with the paramount chief of the Djuka at his house in Dii Tabiki, 28 December 1981. Cf. *The Glossary of the Suriname Vernacular* (Paramaribo: Volklectuur, 1961): p. 15, *dobroesten* means "textile type," p. 66.

48. Ma Apina, interview, Dii Tabiki, 29 December 1981: *Te wan Ndjuka sama o felifi sani den felifi mu kengi keele. Te a u go tapu a mu tapu a wan felifi mofu di de faawe fi en.* I thank James Park, an American linguist based in Paramaribo, for checking this translation.

49. Tony van Omeren of Paramaribo said on 1 January 1982 that *mamio,* which he defined as "different pieces of cloth sewn together," was more than a hundred years old (i.e., made before 1882) on the coast and that old mid-nineteenth-century examples were still to be found in a few Paramaribo collections. Else Henar-Hewitt of Paramaribo said that when a coastal black woman is expecting, they start to make a *mamio.* She also showed me a coastal costume of a festive type called *a meki sanni* "she makes the moves" (Plate 140), worn by a special

hostess whose function is to welcome people. Her costume alternates patterned cloth handkerchiefs set against vertically striped handkerchiefs, not unlike the cross-play between *dobi sten* and *stiipi.*

50. John Vlach, *The Afro-American Tradition in Decorative Arts* (Cleveland: Cleveland Museum of Art, 1978), p. 55.

51. Telephone interview, spring 1980.

52. From field notes generously shared with me by Dominic Julian Parisi. See also his excellent "Needles and Drums: Antebellum Foundations for the Black Quilting Aesthetic" (M.A. thesis, Yale University, May 1980).

53. *Yale Course Critique,* 1973, p. 60.

54. Melville J. Herskovits, *Life in a Haitian Valley* (Garden City, N.Y.: Anchor Books, 1971), pp. 254–55.

55. Informant: Ellen Walters, curator of exhibits, Cleveland Museum of Natural History, spring 1977.

56. Cf. Ruth Bass, "The Little Man," in Alan Dundes (ed.), *Mother Wit from the Laughing Barrel: Readings in the Interpretation of Afro-American Folklore* (Englewood Cliffs: Prentice-Hall, 1973), p. 393: "Newspapers pasted on the walls will cause any spirit to stop and read every word on the papers before bothering you."

57. Gamble, *op. cit.*, p. 41.

58. Cf. Sarah Brett-Smith, *Speech Made Visible: The Irregular as a System of Meaning,* conference paper in press (August 15, 1980), p. 22: "Bamana methods for transcribing the spoken word . . . cannot be clear. . . . [To] fulfill their purpose they must evade linguistic systematization and the socially (perhaps even politically) disruptive possibility of mass communication by introducing aberrant visual symbols which prevent immediate comprehension. Like the spoken, the transcribed word must remain indistinct and allusive; knowledge may thus rest secure in the shadowy realm of the aged or the exceptionally gifted."

59. Mary Douglas, *Purity and Danger: An Analysis of the Concepts of Pollution and Taboo* (London: Routledge & Kegan Paul, 1966), p. 95.

60. Charles S. Bird and Martha B. Kendall, "The Mande Hero: Text and Context," in Ivan Karp and Charles S. Bird (eds.), *Explorations in African Systems of Thought* (Bloomington: Indiana University Press, 1980), p. 17: "[Power]-laden parts of a hunter's kill—skin, horns, teeth, claws, feather—are incorporated into his . . . clothing. These serve to control the *nyama* released by each kill, protecting the hunter from potential destruction; but they also empower him to perform greater deeds."

Notes

1. A list of writings on *nsibidi* and *nsibidi*-related material includes: Alfred Mansfeld, *Urwald-Dokumente* (Berlin: Dietrich Reimer, 1908), Tafeln IV and V; Rev. J. K. MacGregor, "Some Notes on *Nsibidi*," *Journal of the Royal Anthropological Institute*, Vol. XXXIX, (1909), pp. 209–19; E. Dayrell, "Some 'Nsibidi' Signs," *Man*, No. 67 (1910), pp. 112–14; Elphinstone Dayrell, "Further Notes on Nsibidi Signs with Their Meanings from the Ikom District, Southern Nigeria," *Journal of the Royal Anthropological Institute*, Vol. XLI (1911), pp. 521–40; P. Amaury Talbot, *In the Shadow of the Bush* (London: William Heinemann, 1912), Appendix G, "Nsibidi Signs," pp. 447–61; M. D. W. Jeffreys, "Corrections," *Man* 67 (Nsibidi Writing), 1910, *Man*, Nos. 189–93 (September–October 1964), p. 155; Kenneth Murray, unpublished MS. fragment on "nsibidi writing among Ehuman Clan, Enyong, Aro Division," Lagos, 1938; M. D. W. Jeffreys, "Notes on Nsibidi," unpublished MS. compiled at Calabar c. 1925, 10 pp.; David Dalby, "The Indigenous Scripts of West Africa and Surinam: Their Inspiration and Design," *African Language Studies*, Vol. IX (1968), pp. 156–97; Robert Farris Thompson, "Black Ideographic Writing: Calabar to Cuba," *Yale Alumni Magazine* (November 1978), pp. 29–33; Kenneth Campbell, *Secrets of Nsibidi* (unpublished MS. 1978); M.V. Spence, "Nsibidi and Vai: A Survey of Two Indigenous West African Scripts" (M.A. thesis, 21 May 1979).

2. P. Amaury Talbot, *op. cit.*, p. 37.

3. Interview with Peter Eno, Mamfe, Cameroon, 26 May 1969.

4. Cf. Eno, *ibid:* "If you want to execute heavy things, dangerous matters, *nsibidi* takes the lead." Cf. Jacques Derrida, *Of Grammatology* (Baltimore: Johns Hopkins Press, 1976), pp. 101–40, "the violence of the letter."

5. The late *ndidem* of Big Qua Town, Nigeria, told me in January 1972 that the reason few Westerners had ever seen such signs was that they were swiftly drawn in chalk on the floor of the deceased person's house, among family members, and then quickly erased before others were allowed into the room.

6. Peter Eno, 26 May 1969.

7. Franklin W. Knight, *Slave Society in Cuba During the Nineteenth Century* (Madison: University of Wisconsin Press, 1970), p. 50.

8. Daryll Forde (ed.), *Efik Traders of Old Calabar* (London: International African Institute, 1956), p. 66, note 1a.

9. Pedro Deschamps Chappeaux, "Potencias: Secreto Entre Hombres," *Cuba* VII, 72 (1968), 44.

10. Lydia Cabrera, *La Sociedad Secreta Abakuá* (Havana: Ediciones C. R., 1959), includes four terms for Ejagham-related graphic writing in Cuba, including not only the now standard title for the writing, *anaforuana*, but also *ereniyo* ("writing; symbol"), *gandó* ("chalked sign"); and *bangó* ("chalked sign"). See pp. 68, 178.

11. Lydia Cabrera, *Anaforuana: Ritual y símbolos de la iniciación en la sociedad secreta Abakuá* (Madrid: Ediciones R, 1975). I estimate there are approximately 512 discrete signs documented in this important text, a landmark study in the history of black Atlantic writing systems.

12. For a brief discussion of the Ejagham impact on the art of their neighbors, see R. F. Thompson, *African Art in Motion* (Berkeley: University of California Press, 1974), p. 173.

13. Cf. Philip Allison, *Cross River Monoliths* (Lagos: Department of Antiquities, 1968), p. 17: "Fighting was a man's normal occupation and on his success . . . depended his membership of certain important societies."

14. Malcolm Ruel, *Leopard and Leaders: Constitutional Policies Among a Cross River People* (London: Tavistock Publications, 1969), p. 182. During the fifty years up to 1904 there had been no major warfare between tribes but rather a series of skirmishes between single villages, according to Mansfeld, who administered Ejagham territory in what is now western Cameroon.

15. For a recent, brief study of the fatting-house institution among the Ejagham's western neighbors, the Ibibio, see Jill Salmons, "Fat Is Beautiful," *Art Links (The Commonwealth Arts Review)*, September 1981, pp. 23–25.

16. T. J. Hutchinson, *Impressions of Western Africa* (London, 1858), p. 160.

17. Interview with Mme. Grace Davis, Calabar, December 1978.

18. Rev. Hugh Goldie, *Dictionary of the Efik Language* (Ridgewood: Gregg Press, reprint edition, 1964), p. 279.

19. Interview: Mme. Grace Davis, Calabar, December 1978.

20. Talbot, *op. cit.*, p. 152 (illustration).

21. See Ruel, *op. cit.*, for data on a cognate women's society, Ndem, among the Banyang; p. 204: "its primary purpose [was] giving status to women . . . men seeking community status sought to marry these 'leaders among women.' It was not a matter of chance that both in Tali and Besongabang when I inquired about *Ndem*, I was sent to the senior wife of the village leader."

22. Cf. Mansfeld, *op. cit.*, p. 71: "*Die ganze Mode soll in strenger Anlehnung an dass historische Vorbild: die erste Mboandemdame, die in*

Notes

alten Zeiten vom Himmel heruntergestiegen kam, verfertigt sein."

23. I thank the chief and elders of Onun village for the privilege of studying a fine *echi okpere*, kept in the local Ngbe hall, 27 December 1975. I thank Peter Eno of Mamfe for related data from Ekwe areas.

24. Informants: Ngbe elders, Oban, August 1978.

25. Cabrera, *La Sociedad Secreta Abakuá*, p. 148.

26. *Ibid.*

27. The fact that *Akuaramina* is an Efik term is given in Cabrera, *La Sociedad Secreta Abakuá*, p. 151. I am much indebted to Pierre Verger for his unpublished detail of the *Akuaramina* mask (Plate 145).

28. Or, as Ruel, *op.cit.*, p. 184, describes it, "a cult organization by which young men . . . were organized and ritually strengthened for fighting."

29. Edwin Ardener, "Documentary and Linguistic Evidence for the Rise of the Trading Polities between Rio del Rey and Cameroons, 1500–1650," in I. M. Lewis (ed.), *History and Social Anthropology* (London: Tavistock, 1968), p. 126.

30. An elder at Oban, for example, told me that Efut Ngbe still carried prestige, and he pointed to songs sung in Efut in Oban Ngbe liturgy as an indication of that fact (August 1978).

31. A. J. H. Lathan, *Old Calabar: 1600–1891* (Oxford: Clarendon Press, 1973), p. 36.

32. Cabrera *La Sociedad Secreta Abakuá*, p. 88.

33. *Ibid.*, pp. 79, 83–84. My translation occasionally modifies, elides, or adds to the renderings of Cabrera's informants with glosses provided by the late King of the Efut at his residence in Calabar in December 1975, e.g., where Afro-Cubans give the creolized term Efokondo, I restore it to Efut, *Efut Ekondó*, and suggest its actual location in Efut country.

34. *Ibid.*, p. 87: pez del río; pez del mar; *Tanze Uyo* (lit, Lord Fish of the Voice); *Elori lori; Tanze Kefenbere;* Tanze es Ekue (lit., Lord Fish is a leopard); Tanze es Ekue . . . ; *Fuerza . . . ; por quien suspiraban los Adivinos . . . ; oyos amarillos (arema).*

35. *Ibid.*, pp. 92–95.

36. Ejagham art cryptically refers to a miracle of fusion, the blending of the lordly energy of the leopard within the body of the fish. Talbot's drawings show denizens of the deep, crocodiles, with bodies marked with the checkered symbol of leopard presence, and, as we shall see, the Glasgow Art Museum includes in its study collection a brass tray upon which is clearly represented a leopard-fish. Among the Eastern Ejagham Father Druken of the Mamfe area collected (1969) a myth of a stolen fish. When the fish was restored, order resumed within the

world (the very existence of which had been threatened).

37. Ekwe Ejagham informants recited terse, simple myths of Ngbe origin, most of which coincided with the essential structure of the material published by Cabrera, e.g., "Our people say woman discovered Ekpe, but could not keep secret . . . men took over" (Otu village, Cameroon, June 1969).

38. See Thompson, "Black Ideographic Writing."

39. *Ibid.*

40. Informant: the late Ndidem of Big Qua Town, Nigeria, January 1972.

41. Pedro Deschamps Chappeaux, *op. cit.,* pp. 45–46.

42. Cabrera, *Anaforuana,* p. 51. In Cuba there is the highest rank, with the title *ntereñobón,* and then a generalized rank with the title *obón.* This elides seven or more grades in Nigerian and Cameroonian Ngbe societies.

43. Informant: Julito Collazo, Hamden, Connecticut, January 1970. Cf. also Cabrera, *Anaforuana,* p. 183.

44. Cabrera, *Anaforuana,* p. 497.

45. Julito Collazo, interview, January 1970.

46. Cabrera *Anforuana,* pp. 496–97.

47. Cabrera, *La Sociedad Secreta Abakuá,* p. 40.

48. D. José Trujillo y Monagas, *Los Criminales De Cuba* (Barcelona: Establecimiento Tipográfico de Fidel Giro, 1882), p. 366.

49. Cabrera, *La Sociedad Secreta Abakuá,* p. 68, 178.

50. Ruel, *Leopards and Leaders,* p. 245.

51. Cabrera, *La Sociedad Secreta Abakuá: Ese son ereniyo de mué que matá; son Sikán y pescá.*

52. Cabrera, *El Monte,* p. 215. See also her *Sociedad Secreta Abakuá,* p. 178: "The graphic signs create and dominate; whatever is not signed has no reality."

53. Cabrera, *Anaforuana,* pp. 158–77.

54. *Ibid.,* p. 181.

55. Cabrera, *La Sociedad Secreta,* p. 164.

56. Cabrera, *Anaforuana,* p. 187.

57. Informant: William Tayui, a native of the Obang area, western Cameroon, summer 1969.

58. Roger Bastide, *African Religions in the New World* (New York: Harper & Row, 1971), p. 115.

59. Cabrera, *La Sociedad Secreta Abakuá,* p. 257.

60. *Ibid.,* p. 266.

61. Juan Luis Martín, *Vocabularios de Ñáñigo y Lucumí* (Havana: Editorial Atalaya, 1946); Pedro Deschamps Chappeaux, "El Lenguaje Abakuá," *Etnología y Folklore*, 4 (July–December 1967), pp. 39–47.

62. Israel Castellanos, "El Diablito Ñáñigo," *Archivos del Folklore Cubano* III, 4 (1928), 27–37.

63. *Ibid.*, p. 37.

64. Cabrera, *Anaforuana*, p. 440. Further glossed by Lydia Cabrera in conversation with the author, winter 1981.

Index

303

over graves, 144–45
households protected by, 142–44
U.S. artists inspired by, 147, 151, 153–54
bows and arrows, metal, for Oshoosi, 58, 59–60
Bragg, Nelly, 222
Brazil:
Dahomean deities in, 176
Kongo ritual authorities in, 107–8
minkisi (charms) in, 127–28, 129
multistrip textiles in, 208, 212–14
Obaluaiye cult in, 63, 64–68
Ogún cult in, 55–57, 59–60
Oshun cult in, 81, 83
Shàngó cult in, 87, 90
slaves imported by, 17, 206, 212
see also Bahia, Brazil; Rio de Janiero, Brazil
British West Indies, patchwork textiles in, 221
broom imagery, for Obaluaiye *(ha)*, 63–68, 71
Brown, William Well, 218
Bryant, Robert, 129–30

Cabrera, Lydia, 23, 48, 80–81, 125, 128, 239
caldero de ogún (Ogún cauldrons), 55
Canary Islands, slaves from, 253
candomblé (rites), 113, 214
capes, multistrip *(aséesenti; aséesente),* 208, 217, 220
Catholicism, *see* Roman Catholicism
chains:
divining *(opele),* 35–37
as Yoruba ideogram, 61
character, *see iwa*
charms:
good-luck *(toby),* 105
graves as, 132
mystic ground-drawings and, 110–11

nkisi, see minkisi
in *vodun*, 126, 127, 164
chickens, white, on graves, 134–35
Colombia, rondavels in, 206
Combs, Kenneth, 220
Combs, Luiza, 218–20
cone-on-cylinder architecture (rondavels), 197–206
in Colombia, 206
construction techniques for, 200–203
on Costa Chica *(redondos),* 199–205
grouped in circular compounds, 203–5, 222
in Mande area, 197, 200–201
of Native Americans, 200, 205
re-created by Mande slaves, 199–200
of Soninke, 201–3
Western architects influenced by, 206
coolness, *see itutu*
coronas (securing-rings), 203
Correspondencia de Cuba, La, 250
Cosas de negros (Rossi), 105
cosmograms, *see* ground-drawings, mystic; Kongo cosmogram
Costa Chica, Mexico:
Mande-area slaves sent to, 198–200
Native Americans decimated on, 198
redondos on, *see* cone-on-cylinder architecture
"country cloth," 208–11
clashing of colors in, 209, 217, 220
in medieval period, 208–9
New World variants of, 208, 212–22
off-beat phrasing in, 207, 209, 211, 217, 220
patterned vs. unpatterned strips in, 210, 217, 220
predilection for striped cloth and, 209
spontaneity in design of, 211
see also narrow-strip weaving; textiles, rhythmized

cowrie shells:
 in Eshu icons, 22, 23, 25, 26, 27–28
 riverain goddesses and, 75–77, 80
Criminel (Haitian spirit), 182–83
crosses, Christian mystic ground-drawings and, 108, 111, 113, 115
crossroads imagery, 252
 for Eshu, 18, 19, 51, 85, 116
crowns:
 in Oshun cult, 80–81
 raffia (ade iko), 66–68
 of Yoruba kings, 9
Cuba:
 beaded drum tunics in, 95–97
 charms in, 121–25, 128, 129
 Dahomean deities in, 176
 Eshu cult in, 19, 20–21, 22, 23–25
 fans for Yemayá in, 75–77
 feather imagery in, 236–39
 ideographic writing in, see anaforuana
 Ifá continued in, 37, 42
 Kongo ritual authorities in, 107–8
 leopard society in, see Abakuá Society
 mystic ground-drawings in, 110–11
 myths on Ngbe origins in, 239–43, 253–54, 255
 Obaluaiye cult in, 63
 Ogún art in, 55, 59, 60–61
 Osanyin cult in, 42, 43, 44, 45, 48–49
 Oshoosi cult in, 59, 60–61
 Oshun cult in, 80–81
 Shàngó cult in, 18, 89–90, 93
 slaves imported by, 17, 228, 253
 towns in, creolized Efut names for, 250
 Yoruba initiation ceremonies in, 47
Curtin, Philip, 103

Dā (Dan) (Dahomean deity), 176–79, 181
Da Ayido Hwedo (Dahomean spirit), 176–79

Dahomean civilization, 83, 165–79, 182
 Abomey conquests and, 165–66
 deities in, see vodun
 kings and statecraft in, 174–76
 sacred art of, 23, 25, 63–65, 68, 167–69, 173–76
 textiles of, 208, 214
 vodun (voodoo) and, 163, 164, 165–79, 180, 181, 182, 185, 188, 191
 Yoruba migrations and, 165
damata oshoosi (Oshoosi emblem), 59
Damballah (Haitian spirit), 177–79, 187, 191
dancing, in vodun, 172, 179, 180, 181
Danger-Malheur (Haitian spirit), 184
da Silva, Clodimir Menezes, 83
Davis, Madame Grace, 230
death imagery, of Ejagham and Abakuá, 257–60, 268
death shrines, 257
 see also graves
Denis, Ferdinand, 215, 217
dinza (to discharge one's semen), 104
divination:
 in vodun, 184
 of Yoruba, 34; see also Ifá
Djuka, multistrip textiles of, 208, 217–18, 220
Do-Aklin, 165
dobi sten (patterned strips), 217, 220
dogs, as Kongo symbols, 121
Dom Pèdre "dance," 179
Don Pedro (Dom Pèdre), 164, 179–80
Dorsey, Alice White, 150, 153
Dorsey, Bernice, 155
Dorsey, Clarence, 150, 153
Dorsey, Costella A., 153
Dorsey, Guy, 153
Dorsey, Henry, 147–58
 ancestors of, 150
 children's birth dates inscribed by, 151–53
 electrokinetic art by, 150, 157

Jeffreys, M. D. W., 249
Jesus Christ, 108
jewelry, Ogún honored by, 53–54, 55, 59
jizz, etymology of, 104
Jones, Bessie, 135
Joyce, James, 151
jumbie (West Indian spirit), 221

Kalunga (God of Tu-Chokwe), 189
kalunga (Kongo world of dead), 109
Kangaba, cone-on-cylinder architecture in, 197, 201
Kardec, Allen, 113
Kasa-Vubu, Joseph, 106
Kashi, 5
Ketu, Benin Republic, 37, 53
 Nana Bukúu cult in, 69–71, 72
 Oshoosi cult in, 58
 round fans in, 75
Ki-Kongo words, English slang derived from, 104–5
kings:
 Dahomean, 174–76
 of Ejagham, 243–44
 of Kongo *(mfumu)*, 106, 107
 of Oyo, *see* Shàngó
 of Yoruba, 7–9, 33, 34, 52
kneeling, as Yoruba gesture, 13
knots, symbolic, of *minkisi* (charms), 128, 130
kolo (kernel; essential structure), 196–97
Kongo-American societies, 105
Kongo civilization, 77, 103–58
 ancient ideal capital of, 105–6
 bottle trees in, 142–45, 147, 151, 153–54
 charms in, *see minkisi*
 English slang and, 104–5
 gravesites in, 117, 132–42, 146–47, 151, 153, 157, 182
 kings *(mfumu)* in, 106, 107

life-death cyclicity in, 106, 108–9
 peoples and territories encompassed by, 103–4
 ritual authorities in, 107–8
 slave trade and, 103–4
 U.S. artists influenced by, 146–58
 vodun (voodoo) and, 163, 164, 165, 167, 169, 179–84, 185, 188, 191
Kongo cosmogram, 106, 108–16
 form and meaning of, 108–9
 in Kongo rituals, 109–10, 113
 minkisi (charms) and, 110–11, 117, 118, 121
 New World variants of, 110–16, 126, 188–91

Labintan of Otta, 40–41
Lagos, Ejiwa cult in, 68
Laman, Karl, 118
Lamb, Venice, 208
Lander, Richard, 58
Larsen, Jack Lenor, house of (East Hampton), 206
laterite, in Eshu imagery, 20–22, 24–25, 34, 54, 68
Lawal, Babatunde, 11, 12
Lazarus, Saint, 17
Legba, *see* Eshu-Elegbara
Leiris, Michel, 172
Leland, Charley, 130–31
Lemba Society, 107, 109–10, 164, 180
Leontus, Adam, 186–88
leopard societies, *see* Abakuá Society; Ngbe Society
levantamiento de plato (ideograph), 268
lion's jaws, in Dahomean imagery, 169
loa (Haitian spirits), 166
love charms, 127–30
 miniature, 128
lu (lineage), 204
luck, charms for, 105, 130–31
lu-fuki (bad body odor), 104–5